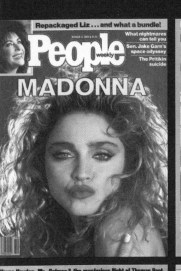

Repackaged Liz ... and what a bundle!

People weekly

What nightmares can tell you
Sen. Jake Garn's space odyssey
The Pritikin suicide

MADONNA

Princess Anne and Mark Phillips call it off

People weekly

Jim Bakker's bizarre trial

LORDY, LORDY!

A witness faints, Jim collapses, and Tammy Faye sobs for sympathy. But stay tuned. A new book details his lurid history of mental instability and sexual escapades

Richard Gere's *Breathless* love

MAY 30, 1983 • $1.25

...n for ...nklin ...uizzes Norman Mailer

People weekly

The A-Team's
MR. T
answers questions you'd never dare ask— on sex, drugs, his violent past and that fool haircut

Wayne Newton, Mr. *Batman* & the mysterious flight of Thomas Root

People weekly

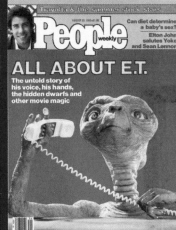

FAME & MURDER

With *Class Struggle* and *My Sister Sam* behind her, Rebecca Schaeffer, just 21, was full of promise. Then along came a stranger with a glossy photo asking neighbors where she lived. A short time later, she was killed. Her death prompted an already anxious Hollywood to beware the increasing threat from deranged fans

Travolta & the summer stock stars

People weekly

Can diet determine a baby's sex?
Elton John salutes Yoko and Sean Lennon

ALL ABOUT E.T.

The untold story of his voice, his hands, the hidden dwarfs and other movie magic

Exclusive: 24 wild & crazy hours with Detroit's test-tube quints

People weekly

MAY 30, 1988 • $1.69

- **BOOK EXCERPT:** *Talking Straight* by Lee Iacocca
- **The biggest rock show of the year**

AMAZING GRACE

In the shadow of death from AIDS, hemophiliac Ryan White, 16, has found a great gift for living. This is a boy you'll never forget.

JON VOIGHT · A SINGLE DAD'S STRUGGLE

People weekly

Debbie Harry vs. Andy Kaufman
Six stars face life after baseball

SEXY FOREVER

How Linda Evans, Dan Travanti, Linda Gray and Stefanie Powers make older look better

Michael Jackson, Diana Ross & Stevie Wonder toast Motown's 25th year

Dynasty's Evans

People weekly

TV's BRAINY, SASSY *DESIGNING WOMEN*

MICHAEL J. FOX

THE SECRET OF HIS SUCCESS

At home with Oscar winner ROBERT DUVALL

Want a date? Call Rex Smith
Jesse Jackson's chaotic road show
The brassy Brit of *Falcon Crest*

People weekly

It's a guy, it's a girl—

IT'S BOY GEORGE!

Joke, freak or pop genius— kids are getting his message...

Cocaine and the death of a ballet star

People weekly

Patrick Bissell, 30

Exclusive: Liz tells the whole emotional story

WHY I GOT FAT— AND HOW I LOST 60 LBS.

"It's a wonder I didn't explode," says Taylor in an excerpt from her revealing new book

People

CELEBRATE
THE '80s!

CONTENTS

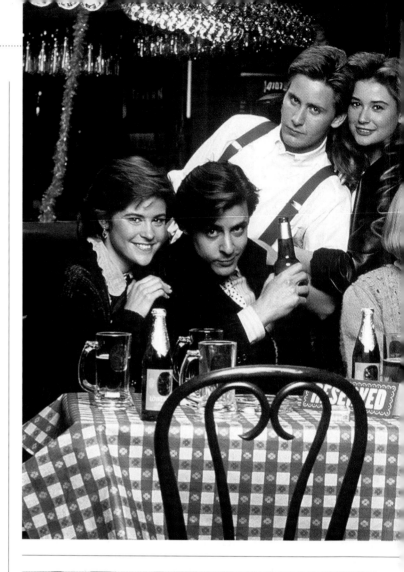

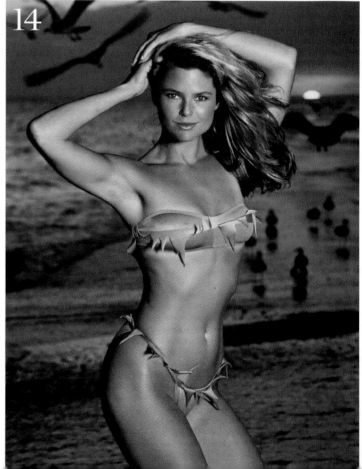

14

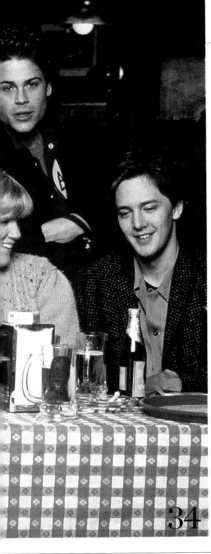

34

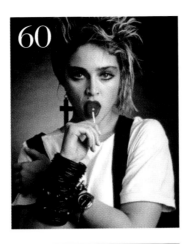

60

12

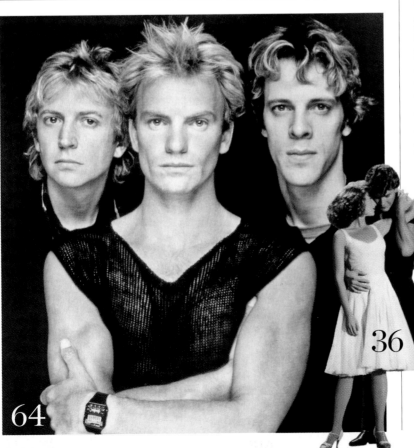

64

36

It was a different world, say those who were there, a time before iPods in a land innocent of cell phones, Crocs, grunge, hybrids and Ryan Seacrest. Hair-metal bands roamed the Earth untamed. Christie loved Billy, Ferris Bueller took the day off, and George Clooney could wear a mullet *without irony.* Anthropologists say it was called "the '80s" and estimate that it lasted, unchecked, for nearly a decade.

Come with us now as we explore the evidence, written and photographic, from a unique period that gave the world E.T., Madonna, the collapse of the Berlin Wall and Smurfs. Lady Di became a princess, Dr. Ruth lobbied for "good sex!" and Mel Gibson was anointed PEOPLE's first Sexiest Man Alive. ("It's true, of course," he later said. "And I was just very relieved to read that I wasn't the sexiest man dead.") In movies, Molly Ringwald was *Pretty in Pink.* In music, Bruce was *Born in the U.S.A.*, and Michael Jackson made it absolutely clear to anyone who would listen that Billie Jean was *not*, repeat *not,* his lover. In politics, Donna Rice proved a (Gary) Hart stopper, and on Wall Street, masters of the universe Ivan Boesky and Michael Milken were brilliant one minute, in handcuffs the next. As Keanu Reeves put it, more than 30 times, in *Bill & Ted's Excellent Adventure,* "Whoa!" So succinct, so true. For proof, turn the page.

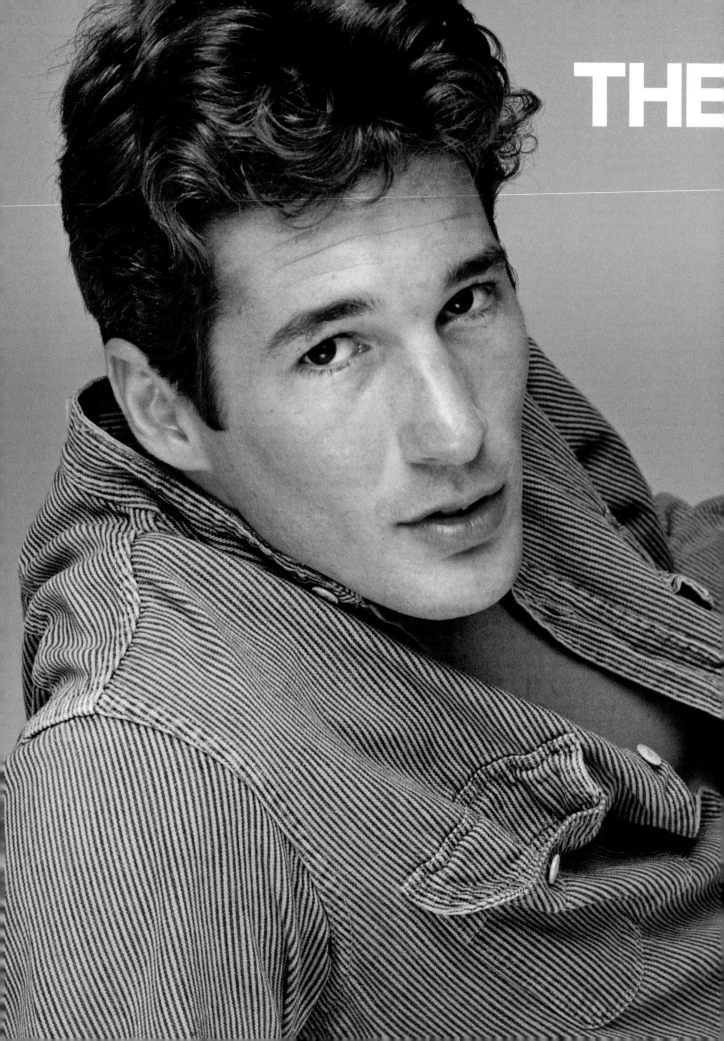

THE

WAY THEY WERE
(When We Fell in Love)

'80s moments: how **RICHARD GERE,** *Kevin Costner, Whitney Houston and other stars looked when they first got hot*

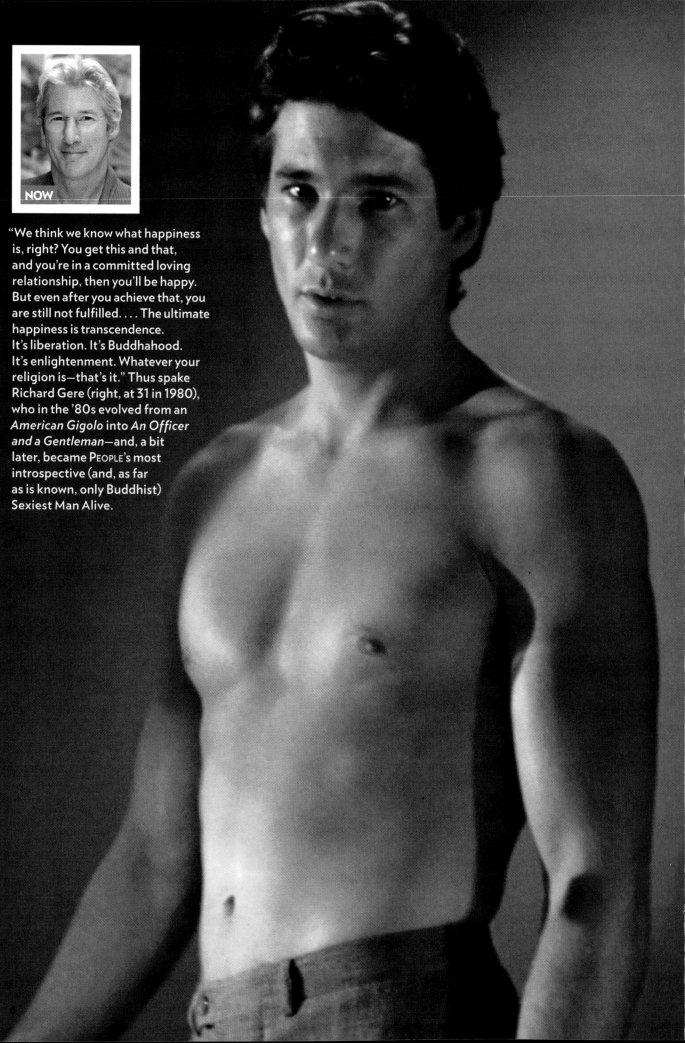

"We think we know what happiness is, right? You get this and that, and you're in a committed loving relationship, then you'll be happy. But even after you achieve that, you are still not fulfilled. . . . The ultimate happiness is transcendence. It's liberation. It's Buddhahood. It's enlightenment. Whatever your religion is—that's it." Thus spake Richard Gere (right, at 31 in 1980), who in the '80s evolved from an *American Gigolo* into *An Officer and a Gentleman*—and, a bit later, became PEOPLE's most introspective (and, as far as is known, only Buddhist) Sexiest Man Alive.

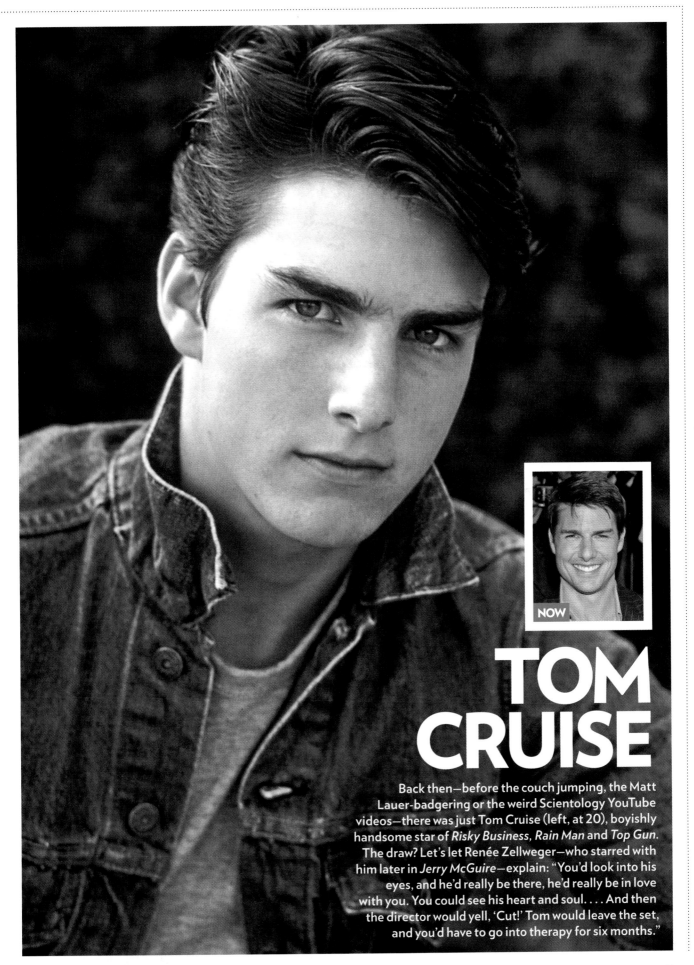

NOW

TOM CRUISE

Back then—before the couch jumping, the Matt Lauer-badgering or the weird Scientology YouTube videos—there was just Tom Cruise (left, at 20), boyishly handsome star of *Risky Business*, *Rain Man* and *Top Gun*. The draw? Let's let Renée Zellweger—who starred with him later in *Jerry McGuire*—explain: "You'd look into his eyes, and he'd really be there, he'd really be in love with you. You could see his heart and soul. . . . And then the director would yell, 'Cut!' Tom would leave the set, and you'd have to go into therapy for six months."

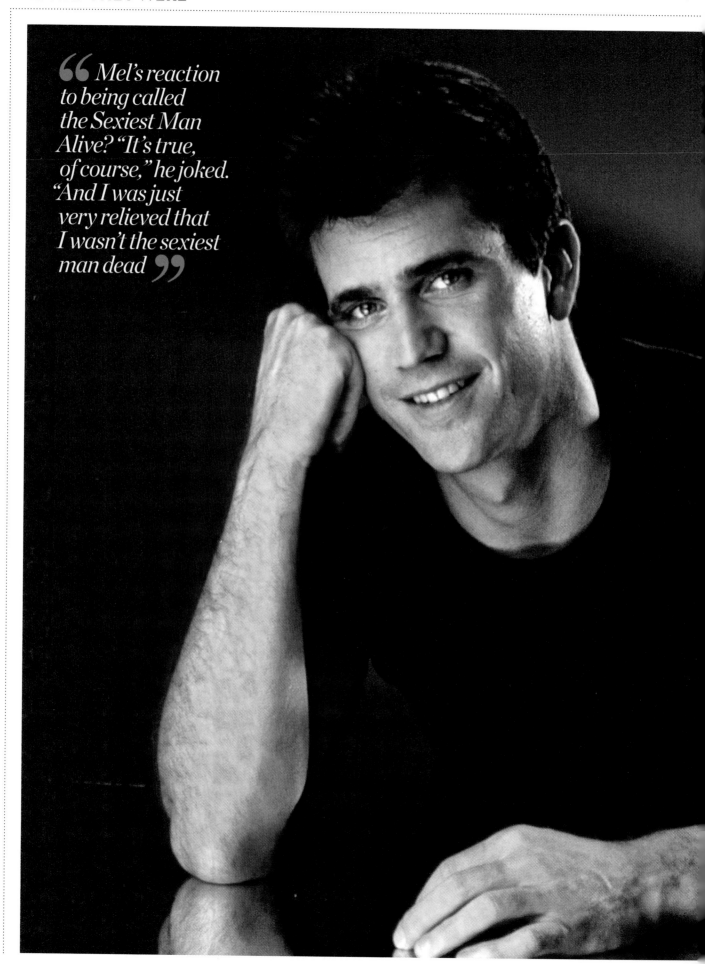

66 *Mel's reaction to being called the Sexiest Man Alive? "It's true, of course," he joked. "And I was just very relieved that I wasn't the sexiest man dead* 99

NOW

MEL GIBSON

Over the years, PEOPLE has christened a lot of men the Sexiest Man Alive. But only one will ever be the first Sexiest Man Alive: Mel Gibson (left, ca. 1985). The 52-year-old star of three *Mad Max* movies and 1983's *The Year of Living Dangerously* ("The most gorgeous man I've ever met," said costar Sigourney Weaver) was so hot at that moment that an editor, struggling to come up with language for a cover story, simply blurted out, "The sexiest man alive!"—thus, simultaneously, solving the problem and giving birth to a franchise that's still thriving 23 years later.

Much happened afterward, of course—more movies (including the megahit *Lethal Weapon* series); directing (*Braveheart,* which won five Oscars, and the controversial *The Passion of the Christ*) and, infamously, Mel's drunken anti-Semitic tirade during a 2006 DUI arrest (he later apologized). It's enough to make fans long for days when they could simply drool in peace. "Across a room, he's just another medium-size handsome guy," director Roger Spottiswoode said at the time, analyzing the Gibson Effect. "But when you get close on him, he's got this old-fashioned movie-star voodoo."

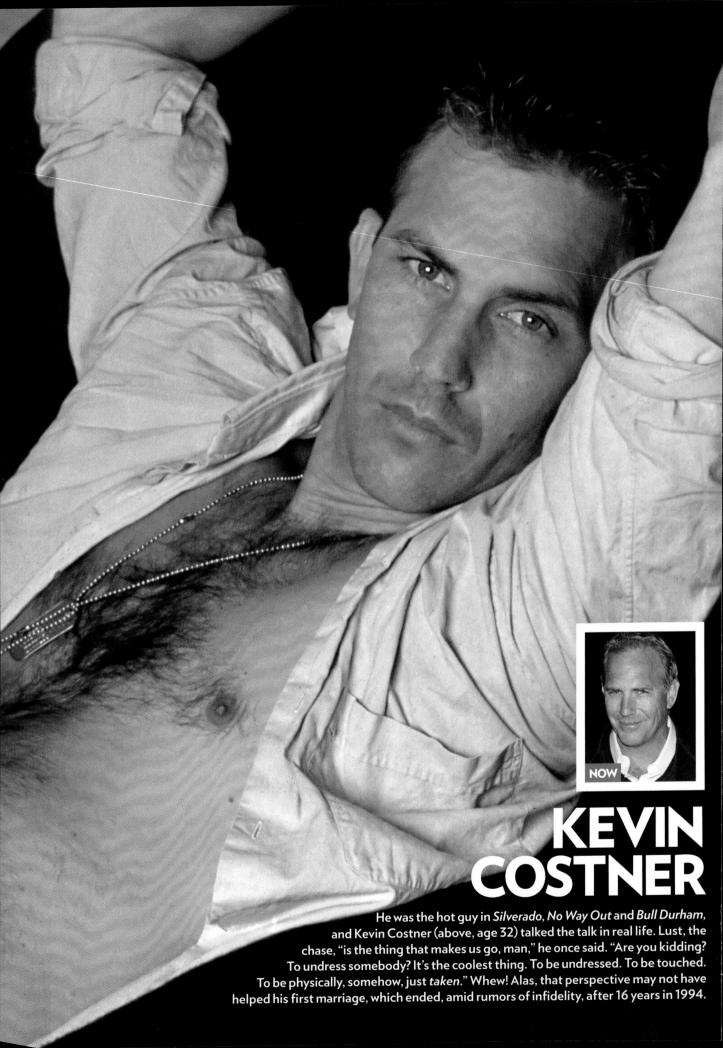

NOW

KEVIN COSTNER

He was the hot guy in *Silverado, No Way Out* and *Bull Durham*, and Kevin Costner (above, age 32) talked the talk in real life. Lust, the chase, "is the thing that makes us go, man," he once said. "Are you kidding? To undress somebody? It's the coolest thing. To be undressed. To be touched. To be physically, somehow, just *taken*." Whew! Alas, that perspective may not have helped his first marriage, which ended, amid rumors of infidelity, after 16 years in 1994.

EDDIE MURPHY

The first thing that struck you was the confidence. Hired at 19 as a bit player on *Saturday Night Live* in 1980, Eddie Murphy later remarked, "I should have been happy to even be a part of the show, but I looked at the rest of the cast and—I'm not saying I was better—but I just knew I was as good as any [of them]." He was right: The next season, most of the cast was fired. But Murphy (left, at 22) stole the spotlight with characters like Velvet Jones, Mr. Robinson and Gumby, and his confidence did not diminish. Invited onto *The Tonight Show*, he declined, he said, because "they wouldn't let me sit down with the panel. I wasn't going to do my stand-up routine, leave and then have some foot doctor come out and talk about his book. I'm not a star, but I'm not just another stand-up comic, either."

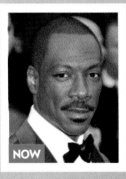

NOW

WHITNEY HOUSTON

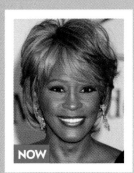

NOW

> 66 *God gave me a voice to sing with. And when you have that, what other gimmick is there?* 99

Looking back, there were hints of what might be about to happen. She was, after all, the daughter of singer Cissy Houston, cousin of Dionne Warwick and goddaughter of Aretha Franklin. And her looks drew attention early, landing her modeling jobs in *Vogue* and the cover of *Seventeen*. But no one was prepared for what occurred when Whitney Houston, then 21, released her self-titled debut album in 1985: Boosted by the hit singles "Saving All My Love for You," "The Greatest Love of All" and "How Will I Know?" (and its infectious MTV video), *Whitney Houston* became, at that time, the bestselling debut ever by a female artist. And no fluke: Her follow-up album *Whitney* produced four more No. 1 hits, making seven in a row—beating the previous record of six, shared by the Beatles and the Bee Gees.

Much turmoil followed—a bad marriage, drug rehab, divorce—but, 23 years later, that record still stands.

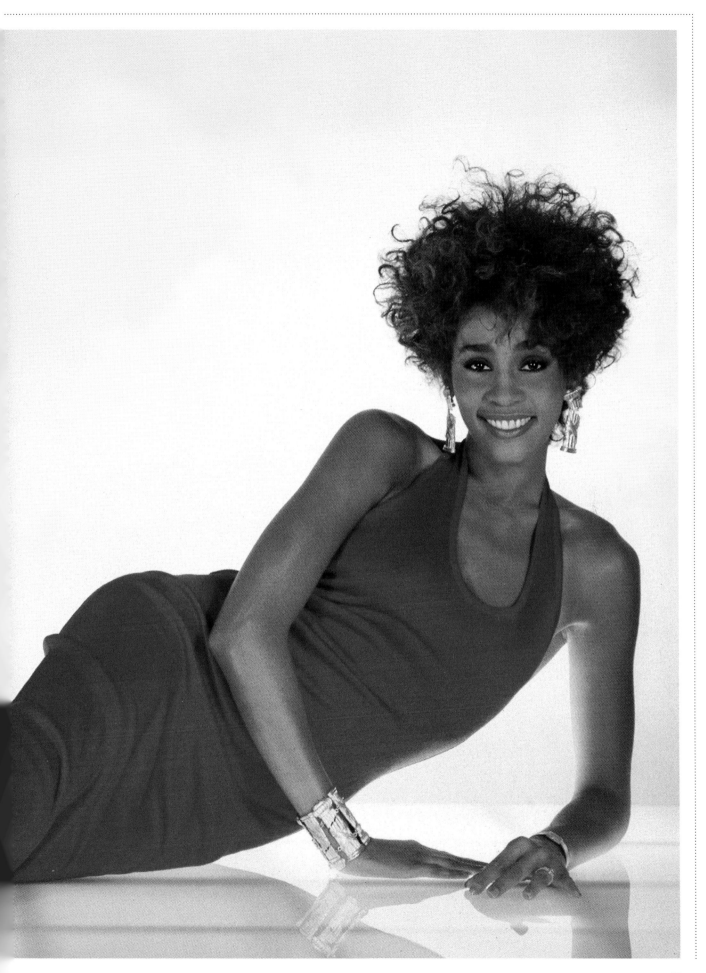

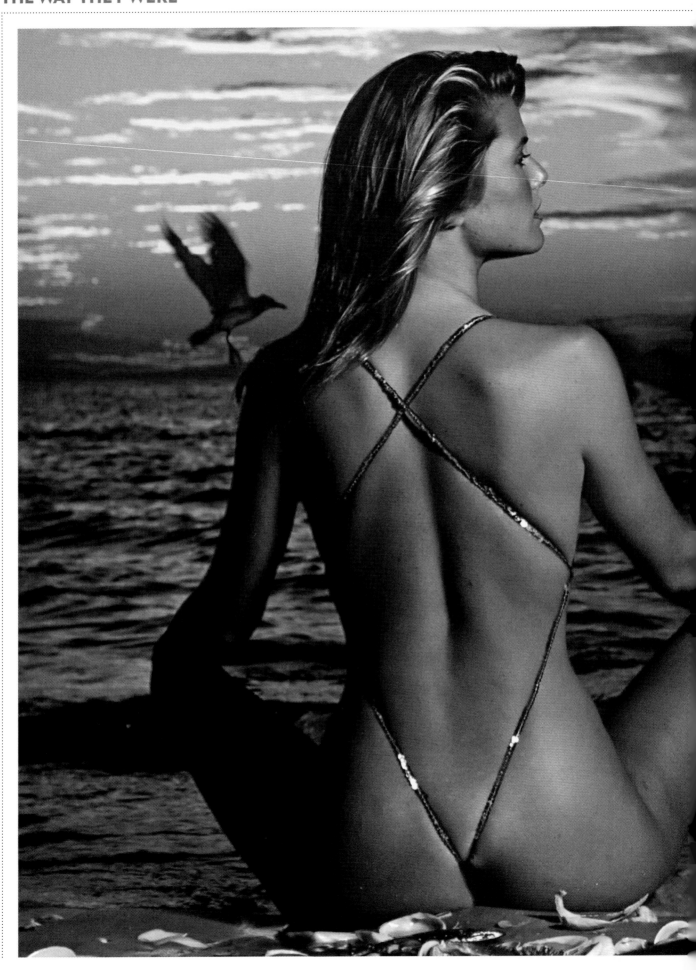

CHRISTIE BRINKLEY

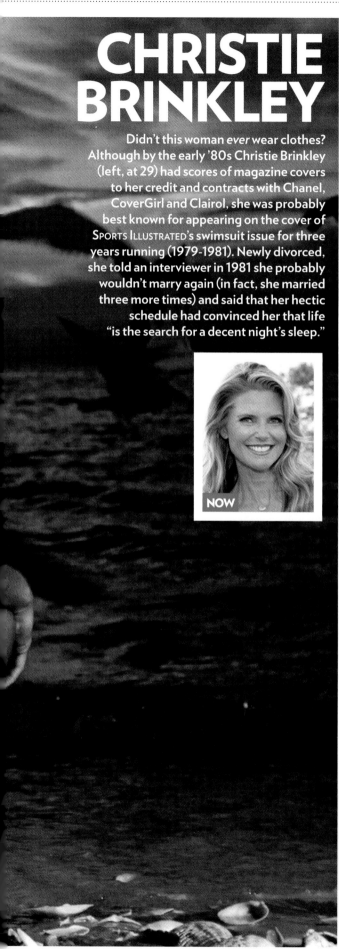

Didn't this woman *ever* wear clothes? Although by the early '80s Christie Brinkley (left, at 29) had scores of magazine covers to her credit and contracts with Chanel, CoverGirl and Clairol, she was probably best known for appearing on the cover of SPORTS ILLUSTRATED's swimsuit issue for three years running (1979-1981). Newly divorced, she told an interviewer in 1981 she probably wouldn't marry again (in fact, she married three more times) and said that her hectic schedule had convinced her that life "is the search for a decent night's sleep."

NOW

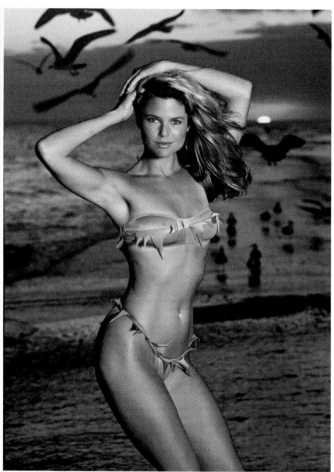

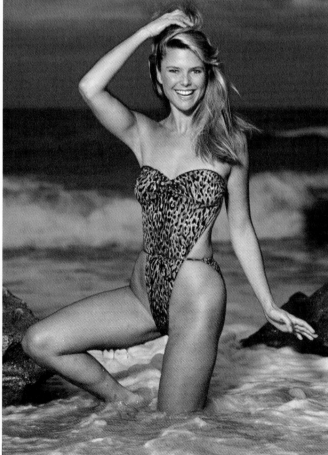

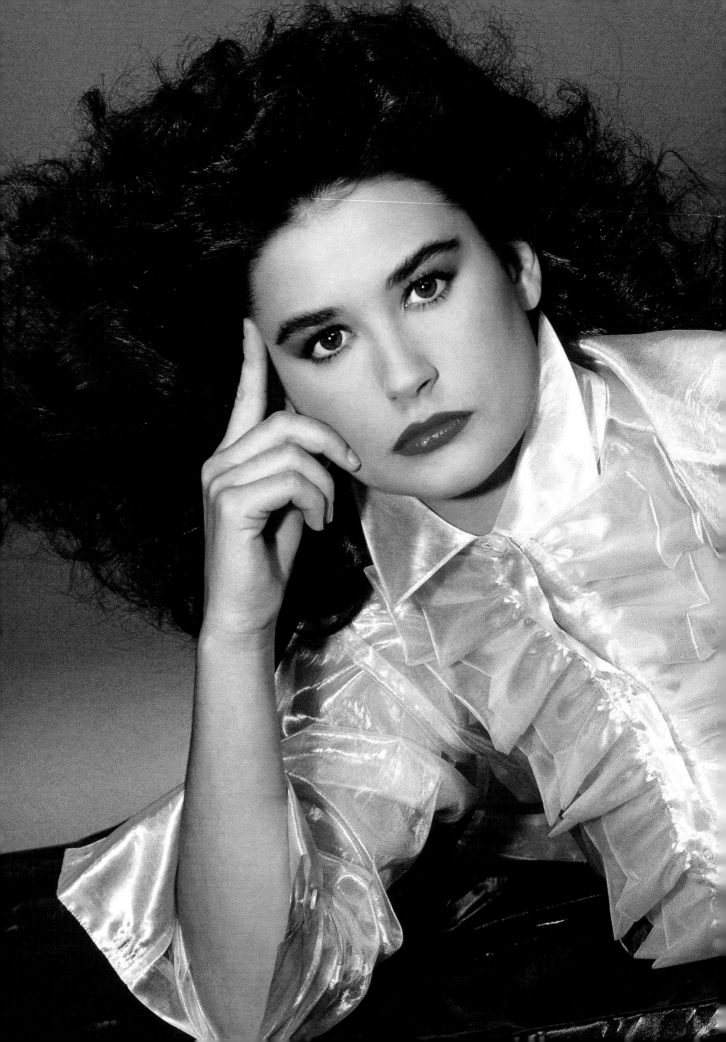

THAT '80s LOOK

*Less is more? Not for **DEMI**, Joan Collins or any of the celebs caught in a wave of trends we're unlikely to see soon again*

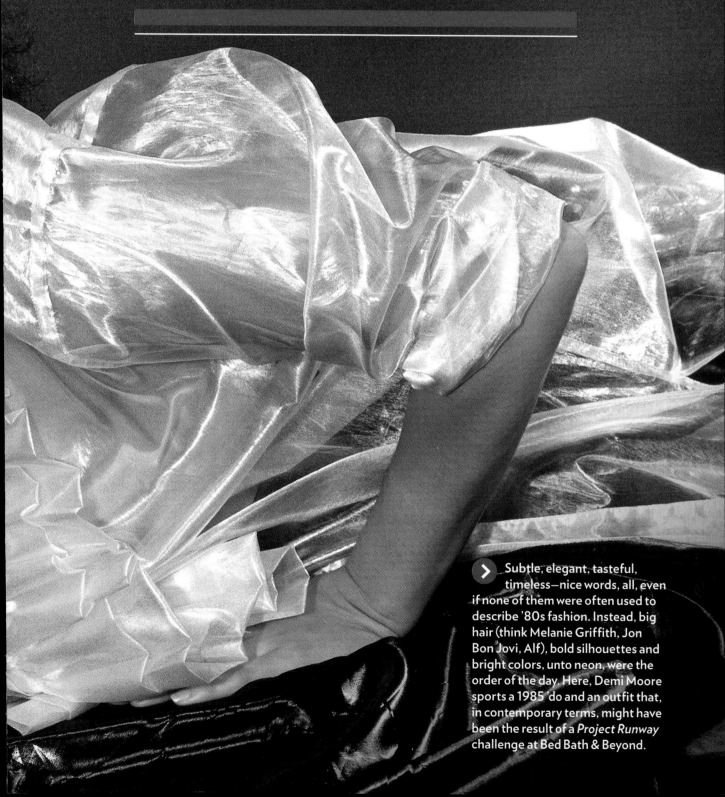

> Subtle, elegant, tasteful, timeless—nice words, all, even if none of them were often used to describe '80s fashion. Instead, big hair (think Melanie Griffith, Jon Bon Jovi, Alf), bold silhouettes and bright colors, unto neon, were the order of the day. Here, Demi Moore sports a 1985 do and an outfit that, in contemporary terms, might have been the result of a *Project Runway* challenge at Bed Bath & Beyond.

STYLIN' STARS

Rumpled socks on the red carpet? Spandex street wear? Such were the times, as styles ping-ponged wildly between costume and casual

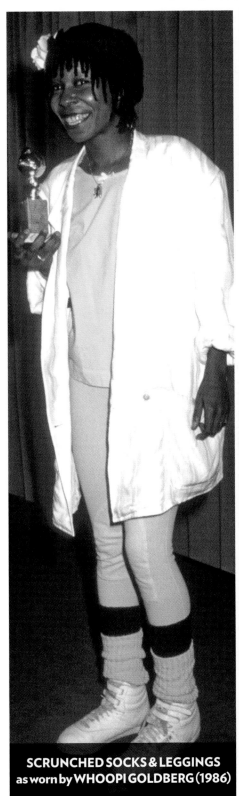

SCRUNCHED SOCKS & LEGGINGS
as worn by WHOOPI GOLDBERG (1986)

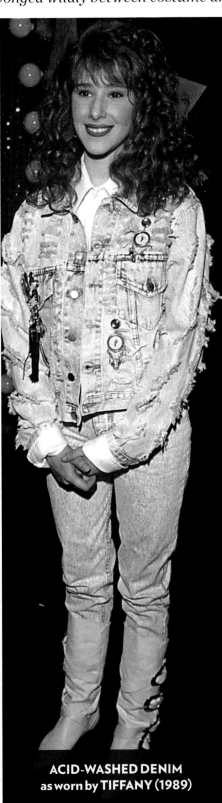

ACID-WASHED DENIM
as worn by TIFFANY (1989)

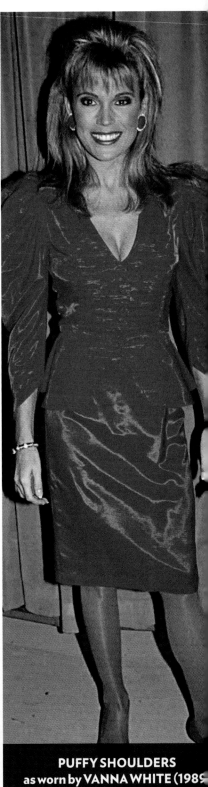

PUFFY SHOULDERS
as worn by VANNA WHITE (1989

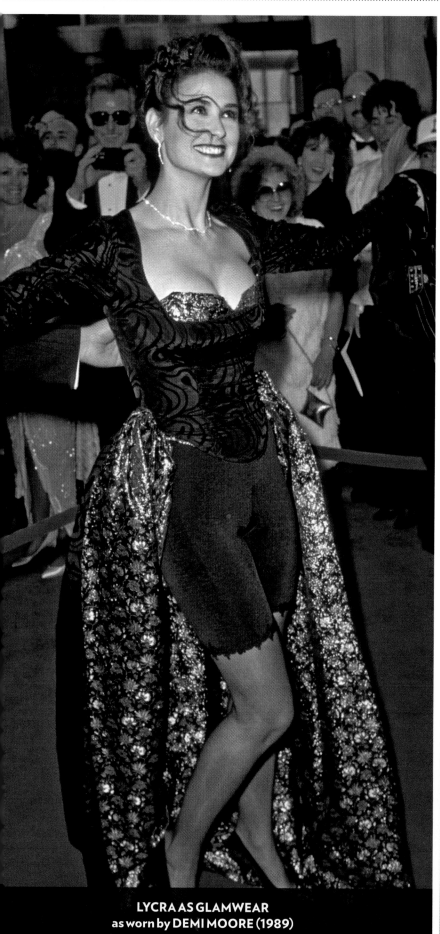

LYCRA AS GLAMWEAR
as worn by DEMI MOORE (1989)

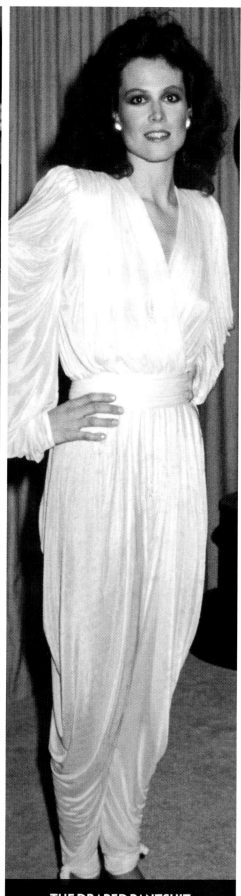

THE DRAPED PANTSUIT
as worn by SIGOURNEY WEAVER (1981)

THAT WAS THEN

We all get swept up in the times and . . . things happen. Here's a look at some fashion choices that, no doubt, made perfect sense at that moment

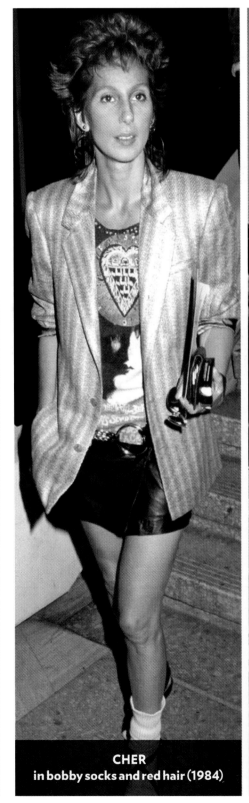

CHER
in bobby socks and red hair (1984)

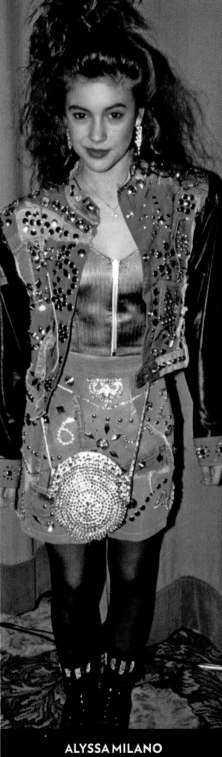

ALYSSA MILANO
in a metal-studded twinset (1988)

JOAN COLLINS
in Pepto-Bismol pink (1982)

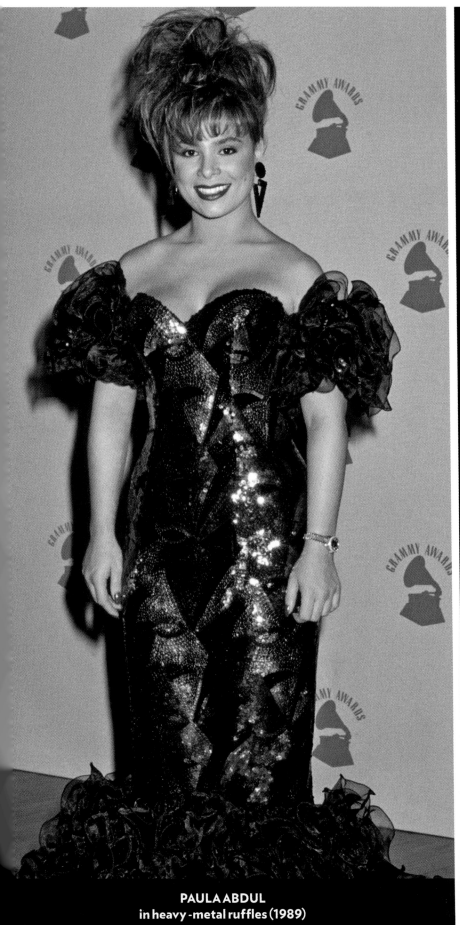

PAULA ABDUL
in heavy-metal ruffles (1989)

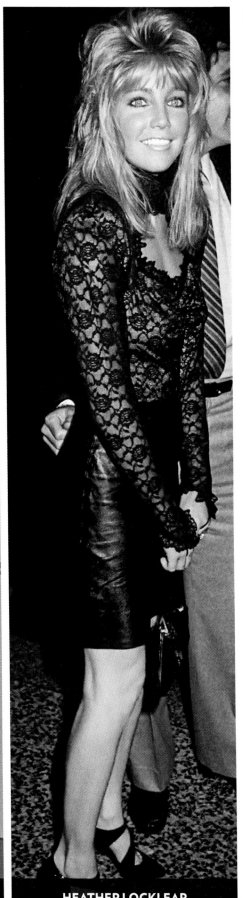

HEATHER LOCKLEAR
in leather, lace & poodle cut (1985)

LET'S GET PHYSICAL

Make it burn, indeed: In 1980 few had ever heard of aerobics. After 1982, when Jane Fonda released *Workout,* it became part of the language. The tape sold an astounding 17 million copies to date—more than any other ever—helped make the VCR a household appliance and launched an army of imitators (including a famous Disney rodent, who urged fans to "Come on, everybody, and Mousercise!"). In Hollywood celebrities lined up to show off their new gym bods—and somewhere, somebody must have made a fortune off leg warmers.

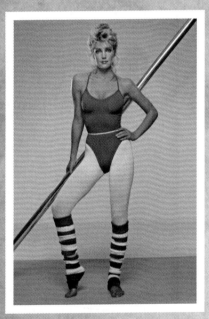

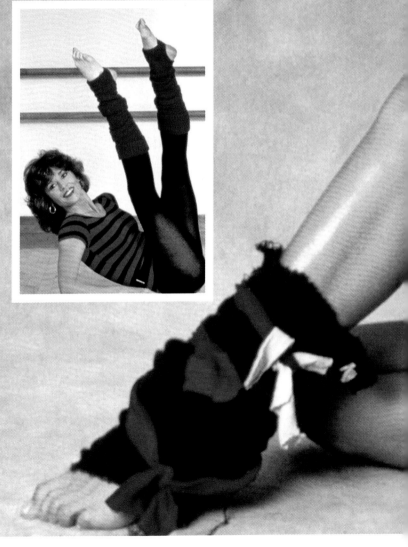

Suddenly, leotards and scrunched-up leg warmers were everywhere (above: Heather Locklear). "I didn't realize that empowerment could begin in the muscles and work inward," says Fonda (above, right) of her videos. "I love the fact that I empowered women."

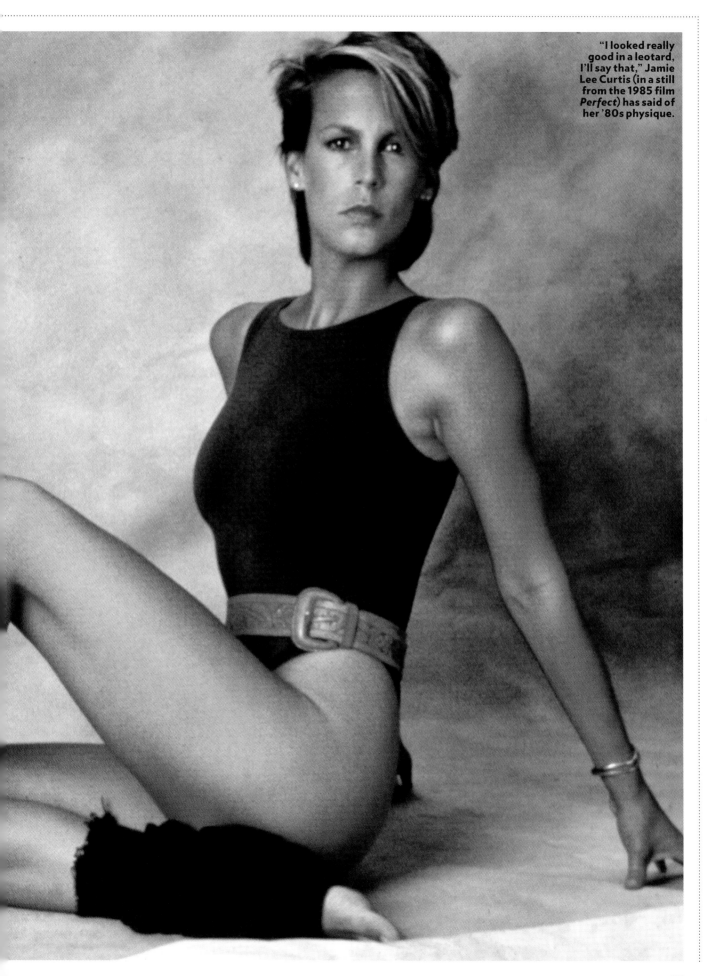

Team *E.T.*
(from left): Robert
MacNaughton,
Henry Thomas,
Dee Wallace-Stone,
Steven Spielberg,
Kathleen Kennedy,
Drew Barrymore
and Peter Coyote
in 2002.

> Audiences cried and
Hollywood rejoiced when
Steven Spielberg's fairy tale about
a space alien lost in the 'burbs
took flight in the summer of 1982.
A sci-fi flick with a galaxy-size heart,
E.T. the Extra-Terrestrial was the
top box office hit of the decade.
Cast members, too, felt it was more
than just a movie. "I treated E.T.
like he was alive and had a soul,"
Drew Barrymore said later. "I brought
him lunch. I'd put covers around
him if I thought he was cold."

THE MOVIES

Hello, blockbusters: From **E.T.** *to* Crocodile Dundee,
*a look at the decade's Top 10—plus the fan faves
that captured the spirit of the times*

1

Total '80s box
office earnings:
$434,974,579

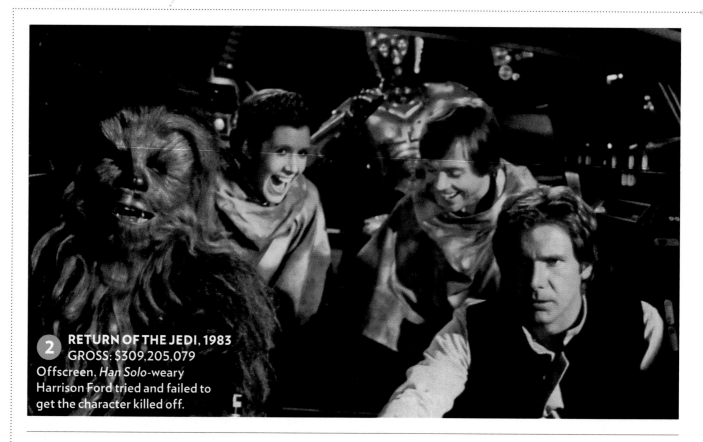

2 RETURN OF THE JEDI, 1983
GROSS: $309,205,079
Offscreen, *Han Solo*-weary
Harrison Ford tried and failed to
get the character killed off.

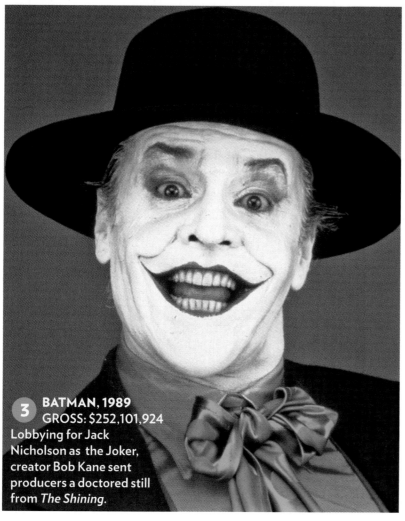

3 BATMAN, 1989
GROSS: $252,101,924
Lobbying for Jack
Nicholson as the Joker,
creator Bob Kane sent
producers a doctored still
from *The Shining*.

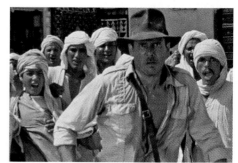

4 RAIDERS OF THE LOST ARK, 1981
GROSS: $242,374,454
"Indiana Smith?" The archaeologist hero's
handle was changed from Smith to Jones
on the first day of production.

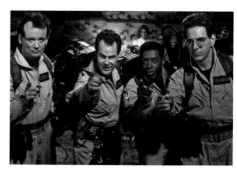

5 GHOSTBUSTERS, 1984
GROSS: $238,632,124
John Belushi was originally supposed to
be a Ghostbuster, but after his death in
1982 was replaced by Bill Murray.

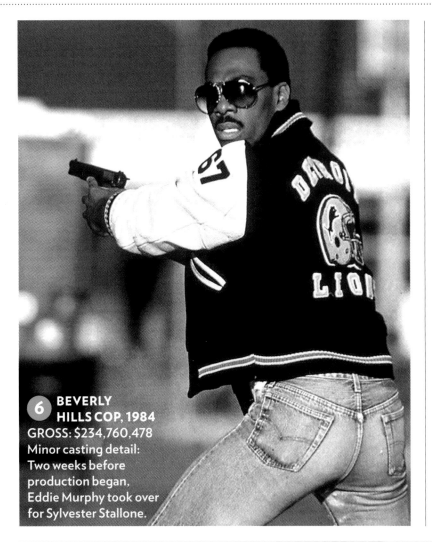

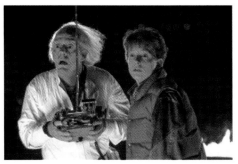

7 BACK TO THE FUTURE, 1985
GROSS: $208,242,016
Oedipal complex: Michael J. Fox was the same age as his film mom (Lea Thompson) and older than his dad (Crispin Glover).

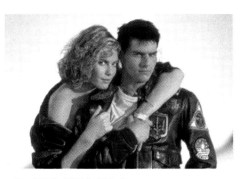

8 TOP GUN, 1986
GROSS: $176,781,728
Tom Cruise prepared for his role by riding in an F-14 Tomcat. His future wife Katie Holmes was 7 when the film was released.

6 BEVERLY HILLS COP, 1984
GROSS: $234,760,478
Minor casting detail: Two weeks before production began, Eddie Murphy took over for Sylvester Stallone.

9 TOOTSIE, 1982
GROSS: $176,397,416
The famously argumentative Dustin Hoffman is mocking method acting (and himself) when, cast as a tomato, he refuses a director's request to sit because "it wasn't logical."

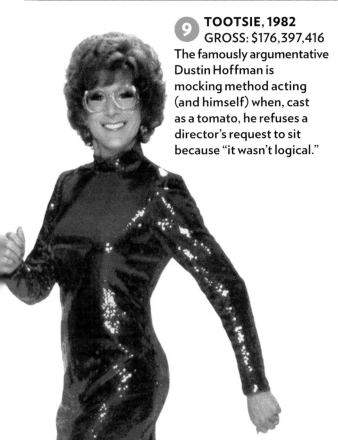

10 CROCODILE DUNDEE, 1986
GROSS: $174,696,237
Ten very G'days: The top-grossing Australian movie ever, it earned $19.5 million in the first 10 days of its U.S. run.

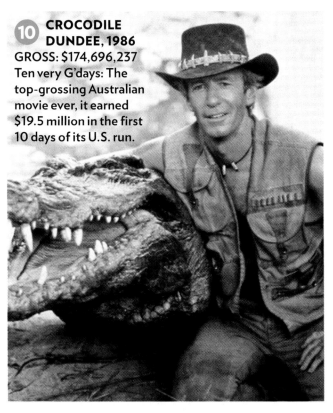

27

THAT'S SO '80s

They weren't always the biggest movies, but Wall Street, The Big Chill *and other zeitgeist films memorably captured a moment or mood*

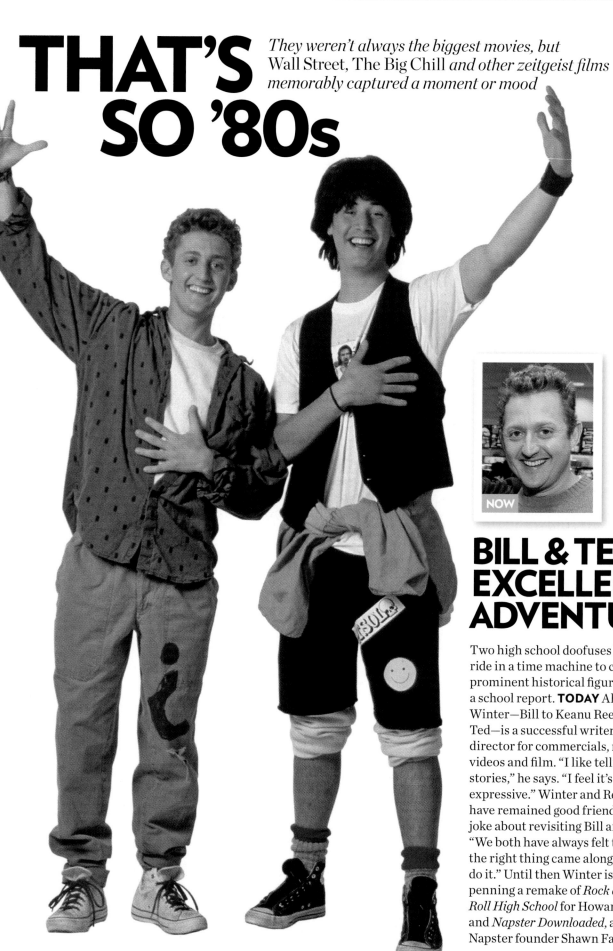

NOW

BILL & TED'S EXCELLENT ADVENTURE

Two high school doofuses hitch a ride in a time machine to collect prominent historical figures for a school report. **TODAY** Alex Winter—Bill to Keanu Reeves' Ted—is a successful writer-director for commercials, music videos and film. "I like telling stories," he says. "I feel it's more expressive." Winter and Reeves have remained good friends and joke about revisiting Bill and Ted. "We both have always felt that if the right thing came along, we'd do it." Until then Winter is busy penning a remake of *Rock and Roll High School* for Howard Stern and *Napster Downloaded*, about Napster founder Shawn Fanning.

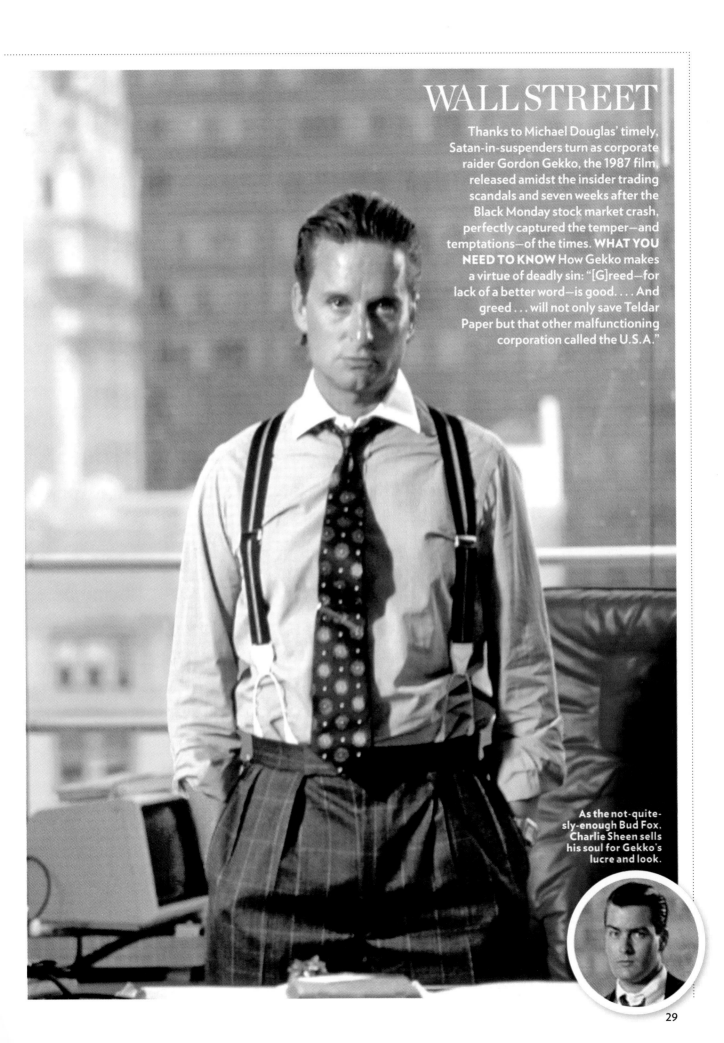

WALL STREET

Thanks to Michael Douglas' timely, Satan-in-suspenders turn as corporate raider Gordon Gekko, the 1987 film, released amidst the insider trading scandals and seven weeks after the Black Monday stock market crash, perfectly captured the temper—and temptations—of the times. **WHAT YOU NEED TO KNOW** How Gekko makes a virtue of deadly sin: "[G]reed—for lack of a better word—is good. . . . And greed . . . will not only save Teldar Paper but that other malfunctioning corporation called the U.S.A."

As the not-quite-sly-enough Bud Fox, Charlie Sheen sells his soul for Gekko's lucre and look.

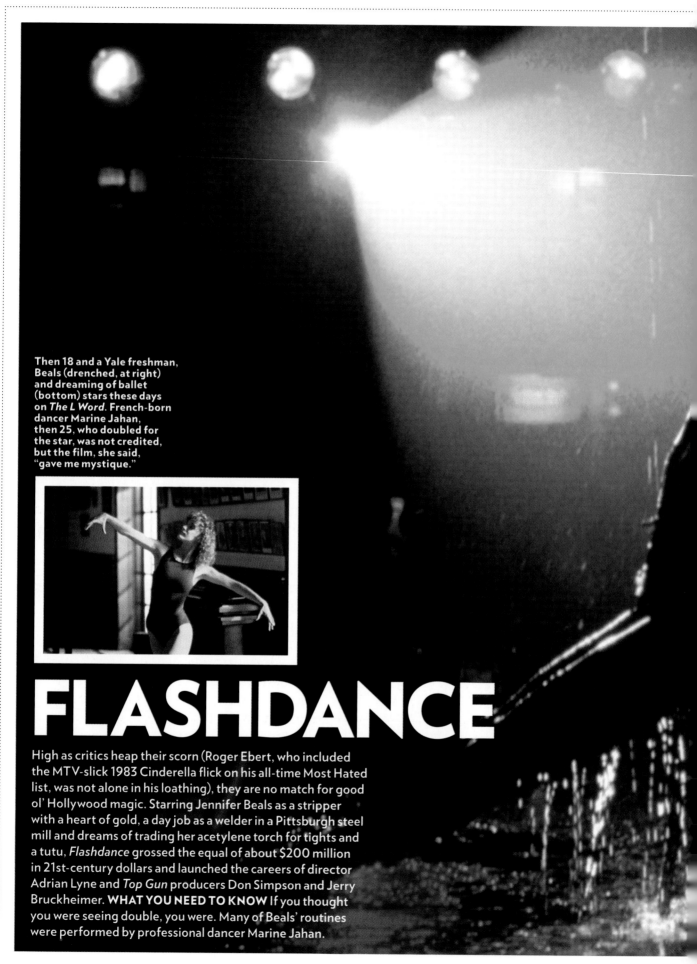

Then 18 and a Yale freshman, Beals (drenched, at right) and dreaming of ballet (bottom) stars these days on *The L Word*. French-born dancer Marine Jahan, then 25, who doubled for the star, was not credited, but the film, she said, "gave me mystique."

FLASHDANCE

High as critics heap their scorn (Roger Ebert, who included the MTV-slick 1983 Cinderella flick on his all-time Most Hated list, was not alone in his loathing), they are no match for good ol' Hollywood magic. Starring Jennifer Beals as a stripper with a heart of gold, a day job as a welder in a Pittsburgh steel mill and dreams of trading her acetylene torch for tights and a tutu, *Flashdance* grossed the equal of about $200 million in 21st-century dollars and launched the careers of director Adrian Lyne and *Top Gun* producers Don Simpson and Jerry Bruckheimer. **WHAT YOU NEED TO KNOW** If you thought you were seeing double, you were. Many of Beals' routines were performed by professional dancer Marine Jahan.

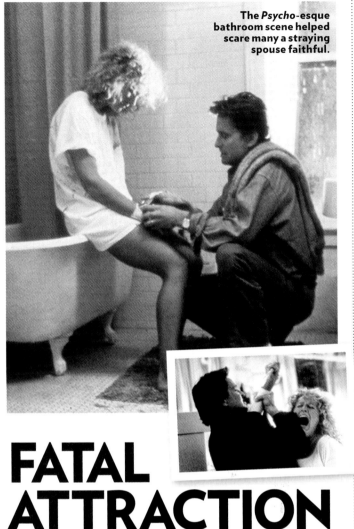

FATAL ATTRACTION

Timely in any age, a cautionary thriller about the wages of adultery and the terrifying dangers of unsafe sex seemed especially unsettling upon its release in 1987. "Years hence, it will be possible to pinpoint the exact moment that produced *Fatal Attraction*," *New York Times* reviewer Janet Maslin wrote about the story of a married attorney (Michael Douglas) whose weekend tryst with a lonely businesswoman (Glenn Close) leads to dire consequences (and doom for a certain bunny rabbit). "It arrived at the tail end of the having-it-all age, just before the impact of AIDS on movie morality was really felt." **WHAT YOU NEED TO KNOW** When Close's character stalks her erstwhile love and his wife (Anne Archer) and daughter (Ellen Hamilton Latzen) at their suburban home, she becomes so unhinged she kills the family pet and sets it to boil on the stove top, an over-the-top act that launched countless rabbit-stew jokes and comedy sketch parodies.

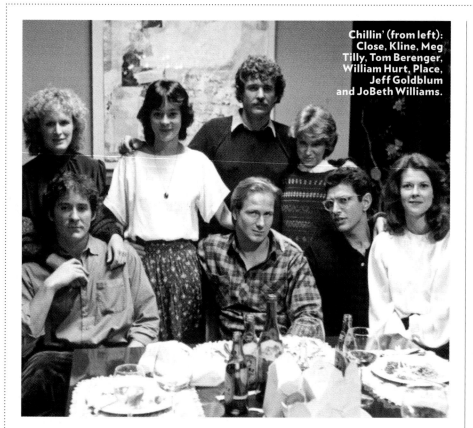

Chillin' (from left): Close, Kline, Meg Tilly, Tom Berenger, William Hurt, Place, Jeff Goldblum and JoBeth Williams.

THE BIG CHILL

The classic Baby Boomer coming-of-age film in which a group of (very good-looking) thirtysomethings gather to mourn a friend's passing and in the process explore how they've all changed since their carefree college days.
MEMORABLE '80s MOMENT Meg Jones (played by Mary Kay Place) is single but longs to have a child, so best pal Sarah Cooper (Glenn Close) loans out her husband, the sensitive, proven procreator Harold (Kevin Kline).
WHO'S THAT GUY? The movie opens with a montage of a man being dressed; only later does it become clear the man is a corpse, being readied for his funeral. The body in question belongs to Kevin Costner (in haler form on the facing page), whose face is never seen. Costner was to have had a livelier role in an epilogue that writer-director Lawrence Kasdan eventually decided to cut from the film. "When I read the script, it was the epilogue that really made me cry, because nobody knew then what life was going to do to them," said Close. "It was wonderful." Costner wound up making his big-screen debut two years later, in 1985's *Silverado,* and stole the film.

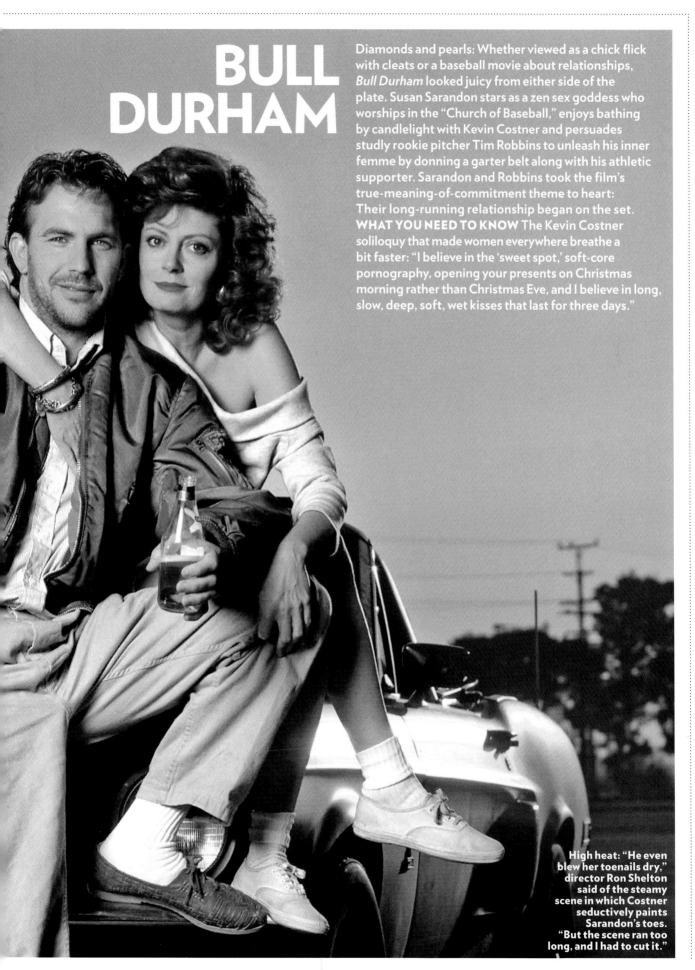

BULL DURHAM

Diamonds and pearls: Whether viewed as a chick flick with cleats or a baseball movie about relationships, *Bull Durham* looked juicy from either side of the plate. Susan Sarandon stars as a zen sex goddess who worships in the "Church of Baseball," enjoys bathing by candlelight with Kevin Costner and persuades studly rookie pitcher Tim Robbins to unleash his inner femme by donning a garter belt along with his athletic supporter. Sarandon and Robbins took the film's true-meaning-of-commitment theme to heart: Their long-running relationship began on the set. **WHAT YOU NEED TO KNOW** The Kevin Costner soliloquy that made women everywhere breathe a bit faster: "I believe in the 'sweet spot,' soft-core pornography, opening your presents on Christmas morning rather than Christmas Eve, and I believe in long, slow, deep, soft, wet kisses that last for three days."

High heat: "He even blew her toenails dry," director Ron Shelton said of the steamy scene in which Costner seductively paints Sarandon's toes. "But the scene ran too long, and I had to cut it."

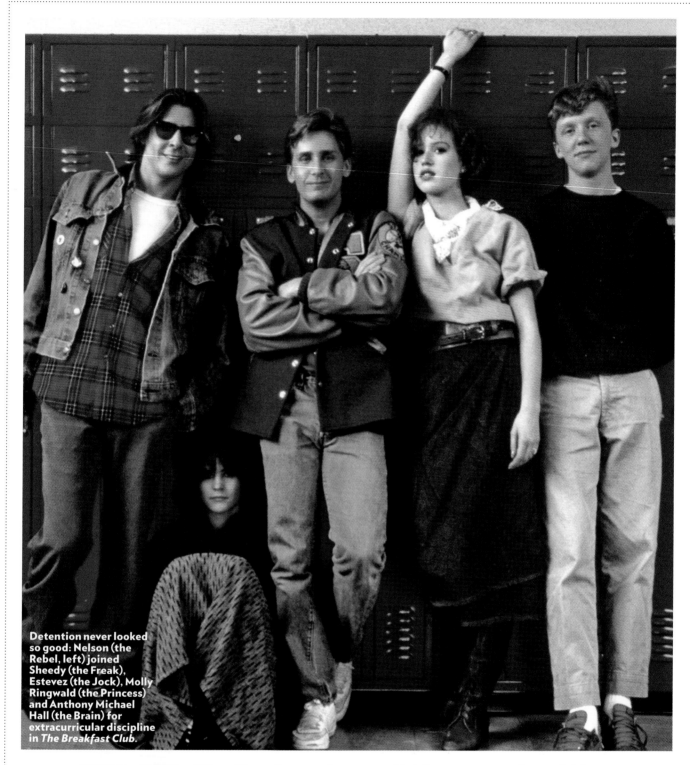

Detention never looked so good: Nelson (the Rebel, left) joined Sheedy (the Freak), Estevez (the Jock), Molly Ringwald (the Princess) and Anthony Michael Hall (the Brain) for extracurricular discipline in *The Breakfast Club*.

THE BRAT PACK

Time flies when you're young. But few actors aged as quickly as Judd Nelson, Emilio Estevez and Ally Sheedy, all of whom starred in both books of the Brat Pack Bible: John Hughes' *The Breakfast Club*, about high school types (Jock, Brain, Princess, Rebel, Freak), was released in February 1985, and four months later the three *Breakfast*ers showed up as much older but hardly wiser grads in Joel Schumacher's dour *St. Elmo's Fire*. **WHAT YOU NEED TO KNOW** The term "Brat Pack," which echoed the glamorous '60s "Rat Pack," first appeared in a not-so-flattering *New York* magazine article about young, highly paid Hollywood stars, which put the accent decidedly on the B-word.

WHERE ARE THEY NOW?

Most are still in the biz and appearing, at least occasionally, on a screen near you. But time does march on, and sometimes it jogs briskly: One of these erstwhile crazy kids will turn 50 next year.

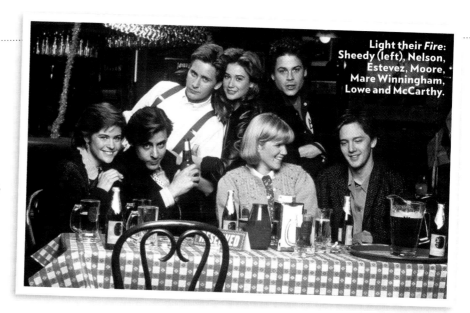

Light their *Fire*: Sheedy (left), Nelson, Estevez, Moore, Mare Winningham, Lowe and McCarthy.

MOLLY RINGWALD
The teen dream of Hughes' *Sixteen Candles* and *Pretty in Pink* is 40 and a hit on ABC Family's *The Secret Life of the American Teenager.*

ANTHONY MICHAEL HALL
There *is* life after *The Dead Zone*: The steadily working ex-Brat played a TV reporter in *The Dark Knight.*

DEMI MOORE
Now 46 and married to actor-producer Ashton Kutcher, the former box office queen is among the most successful ex-Brats.

ROB LOWE
Another star who broke from the Pack, Lowe, 44, followed *The West Wing* with another hit series, *Brothers & Sisters.*

JUDD NELSON
The oldest Pack man, now 49, has mostly appeared on television (*Suddenly Susan*) since starring in films like *New Jack City* in 1991.

ALLY SHEEDY
"It was really a special feeling," the 46-year-old says of *The Breakfast Club.* "One of the best filming experiences I've ever had."

EMILIO ESTEVEZ
After earning indie cred in *Repo Man,* he hit gold with *The Mighty Ducks* and directed *Bobby* to a Golden Globe nomination. Now 46.

ANDREW McCARTHY
After a long eclipse, the *Weekend at Bernie's* alum, now 46, enjoyed a regular role in Brooke Shields' *Lipstick Jungle.*

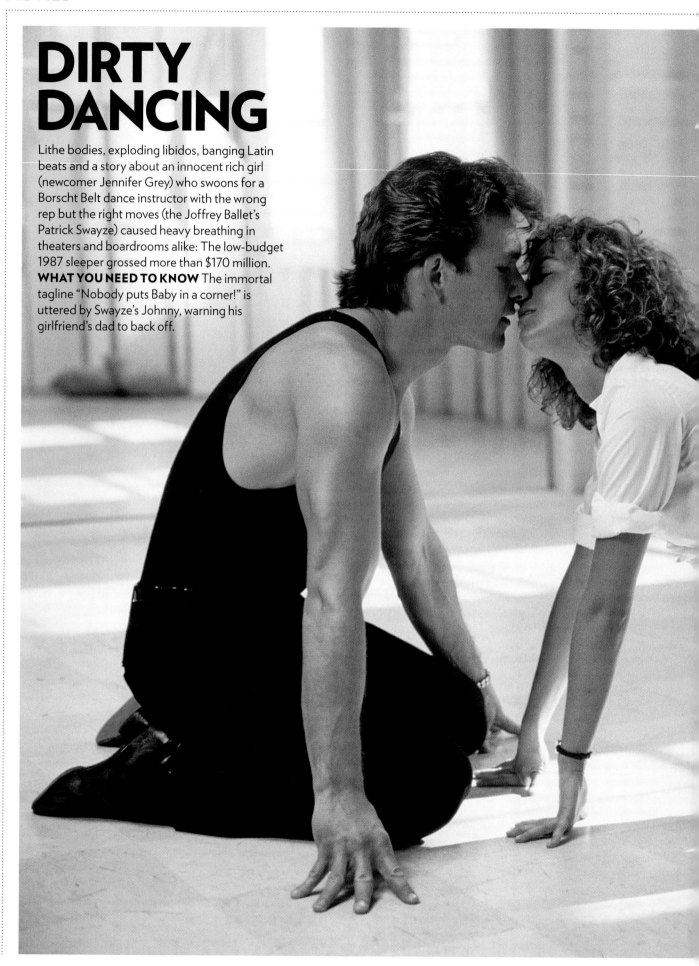

DIRTY DANCING

Lithe bodies, exploding libidos, banging Latin beats and a story about an innocent rich girl (newcomer Jennifer Grey) who swoons for a Borscht Belt dance instructor with the wrong rep but the right moves (the Joffrey Ballet's Patrick Swayze) caused heavy breathing in theaters and boardrooms alike: The low-budget 1987 sleeper grossed more than $170 million. **WHAT YOU NEED TO KNOW** The immortal tagline "Nobody puts Baby in a corner!" is uttered by Swayze's Johnny, warning his girlfriend's dad to back off.

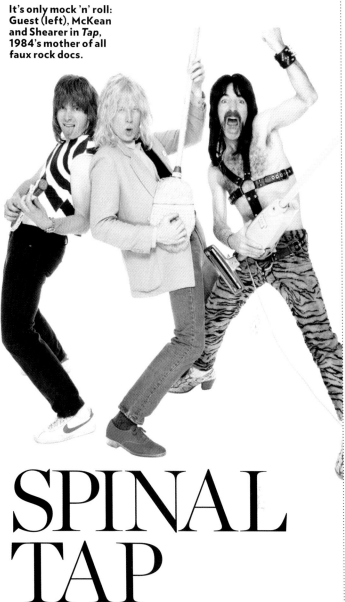

SPINAL TAP

After 17 years and 15 albums, the fictional dinosaur rock group whose comeback tour is documented in *This Is Spinal Tap: A Rockumentary by Martin DiBergi*, has suffered its share of tragedy and triumph. First, the group's founding drummer "died in a bizarre gardening accident." That hardly prepared the surviving Tappers (Christopher Guest, Michael McKean and Harry Shearer) for the fate that befell replacement timekeeper Peter James Bond. "He exploded onstage," Guest tells Rob Reiner (who doubles as the film's faux and actual director), in the droll, Brit-inflected deadpan he and his mates use throughout. Adds McKean solemnly: "Dozens of people spontaneously combust each year. It's just not really widely reported." From unmanageable stage and trouser props to awful food and worse song titles ("Big Bottom"; "Sex Farm") no cliché of VH-1's "Behind the Music" kind is left unshredded. **WHAT YOU NEED TO KNOW** Tap lays claim to its billing as "the world's loudest band" by virtue of amplifier volume knobs unlike any others. "The numbers," Guest proudly explains, "all go to 11."

Bringing up Baby: Swayze teaches Grey a thing or two about dance and romance.

CHARIOTS OF FIRE

The surprise 1982 Best Picture Oscar winner bested *On Golden Pond, Raiders of the Lost Ark* and *Reds*. But 26 years later the Oscar-winning music and images of men running in slow motion are famous, the plot less so (despite the title, the movie offered neither chariots nor fire). **FOR THE RECORD** It was about two British track stars, one Christian, one Jewish, who won gold medals at the 1924 Paris Olympics.

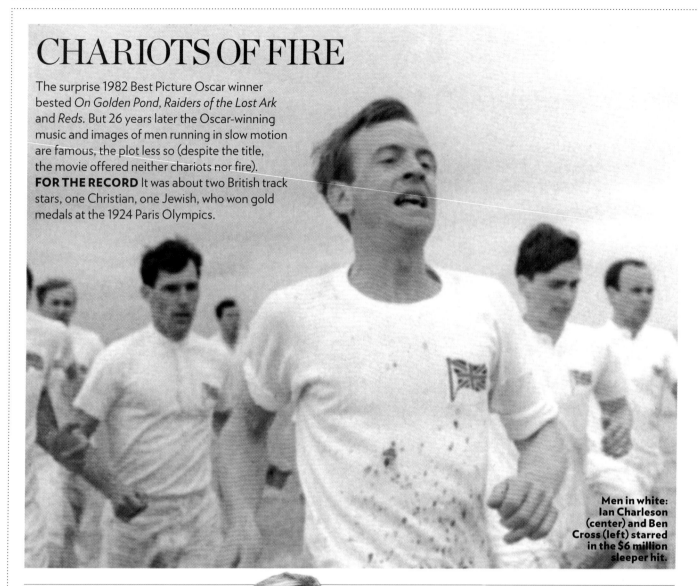

Men in white: Ian Charleson (center) and Ben Cross (left) starred in the $6 million sleeper hit.

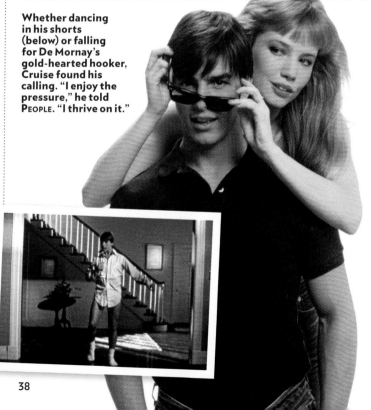

Whether dancing in his shorts (below) or falling for De Mornay's gold-hearted hooker, Cruise found his calling. "I enjoy the pressure," he told PEOPLE. "I thrive on it."

RISKY BUSINESS

"With kids, to be a rock star is the ultimate," Tom Cruise told PEOPLE of his improvised tighty-whities scene miming to Bob Seger's "Old Time Rock & Roll." "When their parents leave, they turn the music up. Dancing with your pants off—it's total freedom." And for Cruise, a sure-fire ticket to fame. After making his debut in a small role in *Endless Love* and parts in *Taps* and *The Outsiders,* he danced to stardom in 1983's *Business.* As the pimpin' teen who loses his virginity to a call girl (Rebecca De Mornay) then turns his family home into a brothel for his buds, Cruise was "able to bridge innocence and heat," director Paul Brickman said of the then-21-year-old actor. "It's a difficult range, but he's got it naturally." **WHAT YOU NEED TO KNOW** Cruise said he avoided a cut look for the role: "He's a very vulnerable person . . . no muscle armor at all."

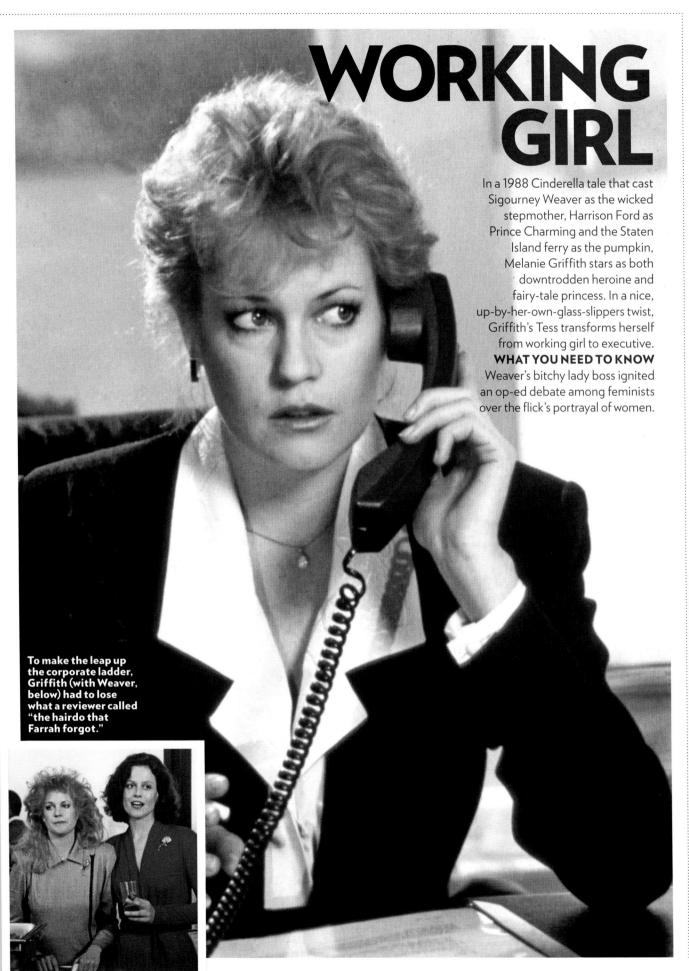

WORKING GIRL

In a 1988 Cinderella tale that cast Sigourney Weaver as the wicked stepmother, Harrison Ford as Prince Charming and the Staten Island ferry as the pumpkin, Melanie Griffith stars as both downtrodden heroine and fairy-tale princess. In a nice, up-by-her-own-glass-slippers twist, Griffith's Tess transforms herself from working girl to executive. **WHAT YOU NEED TO KNOW** Weaver's bitchy lady boss ignited an op-ed debate among feminists over the flick's portrayal of women.

To make the leap up the corporate ladder, Griffith (with Weaver, below) had to lose what a reviewer called "the hairdo that Farrah forgot."

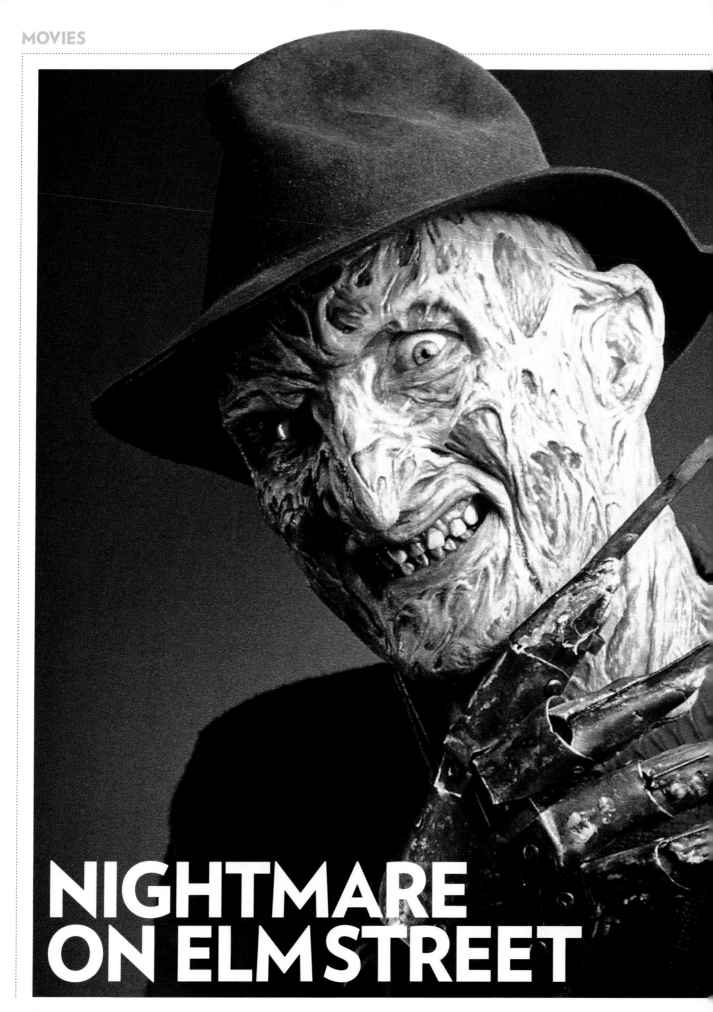

NIGHTMARE
ON ELM STREET

NOW

Before he became an icon of the dark side, Robert Englund tried out for a part that might have awarded him a much different form of film immortality: Luke Skywalker. Alas, it was not to be, and Englund's résumé began filling out with films like 1977's *Eaten Alive* and a 1983 *Manimal* episode, "Night of the Beast." Thus, Englund was well-schooled in horror when he landed the role of an undead lifetime in frightmeister Wes Craven's original 1984 version of *A Nightmare on Elm Street*. Since then he has repeated the role of Freddy Krueger, the fire-disfigured serial slasher, in countless remakes and TV gigs. "I get a lot of teenagers going, 'Yo, Krueger,'" the now-61-year-old Englund has said. "Yeah, I'm recognized."

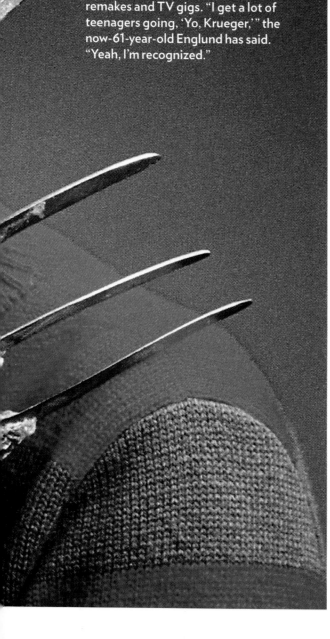

BOMBING AT THE BIJOU

Good as somebody thought they looked on paper, big-budget pictures about a talking duck, comical lounge singers on camels and roller-skating Greek goddesses made their creators' *ka-ching!* dreams go *ka-boom!*

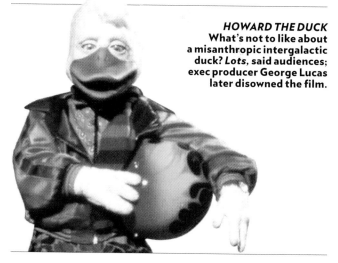

XANADU
Greek goddesses come to life, learn to roller-disco. The 1980 film, with Olivia Newton-John, flopped, but *Xanadu* is now a Broadway hit.

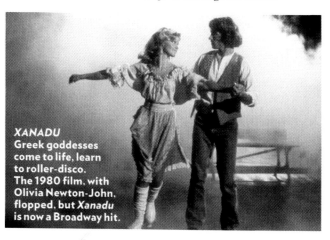

HOWARD THE DUCK
What's not to like about a misanthropic intergalactic duck? *Lots*, said audiences; exec producer George Lucas later disowned the film.

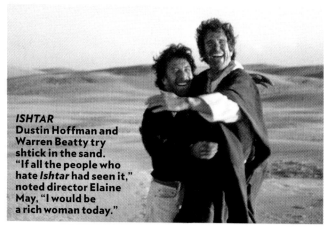

ISHTAR
Dustin Hoffman and Warren Beatty try shtick in the sand. "If all the people who hate *Ishtar* had seen it," noted director Elaine May, "I would be a rich woman today."

WHO SAID IT (IN THE MOVIE)?

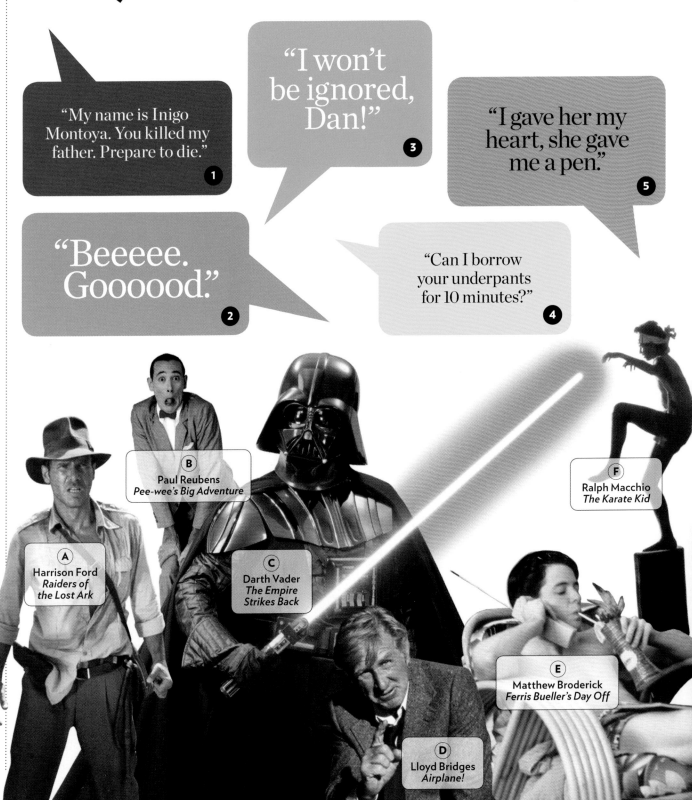

"My name is Inigo Montoya. You killed my father. Prepare to die." **1**

"I won't be ignored, Dan!" **3**

"I gave her my heart, she gave me a pen." **5**

"Beeeee. Goooood." **2**

"Can I borrow your underpants for 10 minutes?" **4**

B Paul Reubens *Pee-wee's Big Adventure*

F Ralph Macchio *The Karate Kid*

A Harrison Ford *Raiders of the Lost Ark*

C Darth Vader *The Empire Strikes Back*

E Matthew Broderick *Ferris Bueller's Day Off*

D Lloyd Bridges *Airplane!*

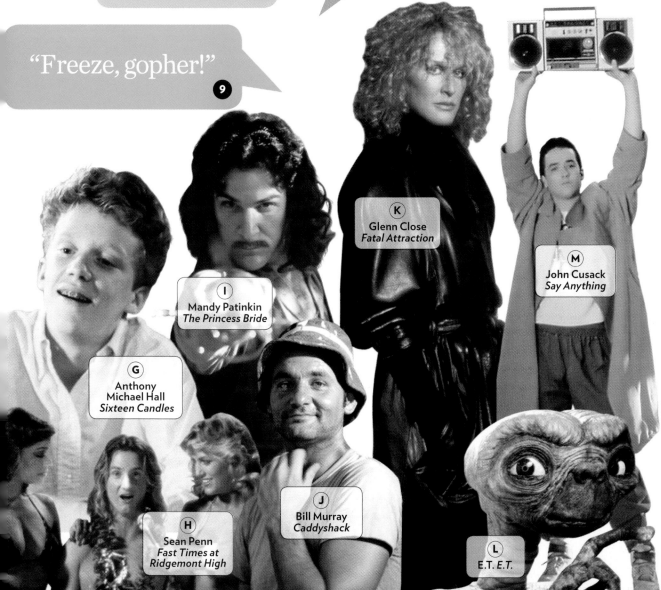

"Life goes by pretty fast. If you don't stop and look around once in a while, you could miss it." **11**

"All I need are some tasty waves, a cool buzz, and I'm fine." **7**

"Snakes. Why'd it have to be snakes?" **12**

"Banzai!" **6**

"Looks like I picked the wrong week to quit sniffing glue." **8**

"No, I am your father." **10**

"I know you are, but what am I?" **13**

"Freeze, gopher!" **9**

Ⓚ Glenn Close *Fatal Attraction*

Ⓜ John Cusack *Say Anything*

Ⓘ Mandy Patinkin *The Princess Bride*

Ⓖ Anthony Michael Hall *Sixteen Candles*

Ⓙ Bill Murray *Caddyshack*

Ⓗ Sean Penn *Fast Times at Ridgemont High*

Ⓛ E.T. *E.T.*

Two-timing! Back-stabbing! Skulduggery! And the occasional Evil Twin! Such were the joys to the '80s defining prime-time phenom, the nighttime soap. Eighty-three million tuned in to watch the 1980 *Dallas* episode that revealed who shot evil oil mogul J.R. Ewing; *Dynasty's* Joan Collins–Linda Evans catfight (right, with John Forsythe) may have been the genre's high-water mark.

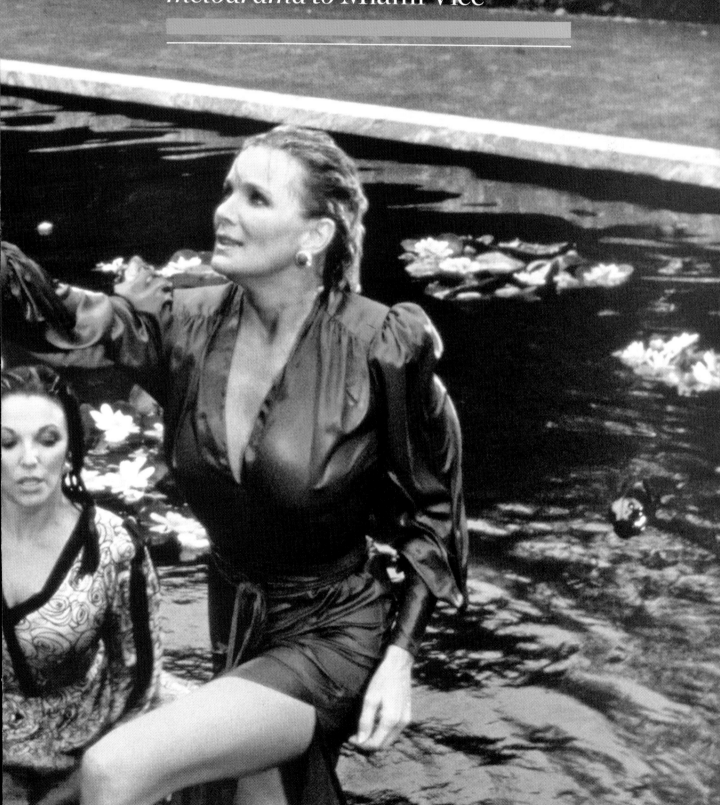

TV'S BIG HITS

Broad-shouldered women and men in pastel: What we watched, from **DYNASTY**'s *melodrama to* Miami Vice

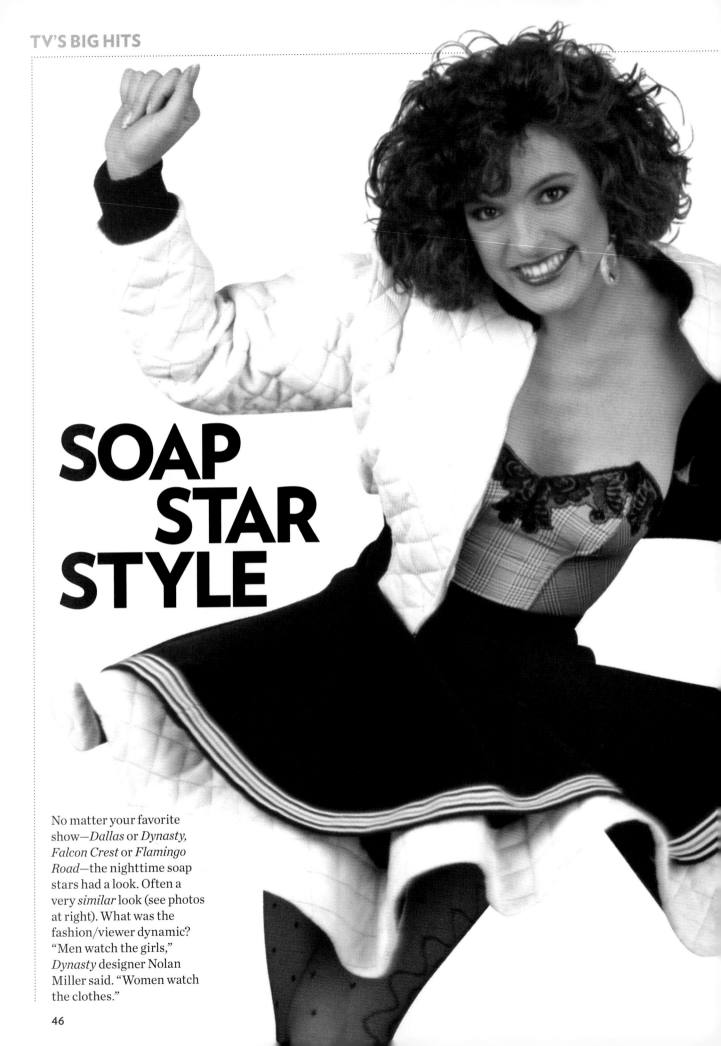

SOAP STAR STYLE

No matter your favorite show—*Dallas* or *Dynasty, Falcon Crest* or *Flamingo Road*—the nighttime soap stars had a look. Often a very *similar* look (see photos at right). What was the fashion/viewer dynamic? "Men watch the girls," *Dynasty* designer Nolan Miller said. "Women watch the clothes."

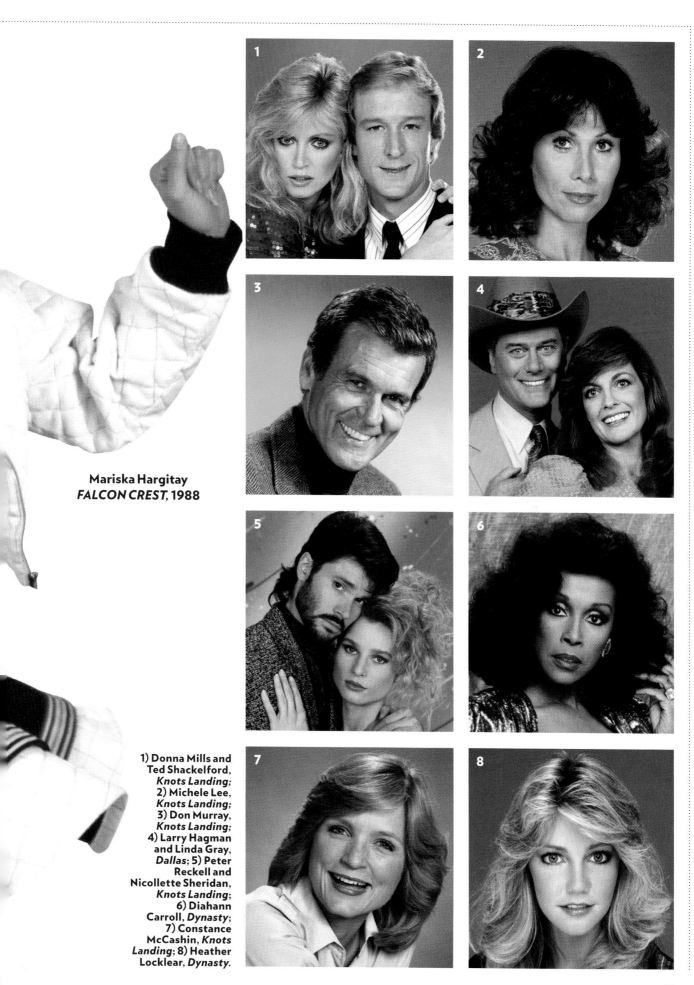

Mariska Hargitay
FALCON CREST, 1988

1) Donna Mills and
Ted Shackelford,
Knots Landing;
2) Michele Lee,
Knots Landing;
3) Don Murray,
Knots Landing;
4) Larry Hagman
and Linda Gray,
Dallas; 5) Peter
Reckell and
Nicollette Sheridan,
Knots Landing;
6) Diahann
Carroll, *Dynasty;*
7) Constance
McCashin, *Knots
Landing;* 8) Heather
Locklear, *Dynasty.*

MORGAN FAIRCHILD

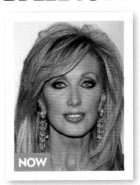

NOW

No one knows the world of prime-time suds better than one of TV's original soap vixens: Morgan Fairchild, who appeared on *Flamingo Road, Paper Dolls* and *Falcon Crest.*
It all began with *Road,* where Fairchild says she was stuck doing only bedroom scenes because they didn't have the other sets finished. "They kept putting me in the bedroom, and I was getting bored," she says. "So I started bringing my teddies and sexier lingerie from home, and that sort of started a trend on all those soap-opera sets." Fairchild, who used her downtime for needlepoint and studying anthropology, says her "sexy scenes" were sometimes the most challenging: "I remember shooting one night in February with David Selby [her *Road* costar at the time], and we were supposed to be having a tryst in a swimming pool. It was freezing. Our teeth were chattering so loud we couldn't even get our lines out. It wasn't as glamorous as it looked."

WHERE'S CLIFF CLAVEN NOW?

After 11 years as the know-it-all postman, John Ratzenberger has found new fame lending his voice to Pixar Animation's films.

YETI, MONSTERS, INC.
Ratzenberger is the only actor to voice a role in all of Pixar's films. They refer to him as their "good-luck charm."

HAMM, TOY STORY AND TOY STORY 2
The wisecracking piggy bank was Ratzenberger's first Pixar role, one that he'll reprise for 2010's *Toy Story 3.*

MACK THE TRUCK, CARS (2006)
Ratzenberger didn't have to go too far to research this one: His dad drove Macks, enabling him to help shape the character.

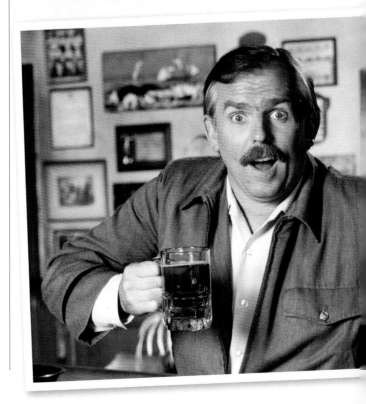

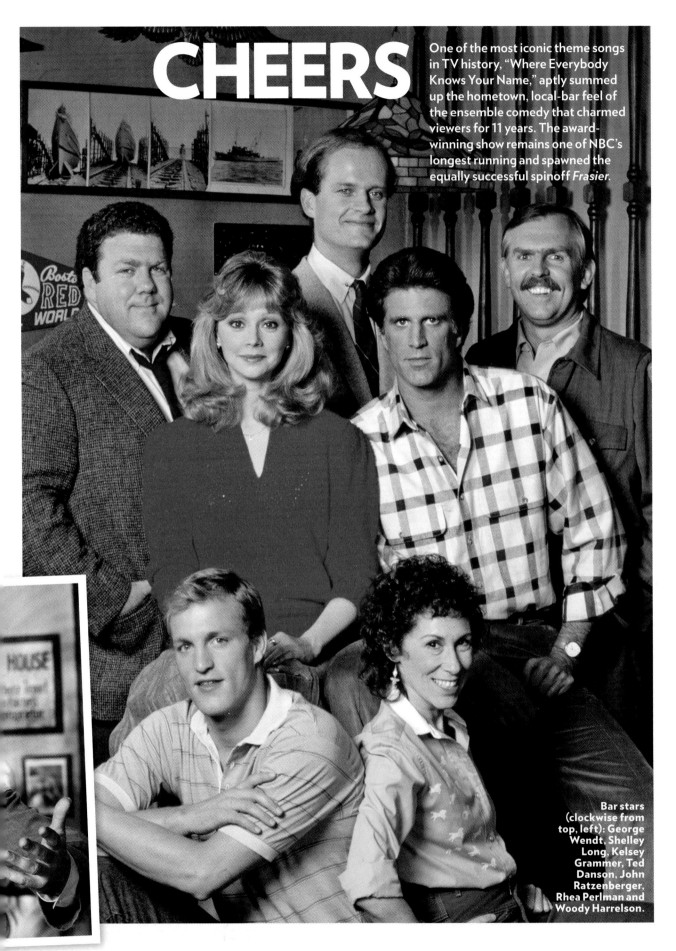

CHEERS

One of the most iconic theme songs in TV history, "Where Everybody Knows Your Name," aptly summed up the hometown, local-bar feel of the ensemble comedy that charmed viewers for 11 years. The award-winning show remains one of NBC's longest running and spawned the equally successful spinoff *Frasier*.

Bar stars (clockwise from top, left): George Wendt, Shelley Long, Kelsey Grammer, Ted Danson, John Ratzenberger, Rhea Perlman and Woody Harrelson.

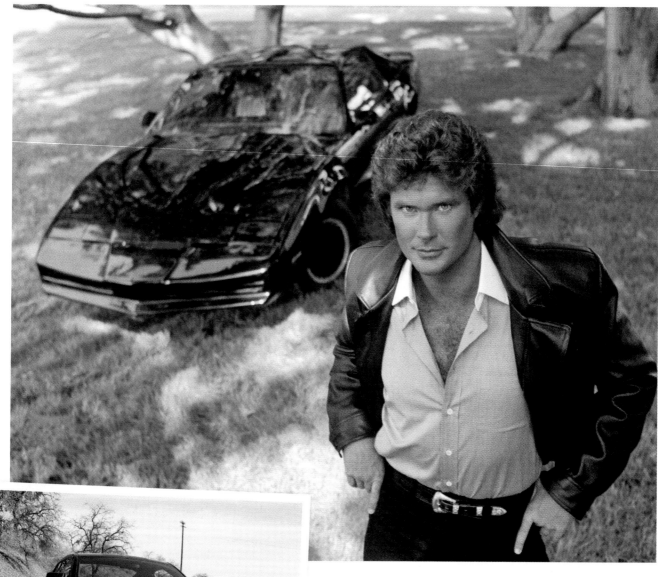

Starring vehicle: Actor William Daniels—who also played *St. Elsewhere*'s **Dr. Mark Craig—provided KITT's voice. The updated version (above) was unveiled on NBC's revamped** *Rider* **in fall 2008. The new KITT has holographic and transformation capabilities, and is voiced by Val Kilmer.**

KNIGHT RIDER

Though David Hasselhoff received top billing as Michael Knight—"a lone crusader in a dangerous world"—the real star of this kitschy, action-escapist show was KITT, Knight's computerized and indestructible Pontiac Trans Am. The talking car even received more fan mail than its flesh-and-blood costar in the beginning—a fact that was sometimes a sensitive subject for Hasselhoff. The actor admitted he once got angry with a fan who told him he was nothing without the car, to which Hasselhoff (who went on to star in *Baywatch* and is a judge on *America's Got Talent*) responded, "Why don't you ask for the car's autograph?"

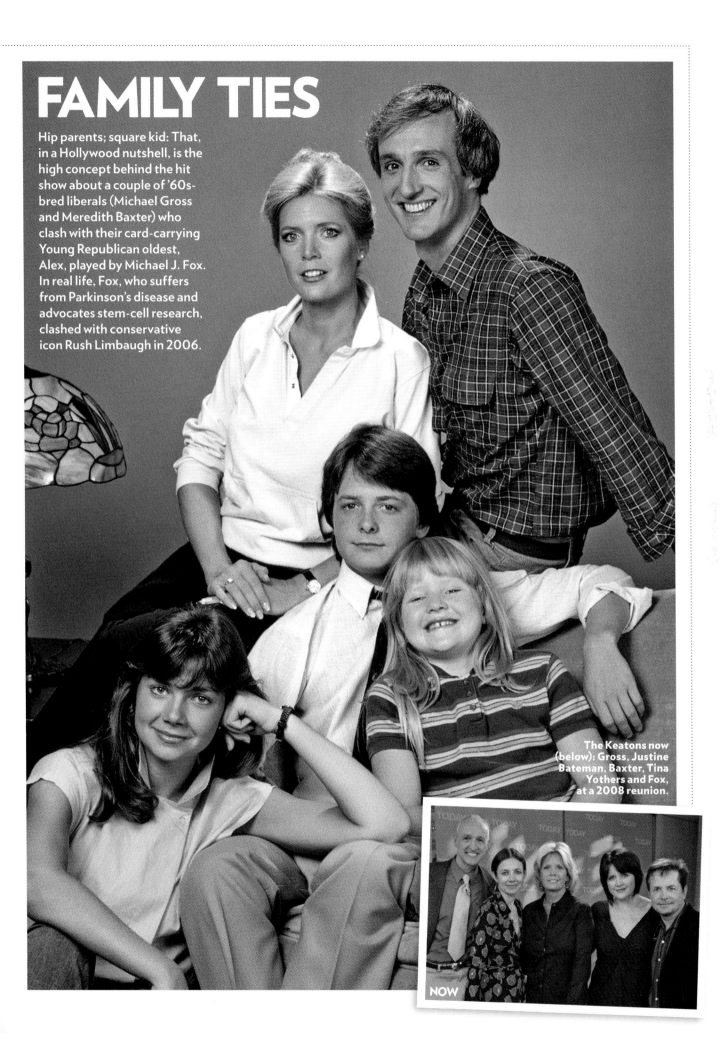

FAMILY TIES

Hip parents; square kid: That, in a Hollywood nutshell, is the high concept behind the hit show about a couple of '60s-bred liberals (Michael Gross and Meredith Baxter) who clash with their card-carrying Young Republican oldest, Alex, played by Michael J. Fox. In real life, Fox, who suffers from Parkinson's disease and advocates stem-cell research, clashed with conservative icon Rush Limbaugh in 2006.

The Keatons now (below): Gross, Justine Bateman, Baxter, Tina Yothers and Fox, at a 2008 reunion.

NOW

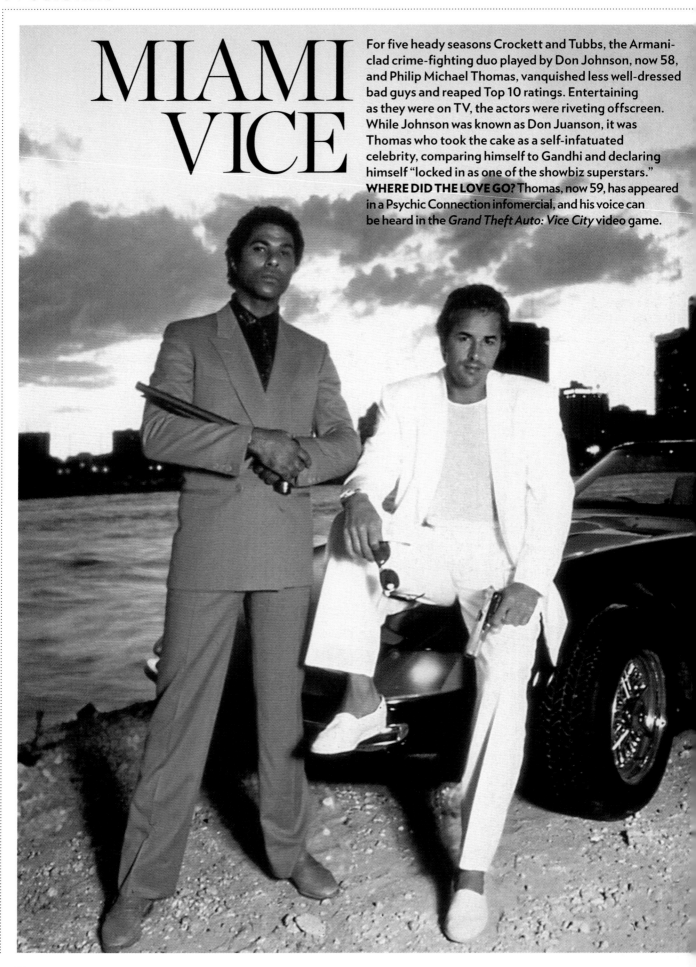

MIAMI VICE

For five heady seasons Crockett and Tubbs, the Armani-clad crime-fighting duo played by Don Johnson, now 58, and Philip Michael Thomas, vanquished less well-dressed bad guys and reaped Top 10 ratings. Entertaining as they were on TV, the actors were riveting offscreen. While Johnson was known as Don Juanson, it was Thomas who took the cake as a self-infatuated celebrity, comparing himself to Gandhi and declaring himself "locked in as one of the showbiz superstars." **WHERE DID THE LOVE GO?** Thomas, now 59, has appeared in a Psychic Connection infomercial, and his voice can be heard in the *Grand Theft Auto: Vice City* video game.

Conceived as "MTV cops," Thomas (left) and Johnson looked good and for trouble on Miami's mean streets and waterways.

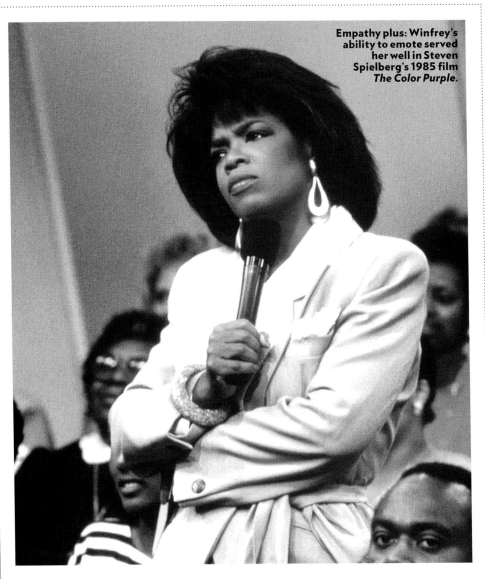

Empathy plus: Winfrey's ability to emote served her well in Steven Spielberg's 1985 film *The Color Purple*.

NOW

OPRAH WINFREY

Younger readers will find it hard to believe, but there was a time when the biggest name in daytime talk was Phil—no, not the Doc. In 1984 *The Phil Donahue Show* was the most popular talk show in Chicago, where it was based, and across America. **AND THEN** A 30-year-old from Kosciusko, Miss., took over as host of a local program called *AM Chicago*. "It was opposite the top-rated Phil Donahue," recalled *Chicago Sun-Times* film critic Roger Ebert. "Within a few weeks, Phil Donahue was no longer top-rated. Oprah's show was expanded to an hour and became a smash hit." Years later she credited Ebert with convincing her to go national in 1986. "Yes, it is true," Ebert wrote in 2005, "I persuaded Oprah to become the most successful and famous woman in the world." **HOW, EXACTLY?** The two went on a date at Chicago's Hamburger Hamlet. Romance, alas, wasn't in the cards, but Ebert's advice, backed by some eye-popping calculations he scribbled on a napkin, led her to syndicate her show rather than sign with a network—and made her, over time, a billionaire.

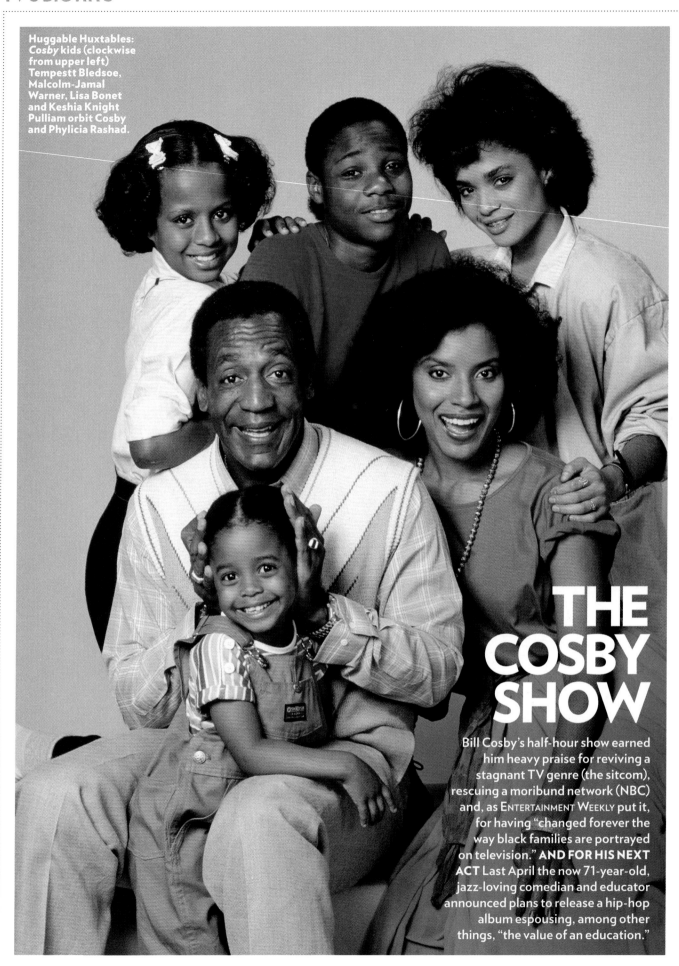

Huggable Huxtables: *Cosby* kids (clockwise from upper left) Tempestt Bledsoe, Malcolm-Jamal Warner, Lisa Bonet and Keshia Knight Pulliam orbit Cosby and Phylicia Rashad.

THE COSBY SHOW

Bill Cosby's half-hour show earned him heavy praise for reviving a stagnant TV genre (the sitcom), rescuing a moribund network (NBC) and, as ENTERTAINMENT WEEKLY put it, for having "changed forever the way black families are portrayed on television." **AND FOR HIS NEXT ACT** Last April the now 71-year-old, jazz-loving comedian and educator announced plans to release a hip-hop album espousing, among other things, "the value of an education."

FACTS OF LIFE

Set in a girls' boarding school in Peekskill, N.Y., the sitcom served life lessons along with laughs. Warmer, fuzzier and less ironic than most of today's TV fare, *Facts* tackled controversial issues including sexual orientation, drugs and teen pregnancy. George Clooney was one of a roster of future stars (Molly Ringwald, Seth Green, David Spade and Juliette Lewis among them) who made appearances during the show's nine-season run. Had she known Clooney would "grow up to be so handsome," recalled a cast member, "I would have worn makeup on the set more often."

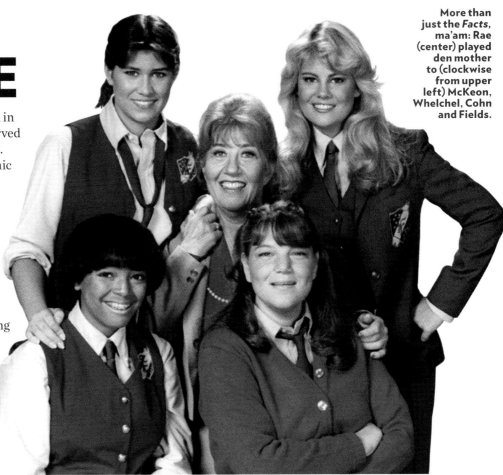

More than just the *Facts*, ma'am: Rae (center) played den mother to (clockwise from upper left) McKeon, Whelchel, Cohn and Fields.

WHERE ARE THEY NOW?

KIM FIELDS
Now 39, she played mischievous, gossip-prone Tootie. Since the show was canceled in 1988, Fields, now married to actor Christopher Morgan and the mother of a son, starred in *Living Single* and is a TV director.

NANCY McKEON
After starring as the tough-but-sensitive tomboy Jo from 1980 to 1988, the Westbury, N.Y. native, now 42 and the mother of two, starred in numerous television dramas, including the tough-gal police series *The Division*.

CHARLOTTE RAE
Typecast as the always-nurturing Edna Garrett, the 82-year-old television veteran (*Car 54, Where Are You?*; *Sisters*), told Entertainment Weekly, "I still meet people who just want me to . . . give them a hug. I always oblige."

MINDY COHN
Cast as sensitive, overweight Natalie, Cohn was 13 when the series began as a *Diff'rent Strokes* spinoff in 1979. Since earning a degree in sociology in 1993, Cohn has given voice to Velma Dinkley in the *Scooby Doo* cartoon series.

LISA WHELCHEL
"My beliefs as a Christian rule out acting in about 90 percent of TV and movies," Whelchel, 45, has said. A mother of three, she prepared to tell her kids the facts of life by listening to tapes about how to teach the birds and bees.

WHO SAID IT (ON TV)?

"I pity the fool." **1**

"Champagne wishes and caviar dreams!" **4**

"You wouldn't like me when I'm angry." **2**

"Nice planet... when do we eat?" **3**

"It's a dog-eat-dog world, and I'm wearing Milkbone underwear." **5**

A Terrapins *Teenage Mutant Ninja Turtles*

C Bronson Pinchot *Perfect Strangers*

E Alf *Alf*

B Gary Coleman *Diff'rent Strokes*

D Mr. T *The A-Team*

F Patrick Stewart *Star Trek: The Next Generation*

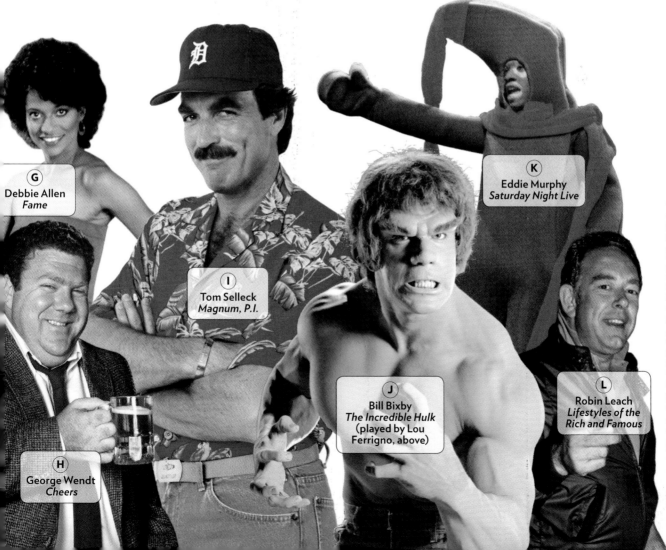

"Fame costs. And right here is where you start paying. In sweat." 6

"I'm Gumby, dammit!" 11

"When I write my book on how to be a world-class private investigator..." 7

"Cowabunga!" 10

"Whatchoo talkin' 'bout, Willis?" 9

"Make it so." 8

"Now we are so happy, we do the dance of joy!" 12

G
Debbie Allen
Fame

H
George Wendt
Cheers

I
Tom Selleck
Magnum, P.I.

J
Bill Bixby
The Incredible Hulk
(played by Lou Ferrigno, above)

K
Eddie Murphy
Saturday Night Live

L
Robin Leach
Lifestyles of the Rich and Famous

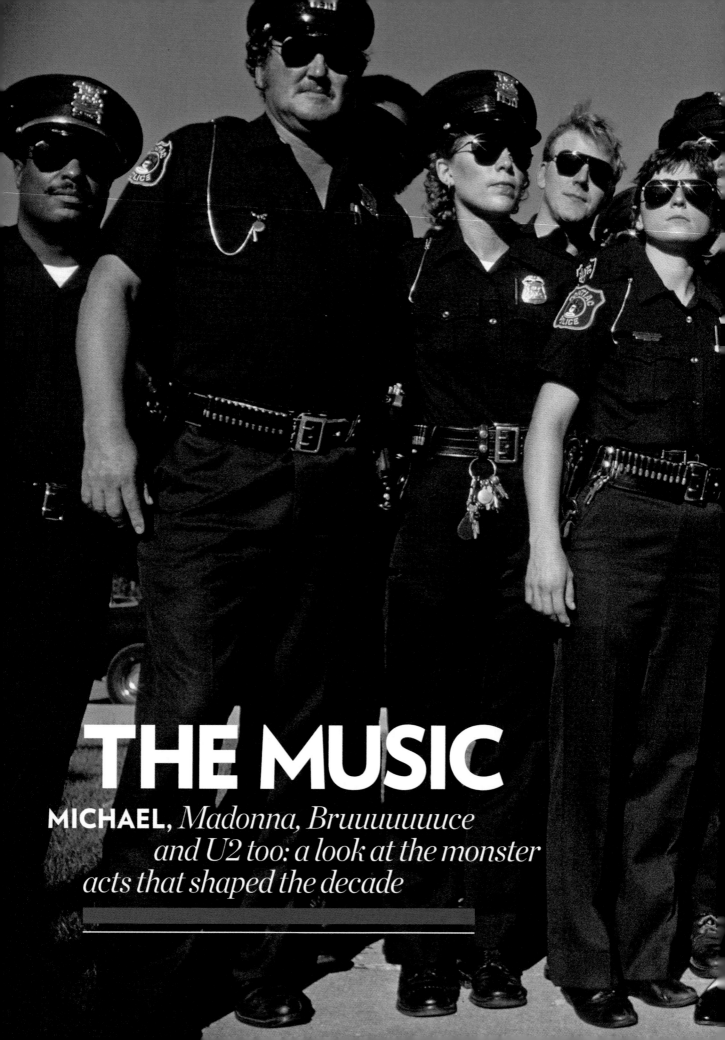

THE MUSIC

MICHAEL, *Madonna, Bruuuuuuuuce and U2 too: a look at the monster acts that shaped the decade*

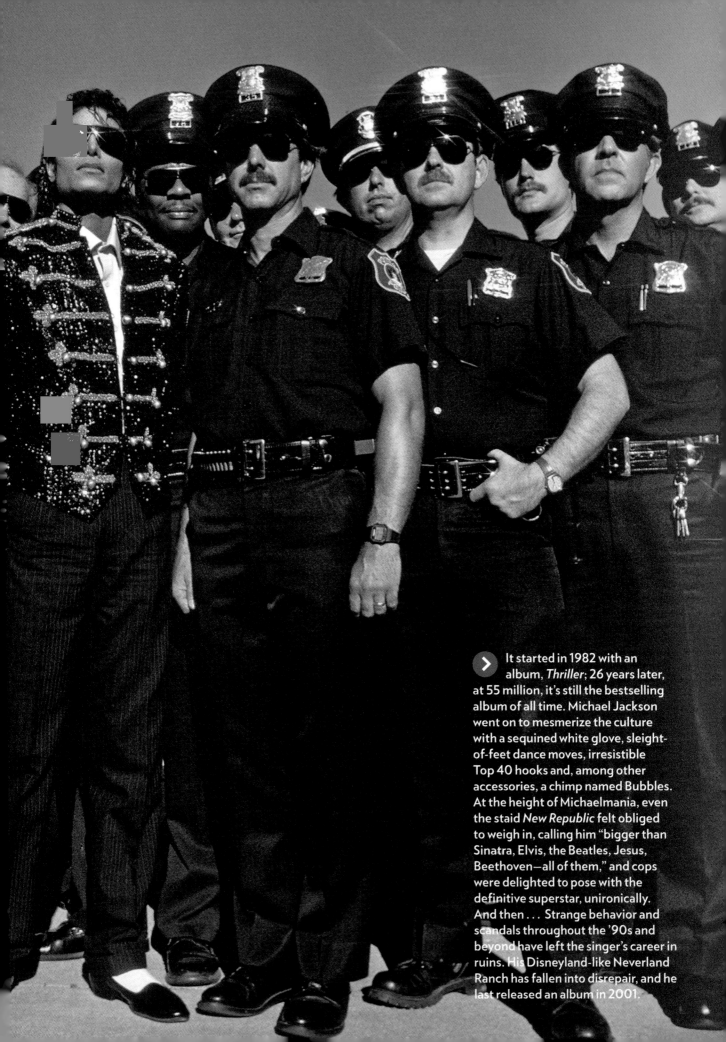

It started in 1982 with an album, *Thriller*; 26 years later, at 55 million, it's still the bestselling album of all time. Michael Jackson went on to mesmerize the culture with a sequined white glove, sleight-of-feet dance moves, irresistible Top 40 hooks and, among other accessories, a chimp named Bubbles. At the height of Michaelmania, even the staid *New Republic* felt obliged to weigh in, calling him "bigger than Sinatra, Elvis, the Beatles, Jesus, Beethoven—all of them," and cops were delighted to pose with the definitive superstar, unironically. And then . . . Strange behavior and scandals throughout the '90s and beyond have left the singer's career in ruins. His Disneyland-like Neverland Ranch has fallen into disrepair, and he last released an album in 2001.

Insouciance, anyone? "Bruce Springsteen was born to run," said Madonna (below, in 1982). "I was born to flirt."

BLOND AMBITION

Now, looking back, there *were* early, obvious signs. "We had to wear uniforms to [parochial] school," Madonna recalled years later. "So I would put bright panty bloomers underneath and hang upside down on the monkey bars at recess." Metaphorically speaking, she's been doing that pretty much ever since, to the delight of fans and the predictable, promotionally valuable outrage of critics. "I've been called a tramp, a harlot, a slut and the kind of girl that always ends up in the backseat of a car," she said in the early '80s, when she was cooing "Like a Virgin," wearing bustiers as outerwear and writhing in state in a wedding dress and a Boy Toy belt buckle. "If people can't get past that superficial level of what I'm about, fine." Her fashion sense inspired millions of pubescent wannabes, and the album *Like a Virgin* and its two successors rocketed to No. 1. Critics—one of whom described her voice as "Minnie Mouse on helium"— began to seem as irrelevant to her career as they were to Madonna herself. "I'm tough, ambitious and I know exactly what I want," she said. "If that makes me a bitch, okay."

NOW

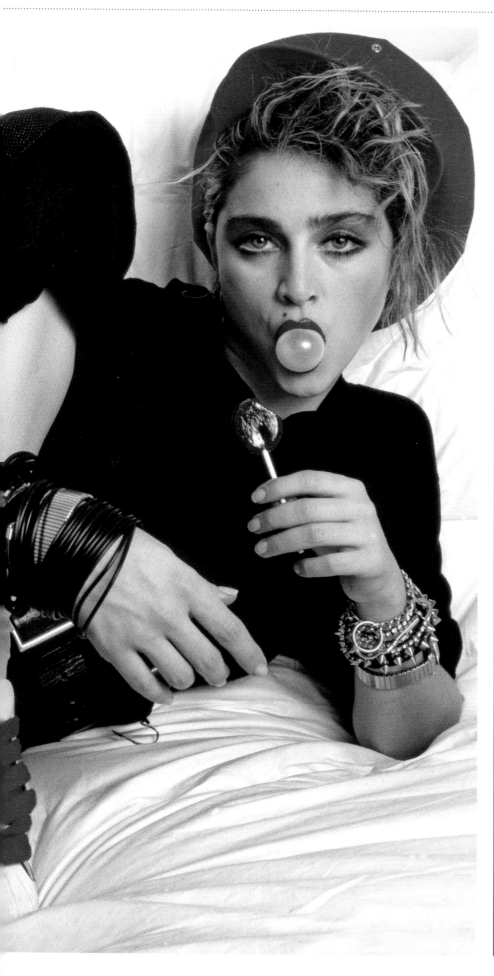

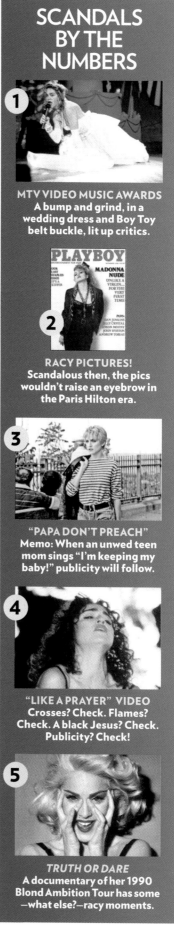

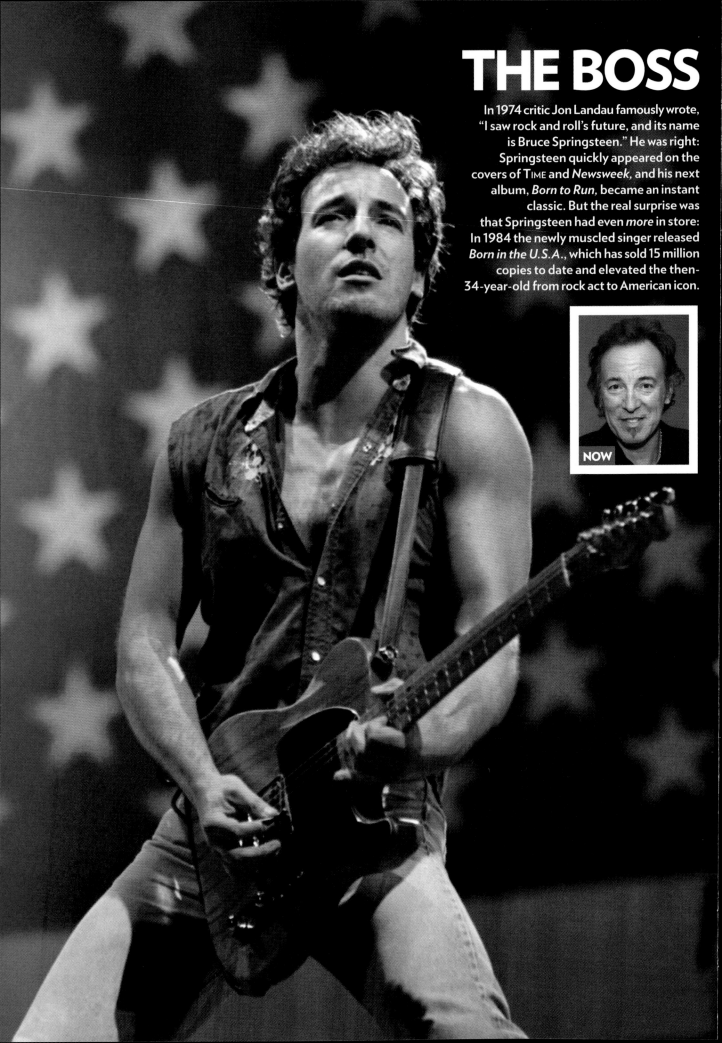

THE BOSS

In 1974 critic Jon Landau famously wrote, "I saw rock and roll's future, and its name is Bruce Springsteen." He was right: Springsteen quickly appeared on the covers of TIME and *Newsweek,* and his next album, *Born to Run,* became an instant classic. But the real surprise was that Springsteen had even *more* in store: In 1984 the newly muscled singer released *Born in the U.S.A.,* which has sold 15 million copies to date and elevated the then-34-year-old from rock act to American icon.

NOW

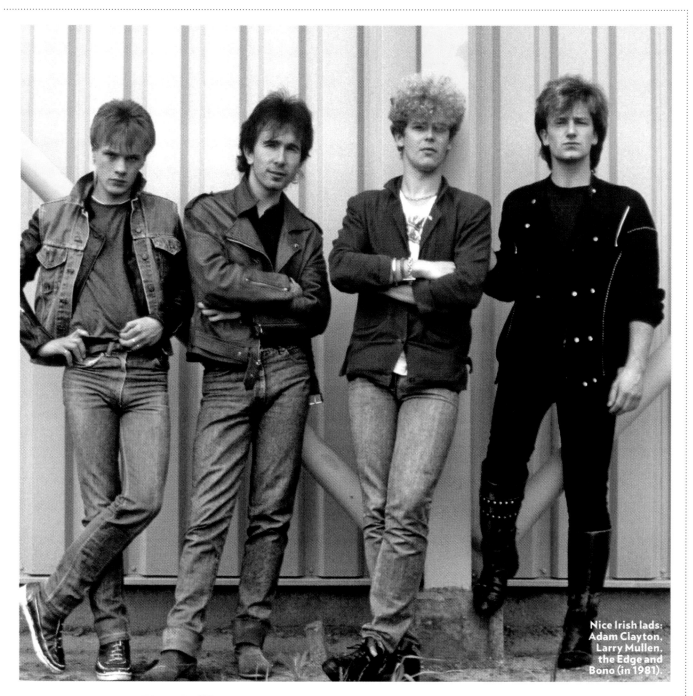

Nice Irish lads: Adam Clayton, Larry Mullen, the Edge and Bono (in 1981).

U2

NOW

In 1985 they were, most likely, the only band on the planet that ended concerts by having ecstatic, sold-out audiences sing along to lyrics that quoted Psalm 40: "I waited patiently for the Lord, and He inclined . . . and heard me cry." U2 made their mark by striving to create rock with overtones of humanism and spirituality—something beyond, as lead singer Bono (left) once said, mere "crashing drums and clanging guitars." By the end of the decade, many fans had the fervor of devotees—and Bono, backing up his words with action, had started raising millions for African relief and other causes. "I couldn't walk onstage if I thought, 'It's only rock and roll, a shot in the arm to get you through the night,'" he once said. "Maybe it is a shot in the arm, but I like to think it's still running through people's veins the next week, just a tiny bit."

THE POLICE

Stewart Copeland, Andy Summers and a charismatic singer with the singular monicker Sting (birth name: Gordon Matthew Sumner) created a hard-driving, minimalist sound that produced maximum sales in the '80s. The Police, along with The Clash, were among the first mainstream rockers to experiment with reggae rhythms, and former high school English teacher Sting added a literary lilt to the band's lyrics (among other things, offering a tip o' the hat to Nabokov in "Don't Stand So Close to Me"). The group broke up in 1984 but reunited for Sting's wedding reception in 1992, briefly at their induction into the Rock and Roll Hall of Fame in 2003 and again in 2007 for a 14-month tour.

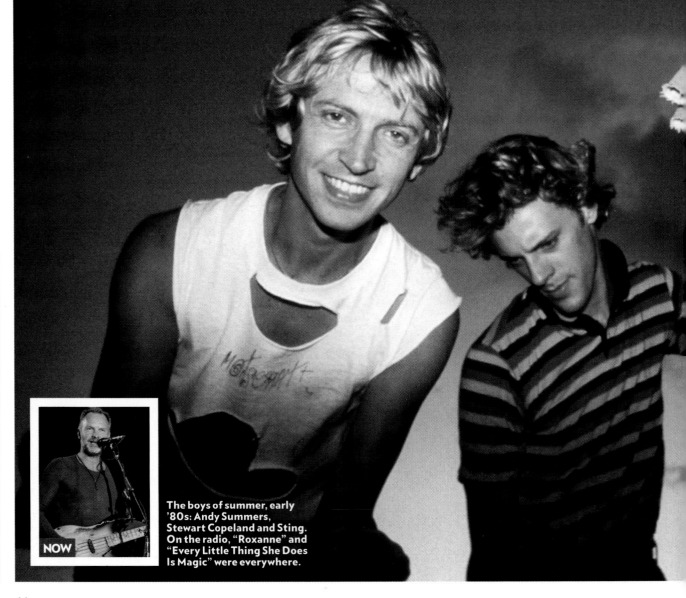

NOW

The boys of summer, early '80s: Andy Summers, Stewart Copeland and Sting. On the radio, "Roxanne" and "Every Little Thing She Does Is Magic" were everywhere.

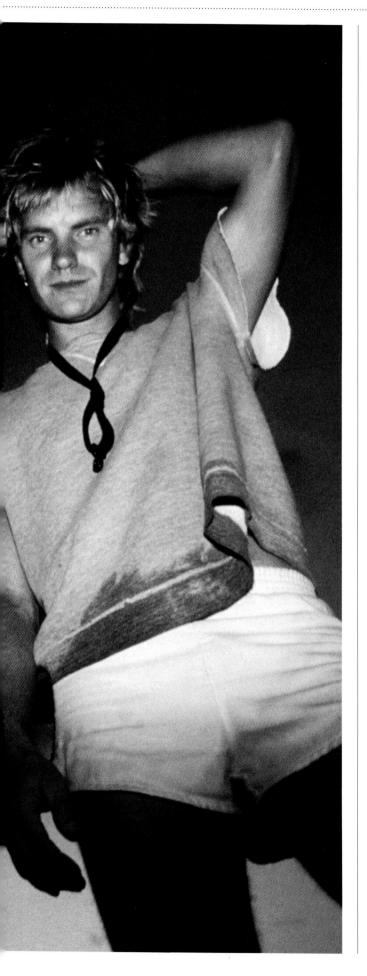

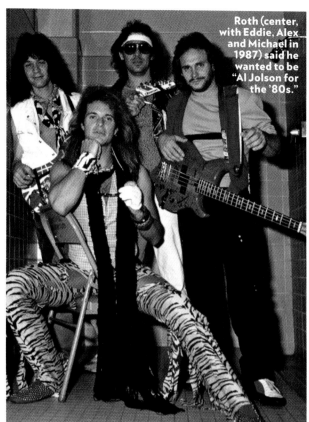

Roth (center, with Eddie, Alex and Michael in 1987) said he wanted to be "Al Jolson for the '80s."

VAN HALEN

NOW

Rock band, soap opera or dysfunctional family? Discuss! The original quartet— brothers Eddie and Alex Van Halen, bassist Michael Anthony and lead singer David Lee Roth—began kicking around L.A.'s hard-rock circuit in 1974, but it wasn't until 1984's *1984* that the group—thanks to guitarist Eddie's note- and genre-bending pyrotechnics and Roth's wiseacre showmanship—reached their commercial pinnacle with megahits like "Panama" and "Hot for Teacher." Then, of course, Roth left, singer Sammy Hagar signed on, Hagar left, other singers came and went, and in 2007 Van Halen launched a new world tour—with Roth back in the fold. According to the Van Halen Web site, the tour grossed $93 million—a record for the band.

THE SOUNDTRACK OF THE '80s

Even now, when they come on the radio, you think, "1983!" or "Summer '88!" You can't forget the music—or the mousse

CYNDI LAUPER

BIGGEST HIT "Girls Just Want to Have Fun," 1983
She might have been the long-rumored love child of Popeye and Betty Boop, a Technicolor eccentric with a Queens accent, a four-octave range and no sense of where she belonged in the world. "I didn't fit in, didn't have nobody to do things with," she said of her wilderness years. "I did them by myself." And then . . . someone invented MTV, and Cyndi Lauper's talent and eccentricities made for riveting videos— and helped her first album, *She's So Unusual*, sell more than 9 million copies. What would she do with the money? "Linoleum floors," she speculated. "And I'm gettin' a washer-dryer . . . [and] my girlfriend says I should have slaves by now to wait on me hand and foot—and hair."

NOW

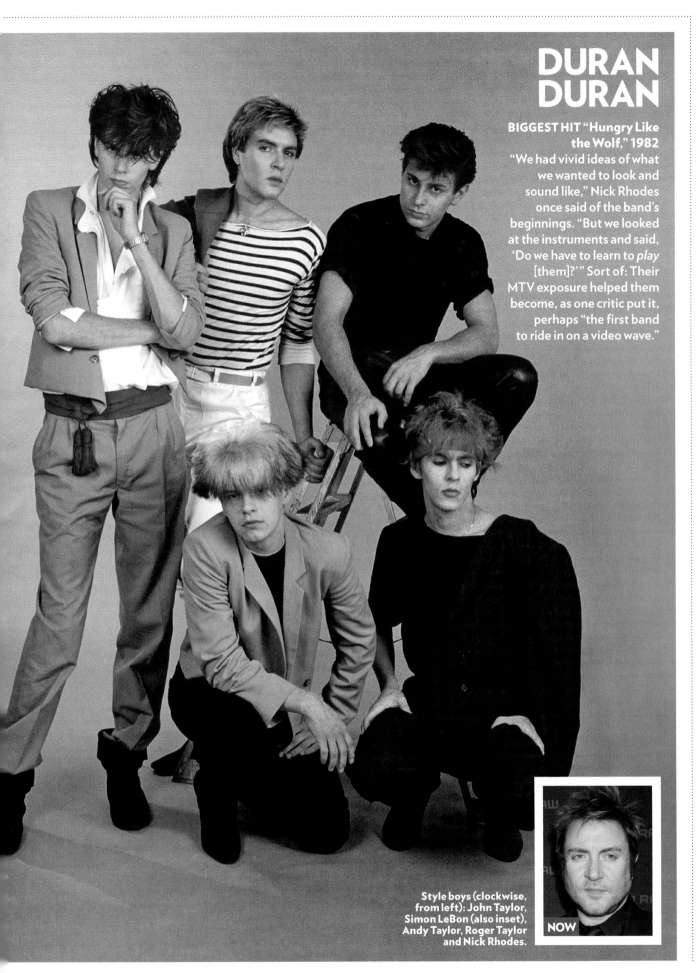

DURAN DURAN

BIGGEST HIT "Hungry Like the Wolf," 1982
"We had vivid ideas of what we wanted to look and sound like," Nick Rhodes once said of the band's beginnings. "But we looked at the instruments and said, 'Do we have to learn to *play* [them]?'" Sort of: Their MTV exposure helped them become, as one critic put it, perhaps "the first band to ride in on a video wave."

Style boys (clockwise, from left): John Taylor, Simon LeBon (also inset), Andy Taylor, Roger Taylor and Nick Rhodes.

NOW

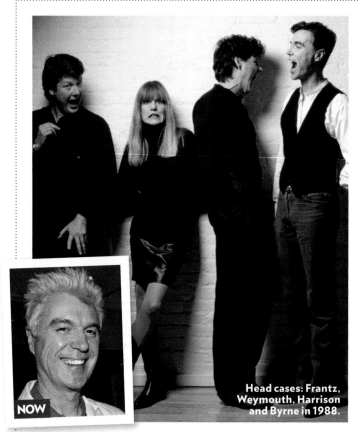

George, now 47, was ordered to pick up garbage in New York in 2006 as community service after falsely reporting a burglary.

NOW

NOW

Head cases: Frantz, Weymouth, Harrison and Byrne in 1988.

TALKING HEADS

BIGGEST HIT "Burning Down the House," 1983

They were the Art Pop band with academic cred: Singer-songwriter David Byrne, drummer Chris Frantz and bassist Tina Weymouth met while students at the Rhode Island School of Design (keyboardist Jerry Harrison, who joined later, was merely a Harvard grad). Audaciously mixing funk, punk, rock and pop, Talking Heads quickly became the unofficial house band of New York City's downtown scene and soon found themselves collaborating with choreographer Twyla Tharp and having their 1983 tour captured by director Jonathan Demme in an award-winning documentary, *Stop Making Sense.*
By the middle of the decade the former cult gods were scoring Top 40 hits with "Burning Down the House" and "Wild, Wild Life." Talking Heads broke up in 1991, reuniting only once, in 2002, for induction into the Rock and Roll Hall of Fame.

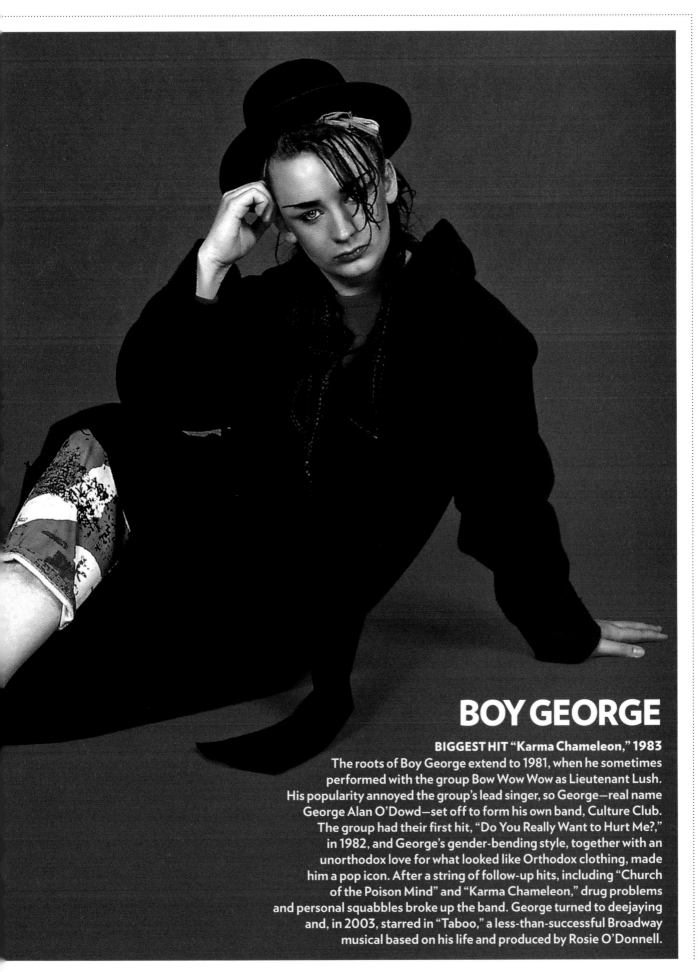

BOY GEORGE

BIGGEST HIT "Karma Chameleon," 1983
The roots of Boy George extend to 1981, when he sometimes performed with the group Bow Wow Wow as Lieutenant Lush. His popularity annoyed the group's lead singer, so George—real name George Alan O'Dowd—set off to form his own band, Culture Club. The group had their first hit, "Do You Really Want to Hurt Me?," in 1982, and George's gender-bending style, together with an unorthodox love for what looked like Orthodox clothing, made him a pop icon. After a string of follow-up hits, including "Church of the Poison Mind" and "Karma Chameleon," drug problems and personal squabbles broke up the band. George turned to deejaying and, in 2003, starred in "Taboo," a less-than-successful Broadway musical based on his life and produced by Rosie O'Donnell.

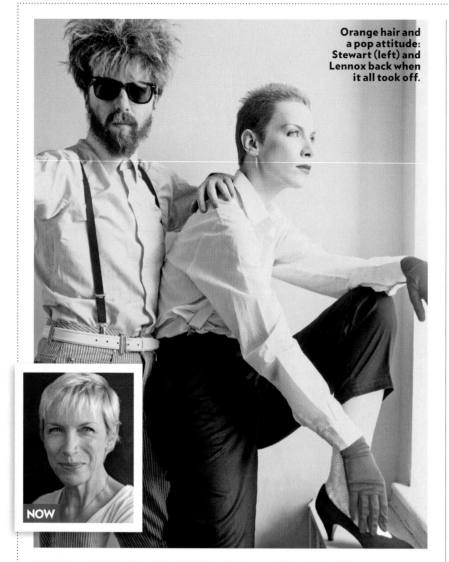

Orange hair and a pop attitude: Stewart (left) and Lennox back when it all took off.

NOW

PRINCE

BIGGEST HIT "Purple Rain," 1984
So much funk, so little time: Purple-clad and prolific, Prince produced three monster '80s albums (*1999*, *Purple Rain* and *Sign o' the Times*); mentored a stable of stars (Vanity, Sheila E) and preened happily as perhaps rock and roll's top tease ("Act your age, Mama, not your shoe size," he sang on "Kiss," "maybe we could do the twirl.") So great was Prince's popularity that in 1989 he even scored a No. 1 hit with a (now forgotten?) Batman-themed tune called "Batdance." Nowadays the singer resides happily in rock and roll's pantheon, and an invitation to his afterparty is Grammy week's hottest ticket.

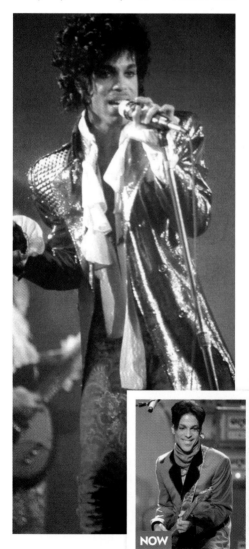

NOW

EURYTHMICS

MEMORABLE HIT "Sweet Dreams (Are Made of This)," 1983

It was 1975; he was a struggling musician, she was working as a waitress, and a friend introduced them. "You know how normally when you meet somebody you fall in love with, you sort of go through tentative stages?" Dave Stewart said at the time. "Well, there was none of that. It was like I didn't know her one minute, and the next minute we were living together." The romance faded, but not before giving birth to Eurythmics, an inventive pop duo that thrived on Stewart's techspertise and Annie Lennox's dramatic looks and soaring range. "Sweet Dreams (Are Made of This)"—and an accompanying video that made the most of Lennox's orange buzz cut—launched a string of U.S. hits in 1983. Nowadays Stewart, 55, and Lennox, 53, pursue solo careers; she won an Oscar in 2004 for her recording of "Into the West" from *The Lord of the Rings: The Return of the King.*

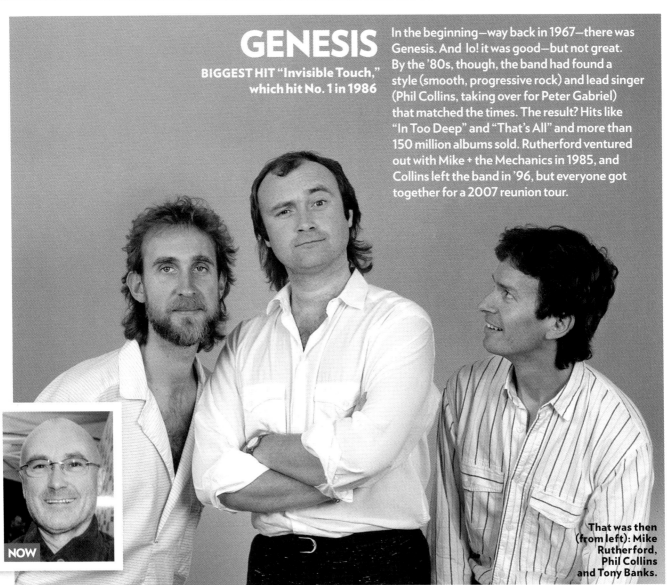

GENESIS

BIGGEST HIT "Invisible Touch," which hit No. 1 in 1986

In the beginning—way back in 1967—there was Genesis. And lo! it was good—but not great. By the '80s, though, the band had found a style (smooth, progressive rock) and lead singer (Phil Collins, taking over for Peter Gabriel) that matched the times. The result? Hits like "In Too Deep" and "That's All" and more than 150 million albums sold. Rutherford ventured out with Mike + the Mechanics in 1985, and Collins left the band in '96, but everyone got together for a 2007 reunion tour.

NOW

That was then (from left): Mike Rutherford, Phil Collins and Tony Banks.

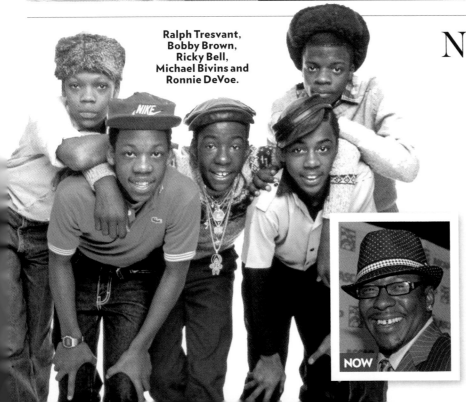

Ralph Tresvant, Bobby Brown, Ricky Bell, Michael Bivins and Ronnie DeVoe.

NOW

NEW EDITION

BIGGEST HIT "Cool It Now," 1984
Think of them as the Jackson 5, Take II: talented, fun and supercute. The teen quintet from Boston's Roxbury neighborhood became bubblegum superstars with their debut album *Candy Girl* in 1983. "Cool It Now," from their follow-up *New Edition*, was a Top 5 hit. New Edition was canceled in 1986 after Bobby Brown left the group, claiming "all I got out of New Edition was $500 and a VCR." He had a successful solo career and married (and divorced) Whitney Houston. Michael Bivins, Ricky Bell and Ronnie DeVoe formed Bell Biv DeVoe in 1990. New Edition reunites every few years.

METAL HAIR

Gather round, children, as we explore a rare cultural moment when "macho" meant "full, fluffy, frosted, dyed, highlighted and curled"

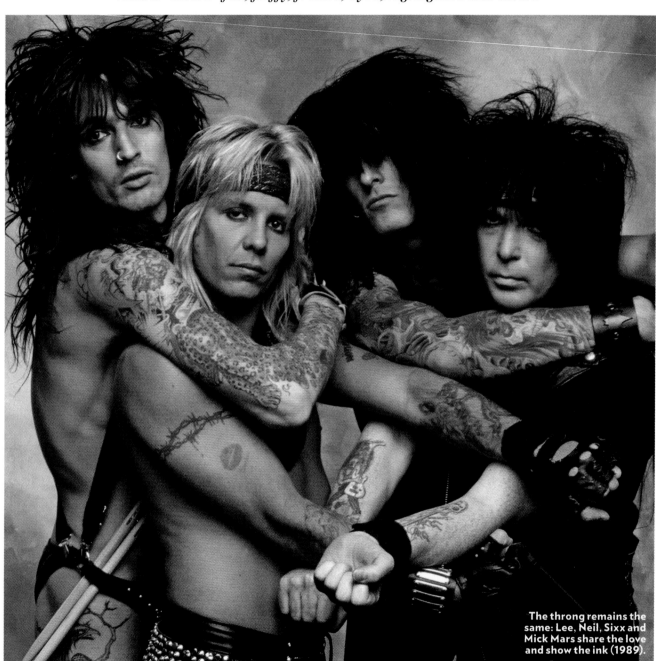

The throng remains the same: Lee, Neil, Sixx and Mick Mars share the love and show the ink (1989).

MÖTLEY CRÜE

The total glam-rock/hard-rock package, Mötley Crüe had it all: epic hair; tattoos; big hits (1985's "Smokin' in the Boys Room," 1987's "Girls, Girls, Girls"); Hollywood marriages (drummer Tommy Lee to Heather Locklear and, later, Pamela Anderson); drug problems (bassist Nikki Sixx, heroin); jail time (Tommy, for hitting Pamela; singer Vince Neil, for vehicular manslaughter, when he wrecked his car); and, of course, inexplicable umlauts.

Jon Bon Jovi
BON JOVI

C.C. DeVille
POISON

David Lee Roth
VAN HALEN

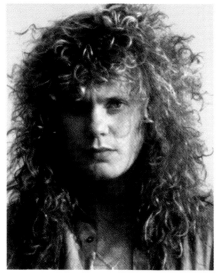

Rick Savage
DEF LEPPARD

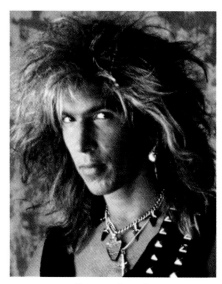

George Lynch
DOKKEN

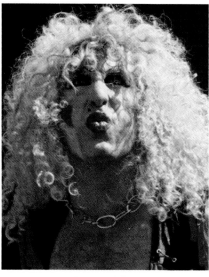

Dee Snider
TWISTED SISTER

SECRETS OF METAL HAIR

So what, exactly, was the deal with the hair? "Bigger, longer and wilder," says singer-guitarist Tom Keifer (below, left), whose band, Cinderella, released their debut album, *Night Songs*, in 1986. "We're a rock and roll band, that's what it's all about."

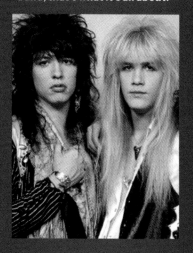

STEAL THEIR LOOK!

STEP 1: DO NOT SHOWER, RINSE, REPEAT
"You don't wash it," says Eric Brittingham (above, right), the band's bass player. "You get it done and then you kinda pick at it every few days and get it shaped back right."

STEP 2: WORK IT
"It's a lot of teasing and rubbing," says Brittingham of the proper technique. Unless you have natural volume like Keifer. "My hair is kind of naturally big," he says. "I was always trying to make it smaller, to be honest. I'm still having that battle."

STEP 3: LET US SPRAY. OFTEN.
"I forget what I used," says Brittingham. "I think whatever was on sale and always pump. Pump, not aerosol, for sure."

STEP 4: YOU GOTTA BE YOU
"We really didn't care [about the look]," says Keifer. "I think the misnomer is that we cared and we didn't. I think some bands did." Adds Brittingham: "You can't take yourself that seriously."

ONE (AND TWO) HIT WONDERS

Two decades later, you still know the lyrics. But whatever did happen to A Flock of Seagulls? And whither Wang Chung?

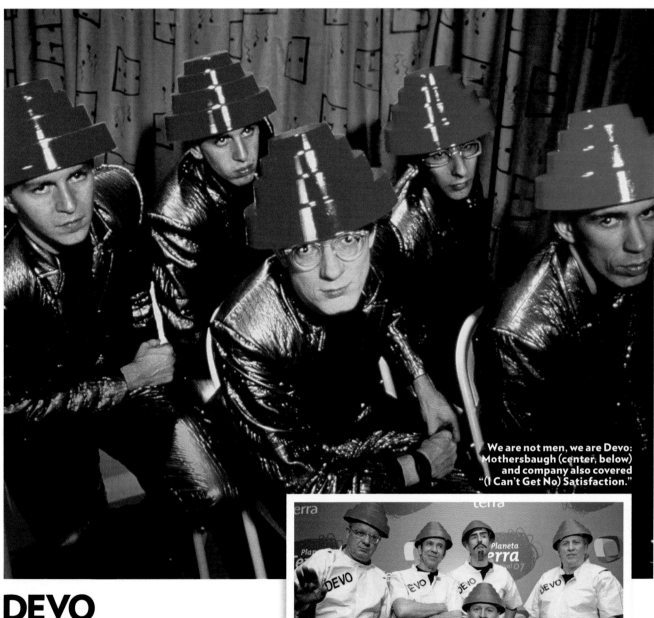

We are not men, we are Devo: Mothersbaugh (center, below) and company also covered "(I Can't Get No) Satisfaction."

NOW

DEVO

THE SONG YOU REMEMBER "Whip It," 1980

Long before techno, there was Devo, whose bizarre S&M-on-the-farm video for their lone hit single was an MTV fave. Cofounder Mark Mothersbaugh went on to score music for films and TV shows like Nickelodeon's *Rugrats*.

BOBBY McFERRIN

THE SONG YOU REMEMBER
"Don't Worry, Be Happy," 1988
A one-man improvisational vocalist, McFerrin infuriated curmudgeons everywhere with this infectious Grammy-winning ditty. He continues to perform and conduct with symphony orchestras.

NOW

TONI BASIL

THE SONG YOU REMEMBER
"Mickey," 1982
The former head cheerleader at Las Vegas High put plenty of pep on the charts with this bouncy No. 1 single. Basil recently choreographed Bette Midler's *The Showgirl Must Go On* Vegas revue.

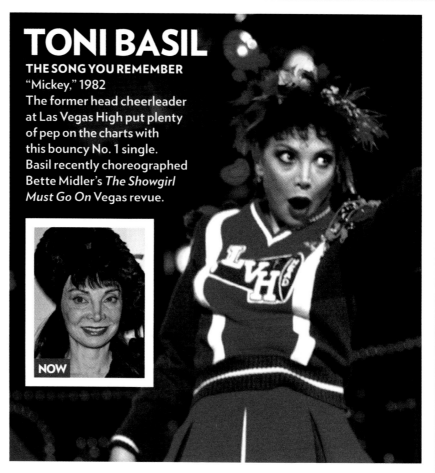

NOW

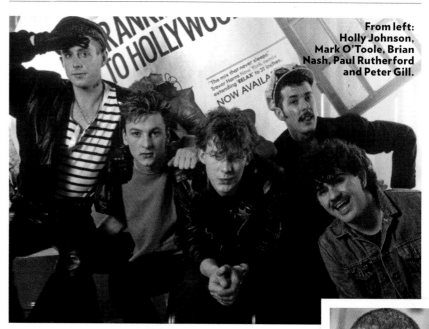

From left:
Holly Johnson,
Mark O'Toole, Brian
Nash, Paul Rutherford
and Peter Gill.

FRANKIE GOES TO HOLLYWOOD

THE SONG YOU REMEMBER "Relax," 1983
The controversial come-on single and racy video were banned by the BBC, which didn't hurt sales anywhere. Singer Holly Johnson (right) was diagnosed with AIDS in 1991.

NOW

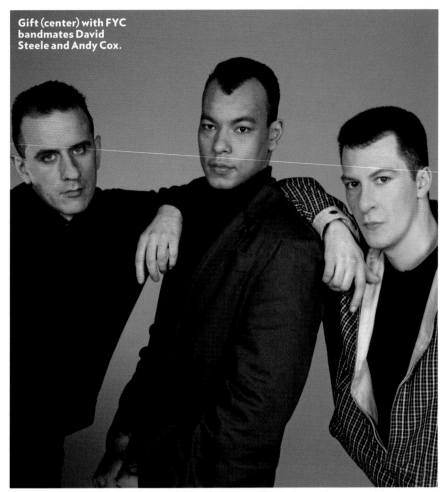

Gift (center) with FYC bandmates David Steele and Andy Cox.

NOW

FINE YOUNG CANNIBALS

THE SONG YOU REMEMBER
"She Drives Me Crazy," 1989
With his Sidney Poitier gaze, lead singer Roland Gift drove girls crazy. Gift acted in films (the group all appeared as the house band in the 1987 comedy *Tin Men*) and on Brit TV. FYC broke up in 1992.

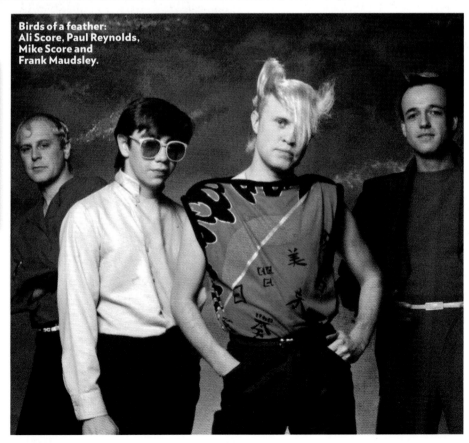

Birds of a feather: Ali Score, Paul Reynolds, Mike Score and Frank Maudsley.

NOW

A FLOCK OF SEAGULLS

THE SONG YOU REMEMBER
"I Ran (So Far Away)," 1982
Hairdresser and lead singer Mike Score's iconic coif made him a rare bird among the MTV set. The band flew their separate ways in 1986, though Score has juggled the lineup with new members over the years.

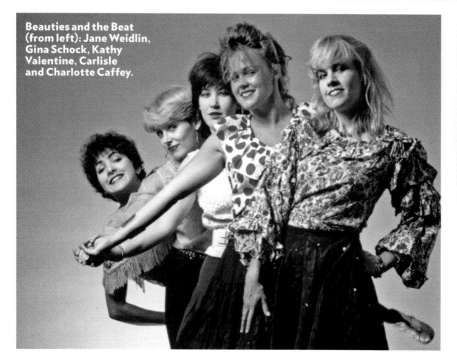

Beauties and the Beat (from left): Jane Weidlin, Gina Schock, Kathy Valentine, Carlisle and Charlotte Caffey.

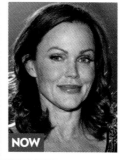

NOW

THE GO-GO'S

THE SONG YOU REMEMBER
"We Got the Beat," 1982
These California girls melded catchy riffs with a punk beat and rode their New Wave sound to the top of the charts. Drugs and conflict broke up the band in '85; frontwoman Belinda Carlisle found solo success.

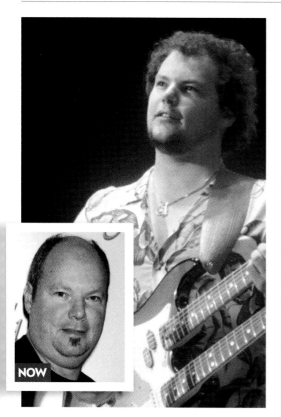

NOW

CHRISTOPHER CROSS

THE SONG YOU REMEMBER "Arthur's Theme (Best That You Can Do)," 1981
Cross rode like the wind up the charts with his gossamer melodies and sentimental lyrics. He says he plans to release a "jazz-based" interpretation of his songs in 2008.

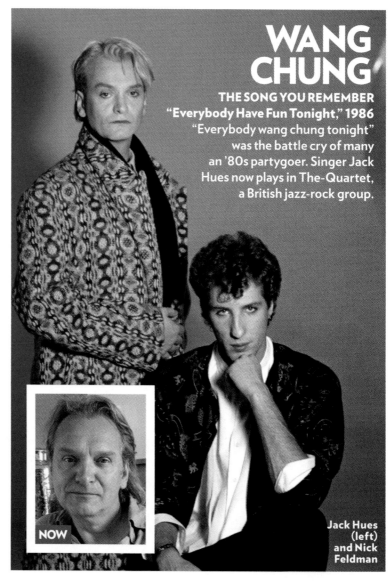

WANG CHUNG

THE SONG YOU REMEMBER
"Everybody Have Fun Tonight," 1986
"Everybody wang chung tonight" was the battle cry of many an '80s partygoer. Singer Jack Hues now plays in The-Quartet, a British jazz-rock group.

NOW

Jack Hues (left) and Nick Feldman

HIP-HOP HOORAY

Like rock and punk before it, a rough-hewn outsider art form, hip-hop, kicked down the walls of pop and announced it was moving in

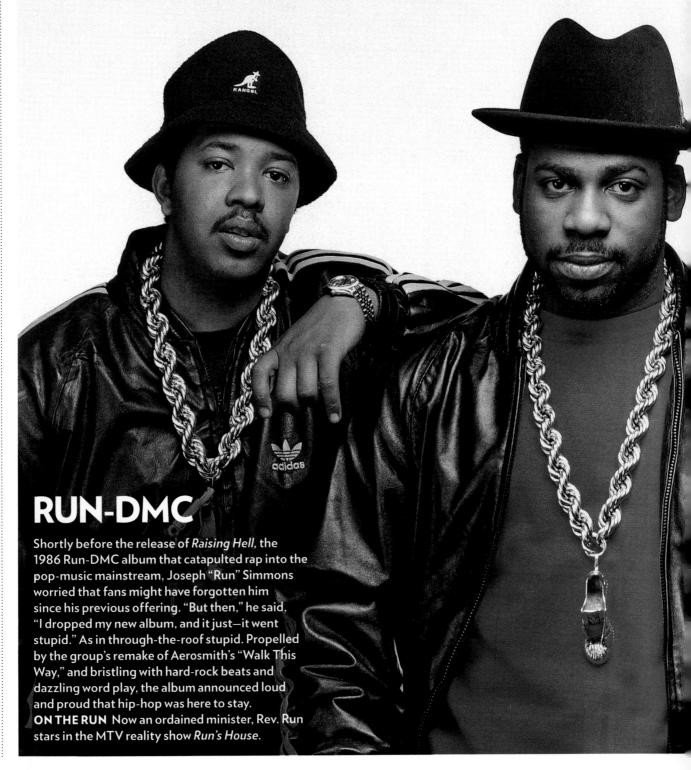

RUN-DMC

Shortly before the release of *Raising Hell*, the 1986 Run-DMC album that catapulted rap into the pop-music mainstream, Joseph "Run" Simmons worried that fans might have forgotten him since his previous offering. "But then," he said, "I dropped my new album, and it just—it went stupid." As in through-the-roof stupid. Propelled by the group's remake of Aerosmith's "Walk This Way," and bristling with hard-rock beats and dazzling word play, the album announced loud and proud that hip-hop was here to stay.
ON THE RUN Now an ordained minister, Rev. Run stars in the MTV reality show *Run's House*.

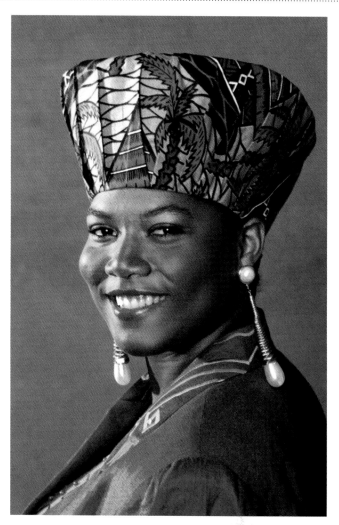

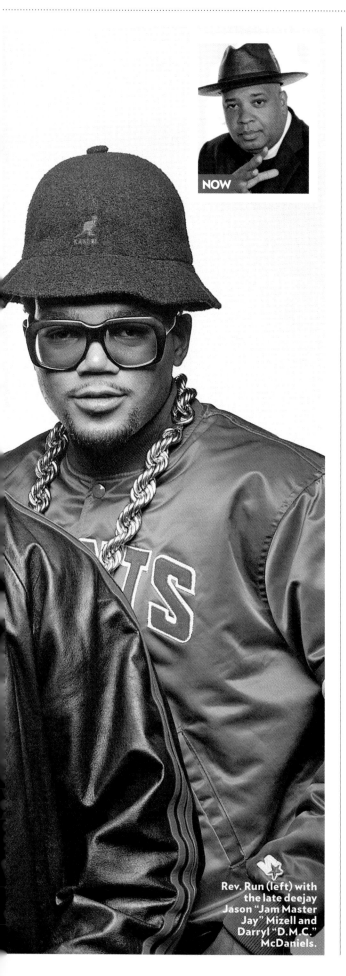

Rev. Run (left) with
the late deejay
Jason "Jam Master
Jay" Mizell and
Darryl "D.M.C."
McDaniels.

QUEEN LATIFAH

NOW

Her Highness's name,
bestowed by a cousin,
means "delicate, kind"
in Arabic. But Dana
Owens wasn't exactly
the fragile type.
"Give her a pot, she'd
bang it. A spoon,
she'd sing into it. A box,
she'd beat it," her mom
said of the motorcycle-riding East Orange,
N.J., tomboy, who also studied karate and
learned from her police officer father how to
handle a gun ("Dad taught us how to shoot
'em, unload 'em and where not to point 'em,"
she said). Her debut album, *All Hail the
Queen,* made the 19-year-old a star in 1989.
STILL REIGNING The Grammy-winning
rapper and Oscar-nominated actress
led the Queen Latifah Orchestra in 2007.

SALT-N-PEPA

Salt-N-Pepa specialized in spicy rhymes with a dash of humor; hits like "Push It" from their 1986 debut album, *Hot, Cool & Vicious*, helped the pair elbow their way into hip-hop's men's club. "We broke down a lot of doors," said Sandi "Pepa" Denton. "People started recognizing females can sell records." **BACK ON THE RACK** Estranged since an acrimonious 2001 breakup, Denton, 44, and Cheryl "Salt" James, 42, who quit the group in order to battle bulimia and depression, reunited in 2007 for VH1's *The Salt-N-Pepa Show*.

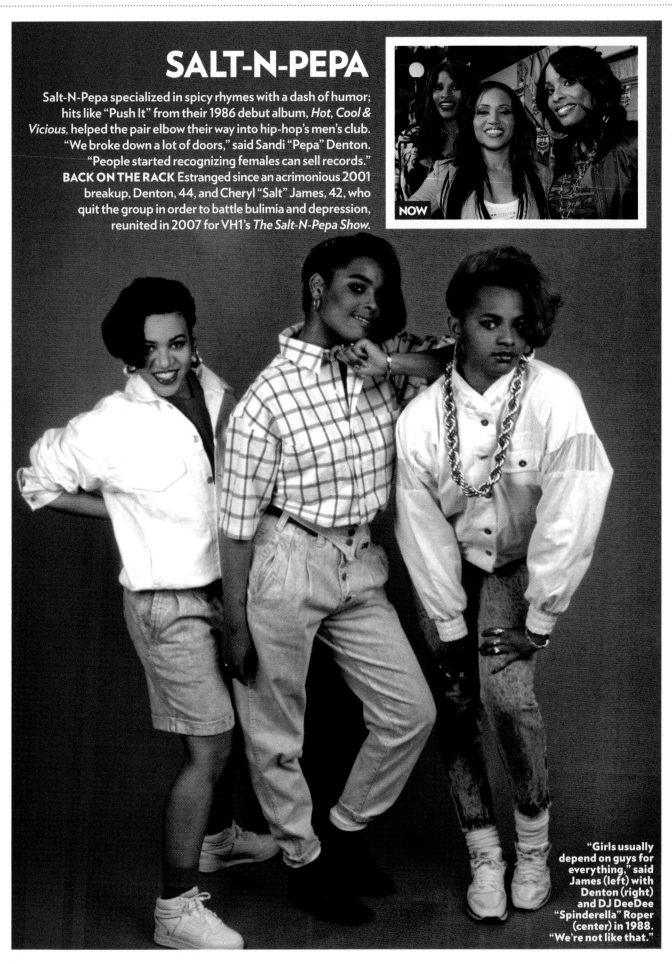

NOW

"Girls usually depend on guys for everything," said James (left) with Denton (right) and DJ DeeDee "Spinderella" Roper (center) in 1988. "We're not like that."

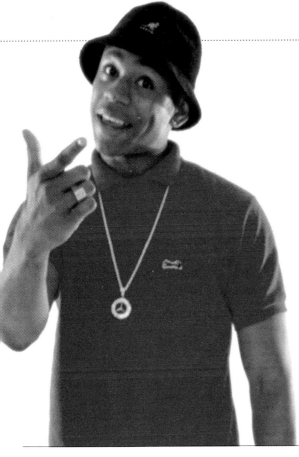

LL COOL J

NOW

"LL is a statement of fact," a friend of 18-year-old James Todd Smith said of the new rap sensation in 1986. "Ladies Love Cool J." That included not only teenage fans but also his grandmother, in whose basement in Queens, N.Y., LL had been making tapes since he was 11. "It was something I seemed to get on to real quick," LL said of the new music that would soon enrapture kids from coast to coast. "I was real good at making up rhymes and scenes." And making himself heard: "He was never a quiet boy," his grandma said. "He always had a mouth."

ADDICTED TO LOVE

A mannequin remembers: Model Mak Gilchrist recalls the making of Robert Palmer's iconic video, one of a handful that helped define MTV

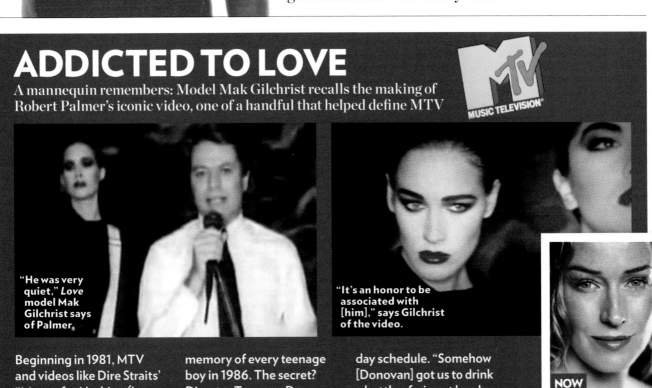

"He was very quiet," *Love* model Mak Gilchrist says of Palmer.

"It's an honor to be associated with [him]," says Gilchrist of the video.

NOW

Gilchrist, 43, has been working as a model for 25 years.

Beginning in 1981, MTV and videos like Dire Straits' "Money for Nothing (I Want My MTV)" and Peter Gabriel's *Sledgehammer* changed the way stars were made and music was sold. Smooth blues-rocker Robert Palmer's *Addicted to Love* was another MTV heavy-rotation sensation, burned forever into the memory of every teenage boy in 1986. The secret? Director Terrence Donovan backed the understated Palmer with five models wearing tight dresses and come-hither—right *now*!—looks. "It was the most efficient of video shoots," recalls Mak Gilchrist, *Addicted*'s blue-eyed bassist, of the one-day schedule. "Somehow [Donovan] got us to drink a bottle of wine at lunch, and we were totally tipsy." That and the quasi-Kabuki makeup gave the quintet the "showroom mannequin" look he wanted. "I think most of the takes come from the afternoon because we've got slightly glazed eyes at that stage," she says.

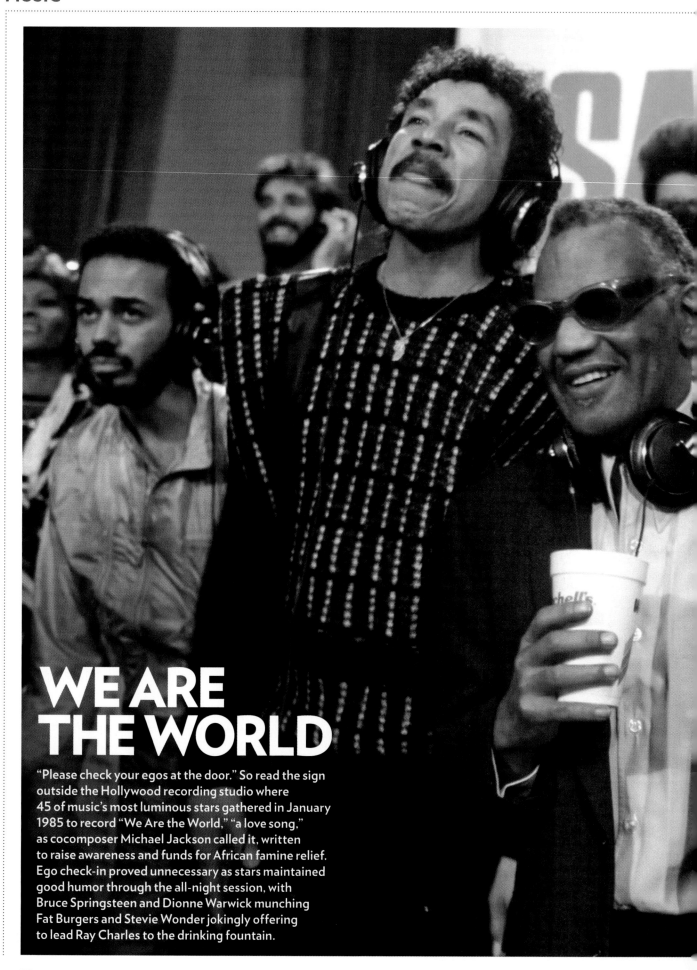

WE ARE THE WORLD

"Please check your egos at the door." So read the sign outside the Hollywood recording studio where 45 of music's most luminous stars gathered in January 1985 to record "We Are the World," "a love song," as cocomposer Michael Jackson called it, written to raise awareness and funds for African famine relief. Ego check-in proved unnecessary as stars maintained good humor through the all-night session, with Bruce Springsteen and Dionne Warwick munching Fat Burgers and Stevie Wonder jokingly offering to lead Ray Charles to the drinking fountain.

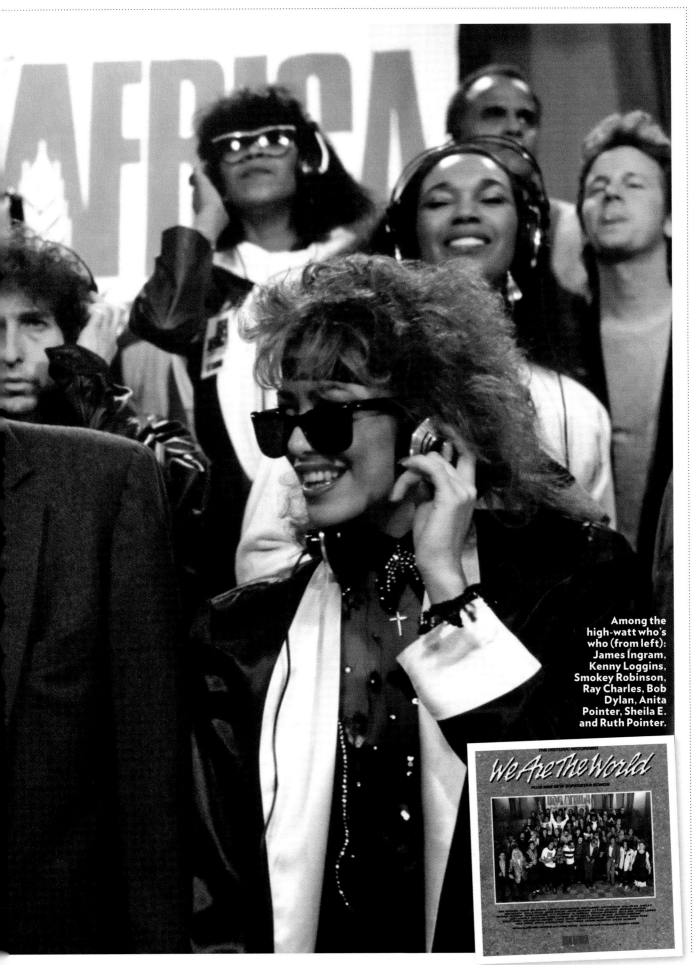

Among the high-watt who's who (from left): James Ingram, Kenny Loggins, Smokey Robinson, Ray Charles, Bob Dylan, Anita Pointer, Sheila E. and Ruth Pointer.

83

WHO SANG IT (IN WHAT SONG)?

"Let me hear your body talk." 2

"Why don't you hit me with your best shot? Fire awayyyyy." 4

"I'm not the kind of girl who gives up just like that, oh, no!" 1

"Do you really want to love me forever (oh oh oh)? Or am I caught in a hit and run?" 3

A
Pat Benatar
Hit Me with Your Best Shot

B
Debbie Harry
The Tide Is High

C
Rick James
Super Freak

D
Wham!
Wake Me Up Before You Go-Go

E
Olivia Newton-John
Let's Get Physical

F
Jon Bon Jovi
Wanted Dead or Alive

"Fame! I'm gonna live forever!"

5

"I've seen a million faces, and I've rocked them all."

8

"Watch out, boy, she'll chew you up!"

11

"Don't leave me hanging on like a yo-yo."

6

"She's a very kinky girl. The kind you don't take home to mother."

9

"What's love got to do with it? What's love but a second-hand emotion?"

12

"How will I know if he really loves me?"

7

"Where can I find a woman like that?"

10

G Tina Turner *What's Love Got to Do with It?*

K Rick Springfield *Jesse's Girl*

I Paula Abdul *Straight Up*

H Hall & Oates *Maneater*

J Irene Cara *Fame*

L Whitney Houston *How Will I Know?*

FACES OF THE '80s

*They weren't actors or politicians, but **GRACE JONES**, Dr. Ruth and others left their mark on the decade*

Her disco albums *Nightclubbing* and *Slave to the Rhythm*? Seldom played nowadays, alas. But Grace Jones' face—captured often in instantly recognizable, highly stylized photos throughout the decade? Unforgettable. Jones, 56, planned to release a new album, *Hurricane*, in the fall.

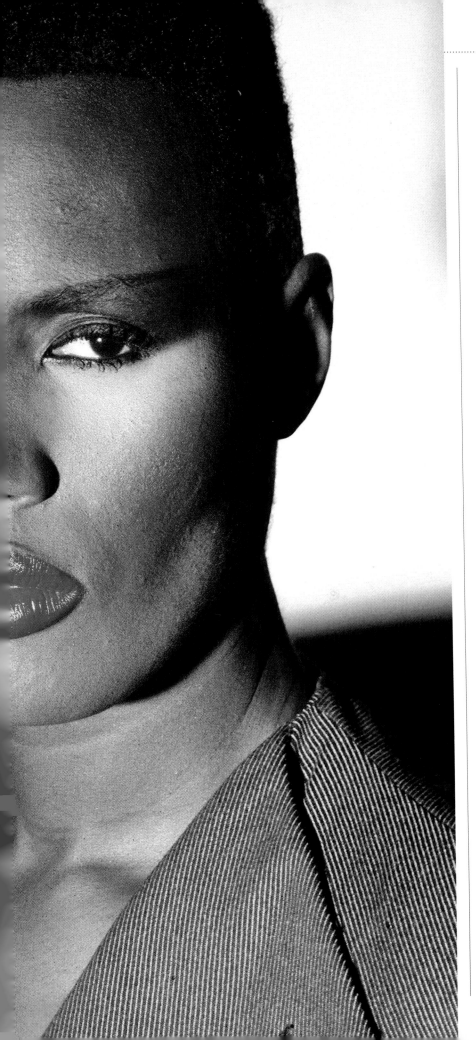

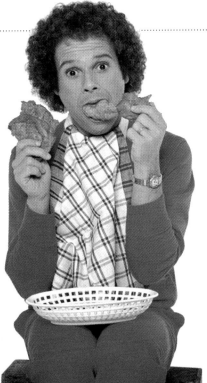

RICHARD SIMMONS

After publishing two bestselling diet books, a workout CD (1982's *Reach*) and hosting his own TV show, the hyperkinetic, white-shorts-wearing workout zealot debuted a 1988 video that became a Simmons classic: *Sweatin' to the Oldies*.

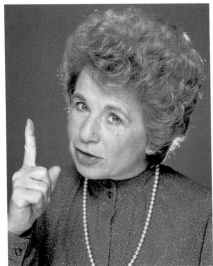

DR. RUTH

Dr. Ruth's no-holds-barred, all-details-fully-explained talk show, *Sexually Speaking,* made the grandmotherly 4'7" sex guru a sensation.

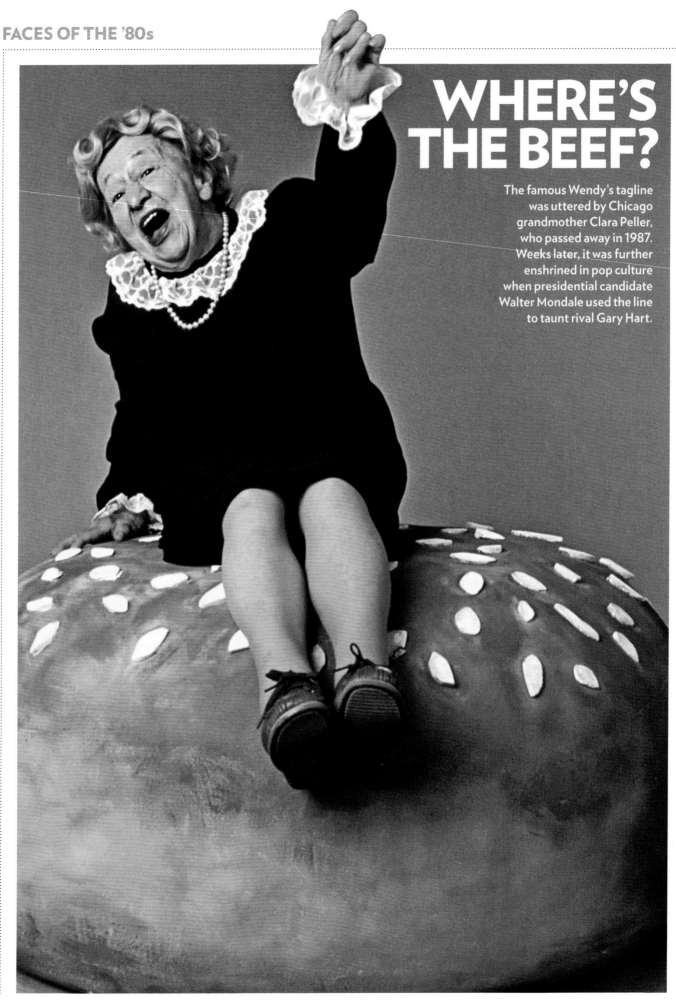

WHERE'S THE BEEF?

The famous Wendy's tagline was uttered by Chicago grandmother Clara Peller, who passed away in 1987. Weeks later, it was further enshrined in pop culture when presidential candidate Walter Mondale used the line to taunt rival Gary Hart.

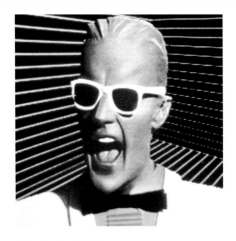

MAX HEADROOM

"Max got marriage proposals," says actor Matt Frewer of his futuristic, computer-generated Cinemax talk show host. "People thought he was real!"

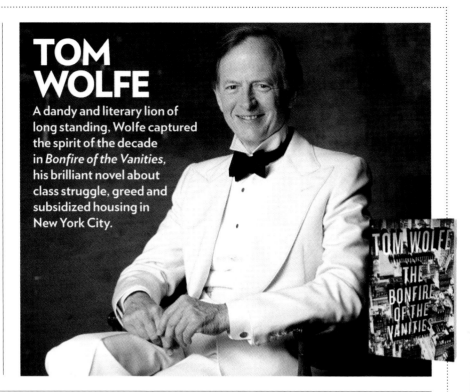

TOM WOLFE

A dandy and literary lion of long standing, Wolfe captured the spirit of the decade in *Bonfire of the Vanities*, his brilliant novel about class struggle, greed and subsidized housing in New York City.

TRENDS, FADS & GOTTA HAVES

The toys and gadgets that made millions in the '80s: If you were a parent, this was the stuff you tripped over.

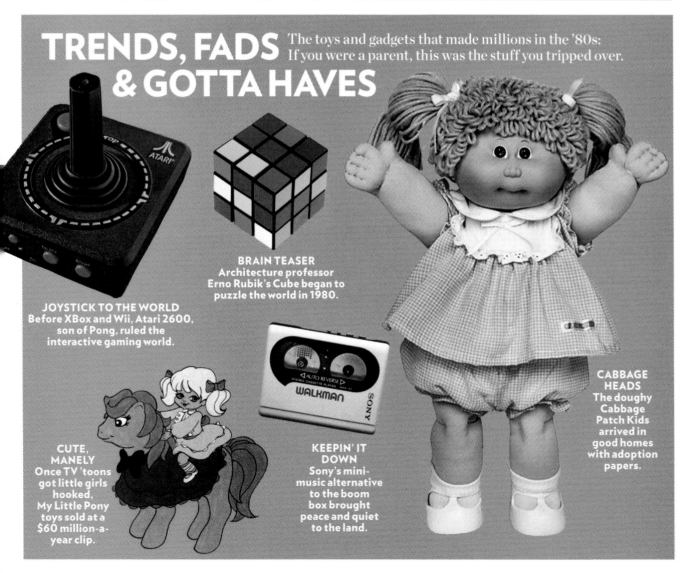

BRAIN TEASER
Architecture professor Erno Rubik's Cube began to puzzle the world in 1980.

JOYSTICK TO THE WORLD
Before XBox and Wii, Atari 2600, son of Pong, ruled the interactive gaming world.

CUTE, MANELY
Once TV 'toons got little girls hooked, My Little Pony toys sold at a $60 million-a-year clip.

KEEPIN' IT DOWN
Sony's mini-music alternative to the boom box brought peace and quiet to the land.

CABBAGE HEADS
The doughy Cabbage Patch Kids arrived in good homes with adoption papers.

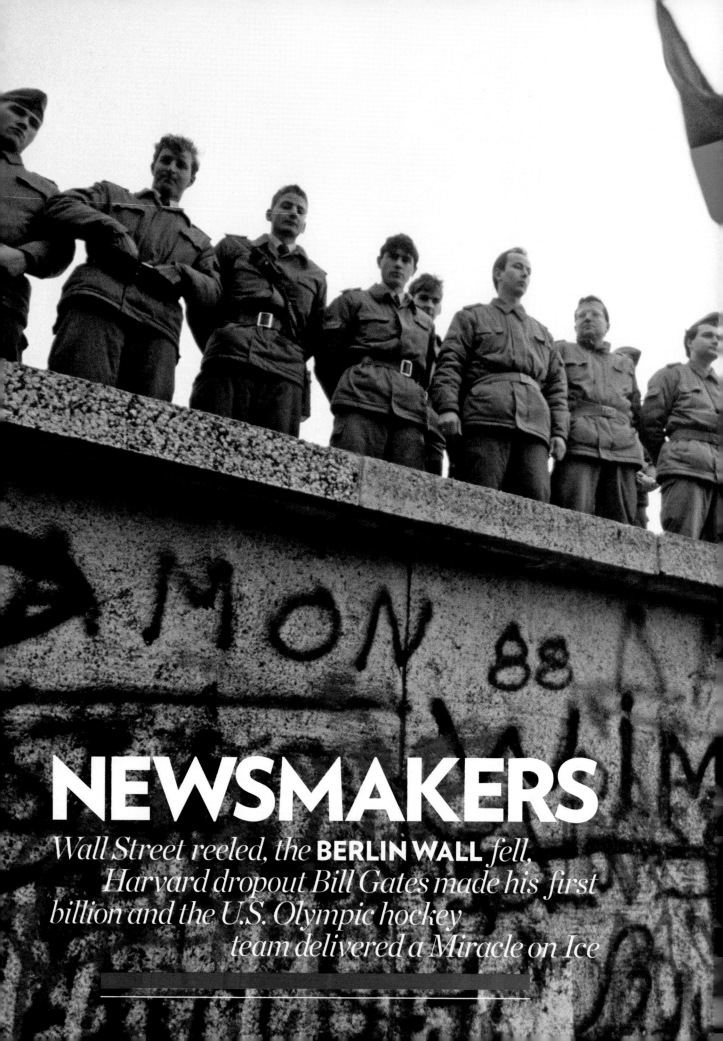

NEWSMAKERS

Wall Street reeled, the **BERLIN WALL** *fell,*
Harvard dropout Bill Gates made his first
billion and the U.S. Olympic hockey
team delivered a Miracle on Ice

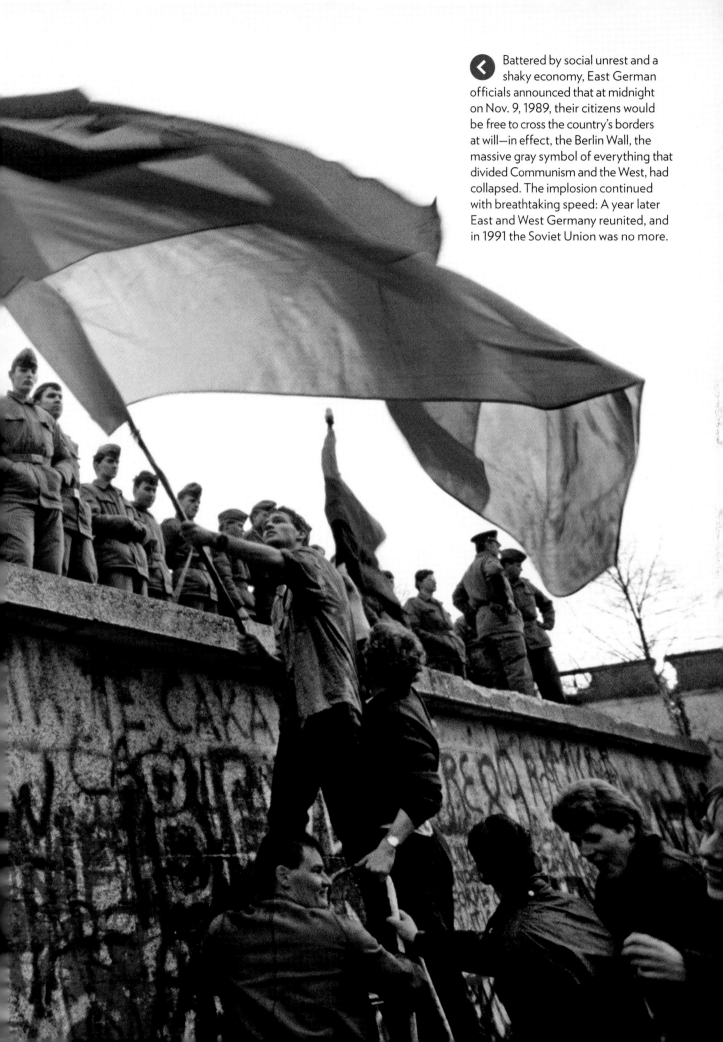

Battered by social unrest and a shaky economy, East German officials announced that at midnight on Nov. 9, 1989, their citizens would be free to cross the country's borders at will—in effect, the Berlin Wall, the massive gray symbol of everything that divided Communism and the West, had collapsed. The implosion continued with breathtaking speed: A year later East and West Germany reunited, and in 1991 the Soviet Union was no more.

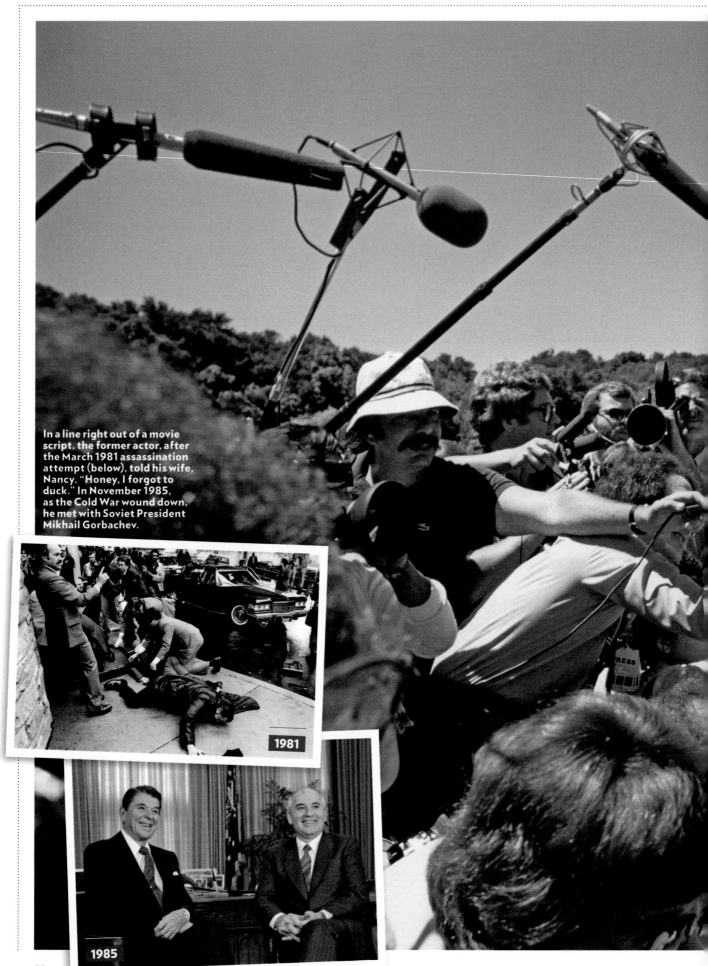

In a line right out of a movie script, the former actor, after the March 1981 assassination attempt (below), told his wife, Nancy, "Honey, I forgot to duck." In November 1985, as the Cold War wound down, he met with Soviet President Mikhail Gorbachev.

1981

1985

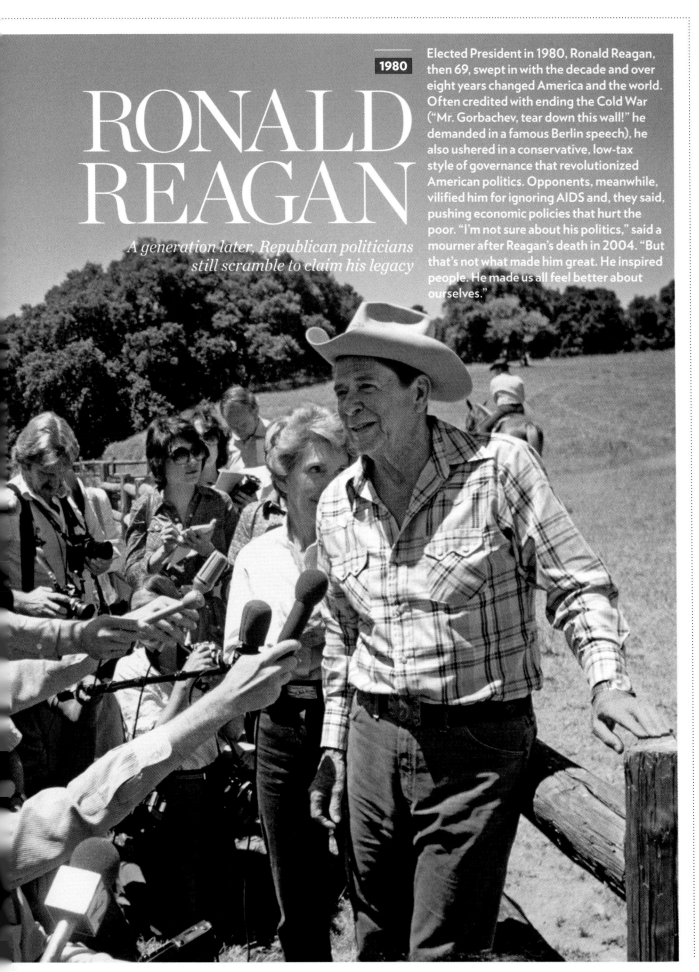

RONALD REAGAN

A generation later, Republican politicians still scramble to claim his legacy

Elected President in 1980, Ronald Reagan, then 69, swept in with the decade and over eight years changed America and the world. Often credited with ending the Cold War ("Mr. Gorbachev, tear down this wall!" he demanded in a famous Berlin speech), he also ushered in a conservative, low-tax style of governance that revolutionized American politics. Opponents, meanwhile, vilified him for ignoring AIDS and, they said, pushing economic policies that hurt the poor. "I'm not sure about his politics," said a mourner after Reagan's death in 2004. "But that's not what made him great. He inspired people. He made us all feel better about ourselves."

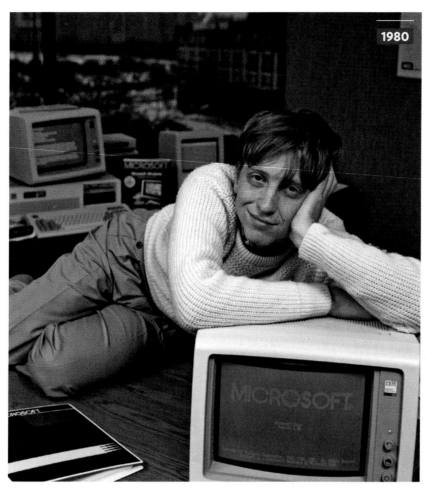

1980

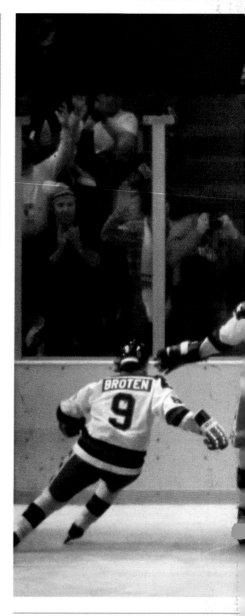

BILL GATES

The geek god was 24 when the decade started and a billionaire seven years later

He dropped out of Harvard at 19 to sell innovative PC software he'd written; when his company, Microsoft, went public in 1986 his net worth jumped more than $300 million overnight. He still looked like your best friend's tag-along younger brother, but the nerd veneer hid a voracious competitor. "I give people a hard time," he admitted. "When they come to meetings they'd better be ready to respond to my questions in real time and at high bandwidth." (Translation: "Tell me now and tell me everything.") What should competitors do? "There are great opportunities," he said, and gave examples. "But you'd better try to make me and the rest of the industry look dumb. Whatever big opportunities I see are sure to show up in Microsoft's products." Now worth an estimated $58 billion, Gates, 52, stepped down from day-to-day activities at Microsoft in July 2008 to work on global charitable projects.

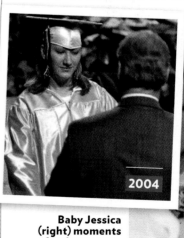

2004

Baby Jessica (right) moments after her rescue, and a grown-up Jessica McClure (above) at her high school graduation.

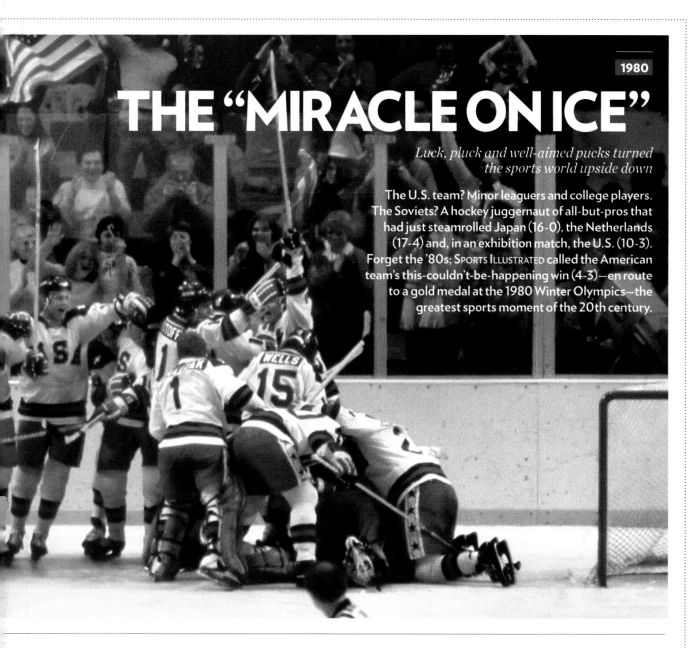

THE "MIRACLE ON ICE"

Luck, pluck and well-aimed pucks turned the sports world upside down

The U.S. team? Minor leaguers and college players. The Soviets? A hockey juggernaut of all-but-pros that had just steamrolled Japan (16-0), the Netherlands (17-4) and, in an exhibition match, the U.S. (10-3). Forget the '80s; Sports Illustrated called the American team's this-couldn't-be-happening win (4-3)—en route to a gold medal at the 1980 Winter Olympics—the greatest sports moment of the 20th century.

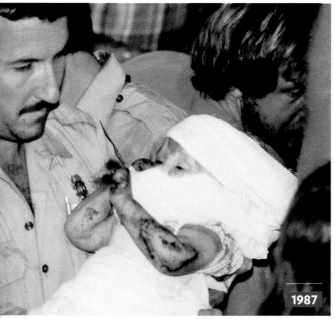

SMALL SURVIVOR

When Texas tot Jessica McClure fell down a well, the nation held its breath for 58 hours

It all started when 18-month-old Jessica McClure, toddling in her aunt's Midland, Texas, backyard, fell down an 8-inch-wide abandoned well (exactly how has never been clear; family and friends say the hole had been covered). For more than two days, as dozens of rescuers bored an access route through solid rock, reporters provided breathless updates to an audience that eventually grew to millions in the U.S. and around the world. Her rescue 58 hours later brought a national sigh of relief, and a picture of her being carried to an ambulance earned a Pulitzer for *Odessa American* photographer Scott Shaw. McClure, now 22 and married with a son, still lives in Midland and has no memory of her ordeal.

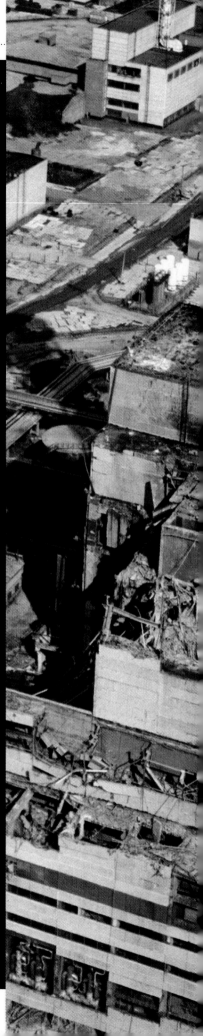

Chernobyl after the disaster: The accident raised new concerns over the safety of nuclear power plants.

1986

CHERNOBYL'S BIG BLAST

Hoping to keep the catastrophe secret, the Soviets said nothing and waited three days before evacuating nearby residents after the worst nuclear accident in history

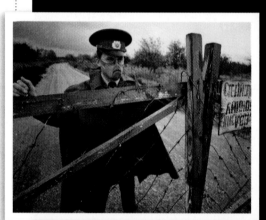

The explosion and fire at the Soviet Union's Chernobyl nuclear plant on April 26, 1986, contaminated food-and-water supplies for tens of thousands of square miles and spread wind-borne radioactive dust to Eastern Europe and Scandinavia. The effects were also felt in the United States, where detectors found traces of iodine 131—but not enough to cause serious health problems—in rainwater. The blast killed 30 people almost instantly and produced 400 times more fallout than had been released by the atomic bombing of Hiroshima. And yet Soviet officials were reluctant to ask for help at first, let alone publicize the problem. A few days after the blast, they did tell residents of Kiev, about 80 miles from the site, to wash often and keep their windows closed. The accident raised worldwide concerns about the safety of Soviet nuclear plants, slowing their expansion and forcing the government to become less secretive about its operations.

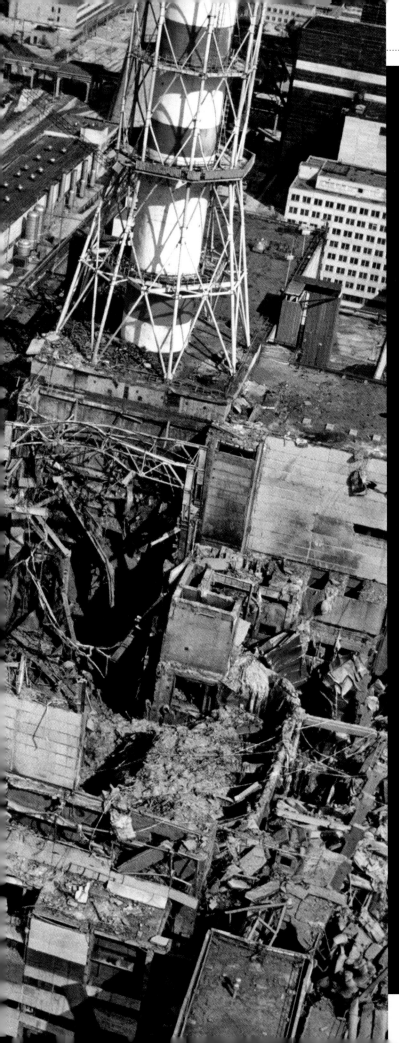

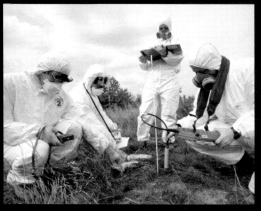

Environmental Damage
Though cesium-137 from the explosion poisoned about a fourth of the arable land in what is now Belarus, the government wants to renew farming in the area, advocating soil tilling to bury radioactive particles beneath crop roots.

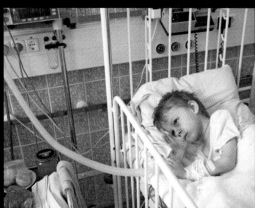

Long-Term Health Problems
A United Nations panel found that contrary to initial forecasts, there was no rise in leukemia, a blood cancer associated with radiation exposure. "The mental-health impact"—overwhelming anxiety—remains the biggest health issue.

Growing Body Count
Though officials at first predicted tens of thousands of cancer-related deaths traceable to Chernobyl, a United Nations report in 2005 said that about 4,000 deaths will most likely be ultimately attributed to the accident.

1983

MURDER IN THE SKY

The Soviet Union's shooting down of a Korean jetliner— and its attempts to dodge blame—shock the world

On Sept. 1, in a murderous moment that encapsulated the West's worst Cold War fears, the Soviet Union, without warning, shot down Korean Airlines Flight 007, which had accidentally strayed into Soviet territory, killing all 269 people aboard. Unrepentant, the U.S.S.R. further stunned the world in the immediate aftermath by at first denying responsibility and then grudgingly admitting only that it "fired warning shots" at a plane that had "rudely violated the state border." (Intercepted Soviet radio traffic, however, captured a Soviet commander ordering, "Take aim" and "Fire" and a pilot replying, "We shot it down.") The U.S. representative at an emergency meeting of the U.N. Security Council called the incident "wanton, calculated, deliberate murder." The Soviet representative stared into space.

A illustration from the era shows the types of planes involved.

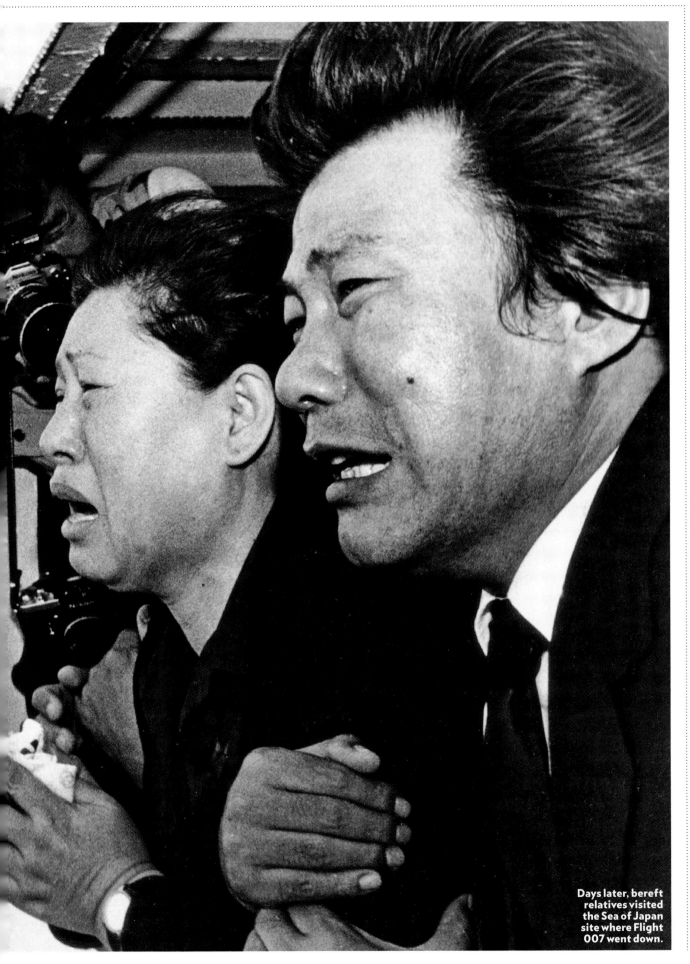

Days later, bereft relatives visited the Sea of Japan site where Flight 007 went down.

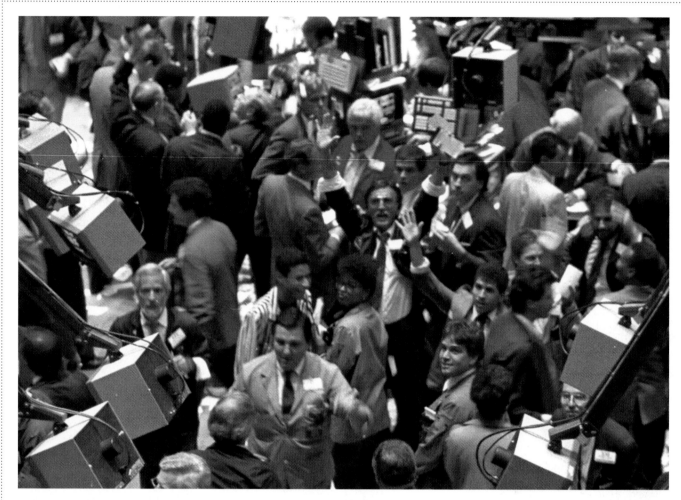

WILD, WILD WALL STREET

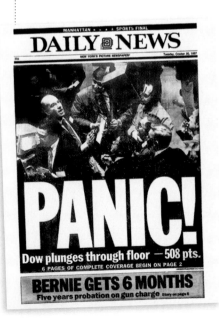

It's up! It's down! He's a genius! He's a crook! Wall Street came to Main Street, and its stars—for better or worse—made front-page news

After a five-year surge in stock prices, Wall Street knew it was time for a correction. But nobody predicted what happened on Oct. 19, 1987, now forever infamous as Black Monday: The Dow Jones Industrial Average fell 22.6 percent, the largest one-day drop since 1914 and the second-largest of all time. Some blamed program trading, in which computers could buy and sell faster than ever before. Others blamed international disputes over foreign exchange and interest rates. It took two years for the wobbly Dow to get back to its precrash levels.

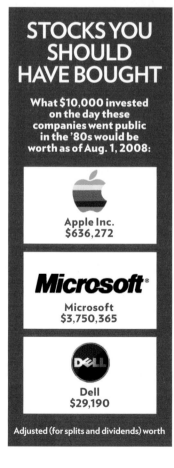

STOCKS YOU SHOULD HAVE BOUGHT

What $10,000 invested on the day these companies went public in the '80s would be worth as of Aug. 1, 2008:

Apple Inc.
$636,272

Microsoft
$3,750,365

Dell
$29,190

Adjusted (for splits and dividends) worth

FINANCIAL WIZARDS TO FAMOUS FELONS

"Greed is good," Michael Douglas famously trumpeted in the 1987 film *Wall Street*. In fact, he was only parroting real-life Wall Street superstar Ivan Boesky, who used almost those exact words—"I think greed is healthy"—in a 1985 commencement address at the University of California-Berkeley's business school. For Boesky, greed certainly worked—for a while. The publicity-loving risk arbitrageur is said to have earned about $65 million when Chevron swallowed Gulf, $50 million when Texaco bought Getty and $50 million when Philip Morris acquired General Foods. Boesky claimed to work 20-hour days, standing in front of the computers and phones at his desk, decoding the secrets of big business. But as became clear after his headline-making arrest and trial, Boesky was at the center of an enormous insider-trading scandal. He was eventually fined $50 million, ordered to pay another $50 million in restitution, banned from securities for the rest of his life and sentenced to three years in jail (he was paroled after two). Boesky's fall begat the decade's other great Wall Street meltdown: Michael Milken.

A hotshot bond trader at Drexel Burnham Lambert, Milken had concluded that broad portfolios of high-yield bonds issued by small and medium-size corporations—though rated as high risk—were safer than bonds issued by FORTUNE 500 firms. He made a fortune creating a broad market for these so-called "junk bonds," then used the money to back corporate raiders taking over such businesses as National Can, TWA, Revlon and Beatrice. On March 29, 1989, a federal grand jury indicted him on 98 counts, including conspiracy, securities fraud and tax evasion. As part of his plea bargain agreement, Milken paid $200 million in fines and was sentenced to 10 years in prison—though he served less than two. Drexel Burnham went out of business.

Boesky, 71, of La Jolla, Calif., made news in 2007 with a donation to Hillary Clinton's presidential campaign. Milken, 62, funds various research foundations.

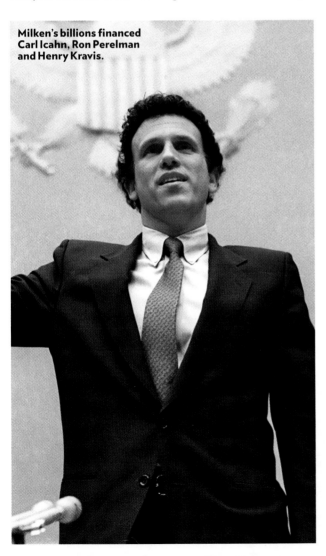

Milken's billions financed Carl Icahn, Ron Perelman and Henry Kravis.

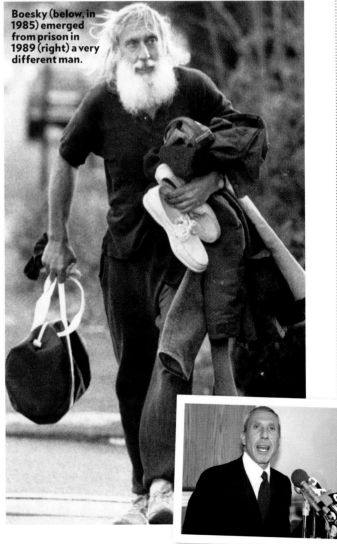

Boesky (below, in 1985) emerged from prison in 1989 (right) a very different man.

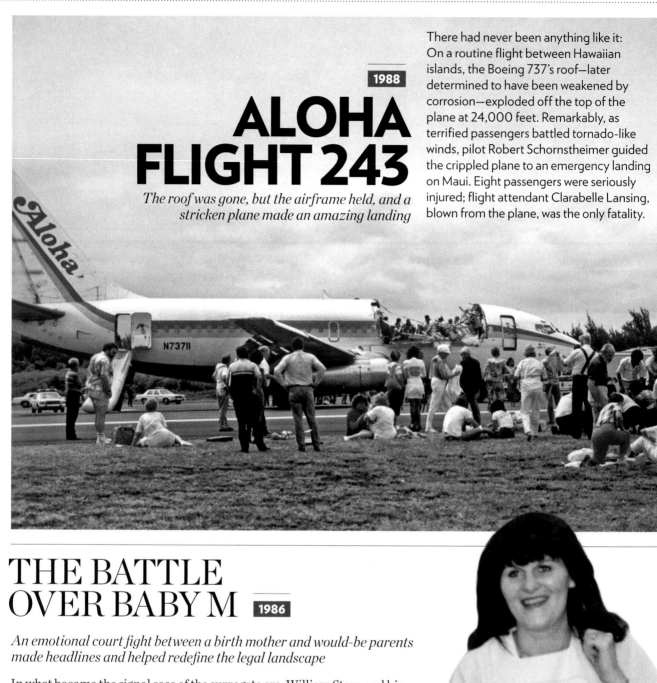

1988
ALOHA FLIGHT 243

The roof was gone, but the airframe held, and a stricken plane made an amazing landing

There had never been anything like it: On a routine flight between Hawaiian islands, the Boeing 737's roof—later determined to have been weakened by corrosion—exploded off the top of the plane at 24,000 feet. Remarkably, as terrified passengers battled tornado-like winds, pilot Robert Schornstheimer guided the crippled plane to an emergency landing on Maui. Eight passengers were seriously injured; flight attendant Clarabelle Lansing, blown from the plane, was the only fatality.

THE BATTLE OVER BABY M 1986

An emotional court fight between a birth mother and would-be parents made headlines and helped redefine the legal landscape

In what became the signal case of the surrogate era, William Stern and his wife, Elizabeth, both 41, a childless New Jersey couple, contracted with housewife Mary Beth Whitehead, then 27, to be artificially inseminated with William's sperm and give the resulting child to the Sterns. But when the infant was born, Whitehead decided to keep it, setting off an emotional legal battle. In the end, New Jersey courts voided the surrogate contract and awarded custody to the Sterns and visitation rights to Whitehead. When she turned 18 in March 2004, the once-anonymous "Baby M," now known as Melissa Stern, reportedly terminated Whitehead's parental rights. "I love my family very much and am very happy to be with them," she told the *New Jersey Monthly.* "I love them, they're my best friends in the whole world, and that's all I have to say about it."

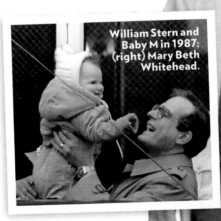

William Stern and Baby M in 1987; (right) Mary Beth Whitehead.

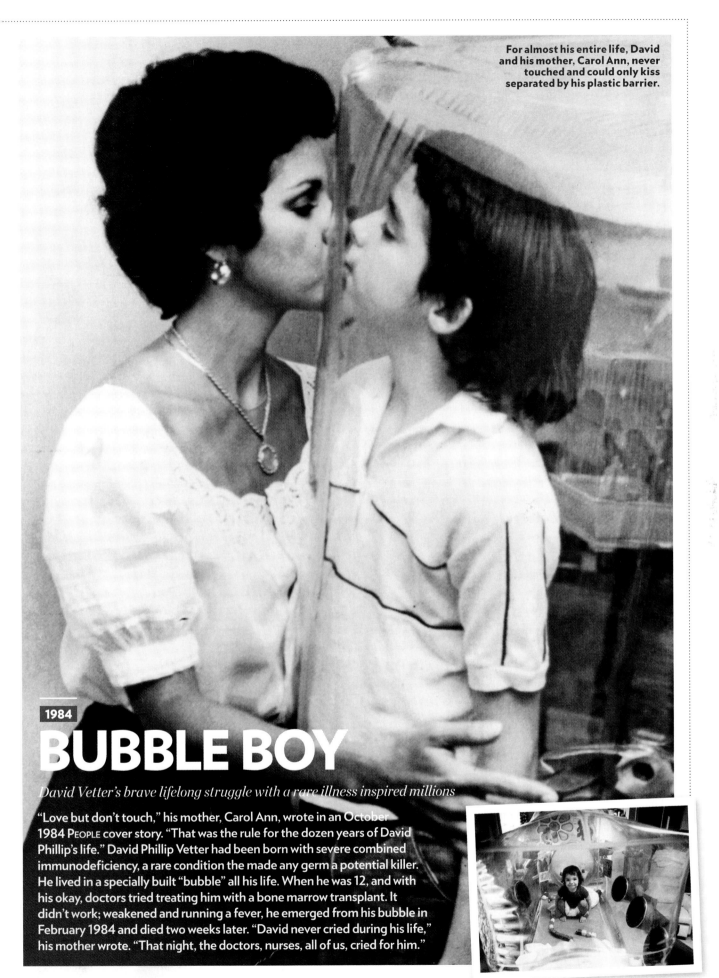

For almost his entire life, David and his mother, Carol Ann, never touched and could only kiss separated by his plastic barrier.

1984
BUBBLE BOY

David Vetter's brave lifelong struggle with a rare illness inspired millions

"Love but don't touch," his mother, Carol Ann, wrote in an October 1984 PEOPLE cover story. "That was the rule for the dozen years of David Phillip's life." David Phillip Vetter had been born with severe combined immunodeficiency, a rare condition the made any germ a potential killer. He lived in a specially built "bubble" all his life. When he was 12, and with his okay, doctors tried treating him with a bone marrow transplant. It didn't work; weakened and running a fever, he emerged from his bubble in February 1984 and died two weeks later. "David never cried during his life," his mother wrote. "That night, the doctors, nurses, all of us, cried for him."

SCANDALS

Sex, crime and politics threw the Mayflower Madam, Jim and Tammy Faye Bakker and **LT. COL. OLIVER NORTH** *into the public spotlight*

He was the true-believer National Security Council operative accused of trading arms for hostages and diverting funds; she was the faithful secretary who smuggled secret documents in her boots. In the end Lt. Col. Oliver North was convicted of nothing in the complicated Iran-Contra affair; today, age 65, he is a syndicated columnist and a grandfather of 11. Fawn Hall married former Doors manager Danny Sugarman, became addicted to crack and cleaned up. Now 49, she has recently been working in an L.A. bookstore.

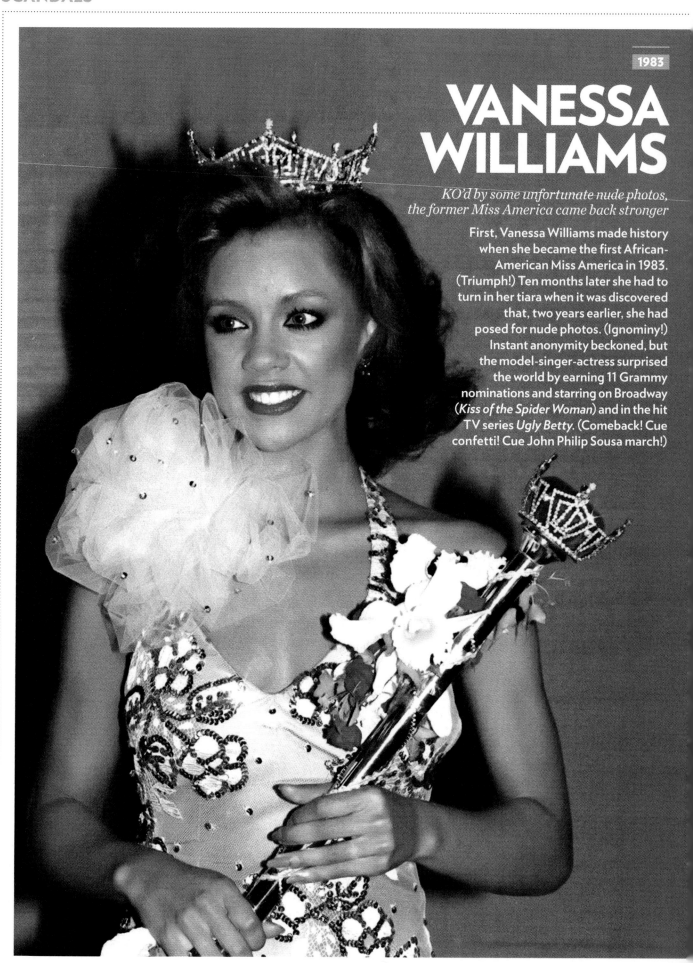

VANESSA WILLIAMS

KO'd by some unfortunate nude photos, the former Miss America came back stronger

First, Vanessa Williams made history when she became the first African-American Miss America in 1983. (Triumph!) Ten months later she had to turn in her tiara when it was discovered that, two years earlier, she had posed for nude photos. (Ignominy!) Instant anonymity beckoned, but the model-singer-actress surprised the world by earning 11 Grammy nominations and starring on Broadway (*Kiss of the Spider Woman*) and in the hit TV series *Ugly Betty*. (Comeback! Cue confetti! Cue John Philip Sousa march!)

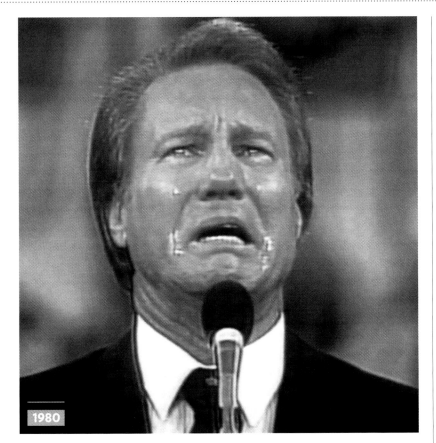

1980

JIMMY SWAGGART

After casting the first stone, and the second,
a televangelist gets caught with a hooker

"I have sinned against you, my Lord," sobbed Jimmy Swaggart in front of a congregation of 8,000 at his cathedral-size Family Worship Center in Baton Rouge, La. One of America's leading televangelists—his audience reached 2 million households in 1985—Swaggart came undone when he was photographed consorting with a prostitute at a New Orleans motel in October 1987. It was a ripe time for evangelical hanky-panky. The photo surveillance came courtesy of Marvin Gorman, a rival who had been defrocked when Swaggart accused him of infidelity. (Gorman later won $10 million in defamation damages.) And Swaggart's confession came only a few months after he bitterly denounced evangelist Jim Bakker for having an adulterous dalliance with a church secretary. His own troubles did little to modify Swaggart's sense of self-importance. "I'm not looking back," he said, cutting short a church suspension, "I still believe that tens of millions of people are going to be saved." Despite another bust with a prostitute in 1991 and an incendiary statement about homosexuals ("If one ever looks at me like that, I'm going to kill him and tell God he died"), Swaggart, 73, is still standing. He may no longer travel the world in a private jet or attend policy briefings at the White House, but Jimmy Swaggart Ministries maintains a national following, with services carried on radio and cable TV.

MAYFLOWER MADAM

Oldest profession meets proper,
preppy entrepreneur

Sydney Biddle Barrows, 32, was just another upper-crusty New Yorker with a blue-blooded pedigree—until October 1984, when police sledgehammered into her office and discovered that, under the name "Sheila Devin," she was running a high-class call-girl service catering to Manhattan's rich and powerful. Dubbed the Mayflower Madam by tabloids, Barrows pleaded guilty to promoting prostitution and was ordered to pay a $5,000 fine, a slap on the wrist that avoided a public trial and possible recitations from her little black book. Uncowed by notoriety, Barrows staged a formal ball to help pay her legal fees and used her infamous moniker as the title of a bestselling 1986 autobiography that was later made into a TV movie starring Candice Bergen. Barrows, now 56, married attorney Darnay Hoffman, 61, in 1994 and makes a living as a writer and public speaker.

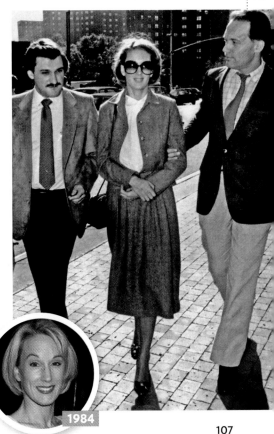

1984

107

1980

JIM & TAMMY FAYE BAKKER

Those lips! Those eyes! That . . . scam! Lust, greed and other, less deadly, sins smite the once-mighty PTL empire

The poster child for hypocritical hucksterism, Jim Bakker built an evangelical empire that included the PTL (for "Praise the Lord") TV network and Heritage USA resort. But all was not as it seemed: The peppy preacher had bilked investors of $150 million and paid church secretary Jessica Hahn (below), with whom he'd had a one-night stand, $265,000 to keep quiet. Jim's spectacularly made-up wife, Tammy Faye, admitted to wild spending and an addiction to prescription drugs. Jim, 68, spent five years in prison, remarried and now preaches from his sprawling Missouri headquarters built for him by a supporter; he still owes the IRS more than $6.1 million. Tammy divorced Jim in 1992 and successfully reinvented herself as a pop icon and supporter of the gay community. She died in 2007.

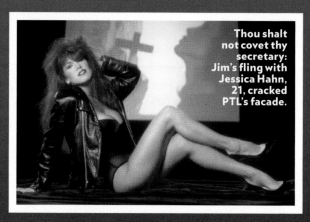

Thou shalt not covet thy secretary: Jim's fling with Jessica Hahn, 21, cracked PTL's facade.

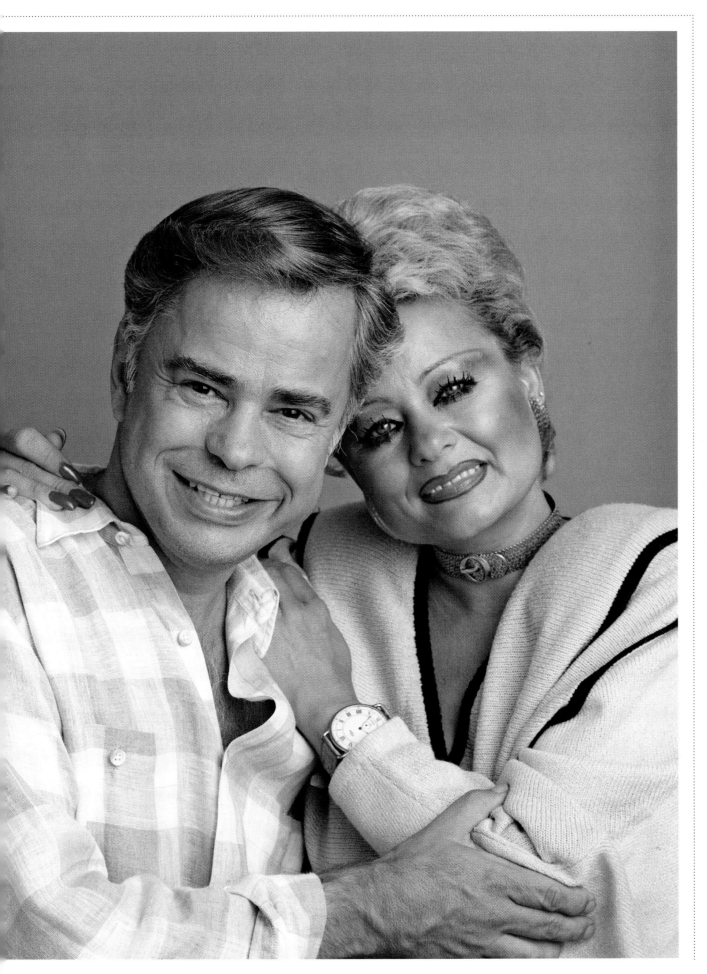

1980

CLAUS VON BULOW

Prosecutors said he tried to kill his wealthy wife; two trials later, he walked

On a typical languid day, Sunny and Claus von Bülow seemed to lead a life straight from the 19th century—strolling the grounds of Clarendon Court, their Newport, R.I., estate, and, tended by a liveried staff, entertaining friends at lavish dinner parties. But on Dec. 21, 1980, Sunny, 49, was found facedown on a bathroom floor in a coma from which she is never expected to recover. Police zeroed in on von Bülow, a dashing gadabout, rejecting his explanation that his wife fell victim to hypoglycemic shock. Prosecutors maintained that he was infatuated with his wife's millions and with another woman, and that he tried to kill Sunny with insulin injections. During his trial, the dapper von Bülow attracted plenty of female fans, but charisma didn't save him from a guilty verdict. Alan Dershowitz, however, did: The Harvard Law professor got the verdict thrown out for technical inconsistencies, and von Bülow was acquitted in a 1985 retrial. Outraged, Sunny's family filed a civil suit, which von Bülow settled in 1988 by agreeing to divorce his wife and abandon any claims to her estate. Now 82, he lives in London, writes theater reviews and hosts parties at his exclusive men's club. Sunny, 77, remains in a persistent vegetative state in a New York nursing home.

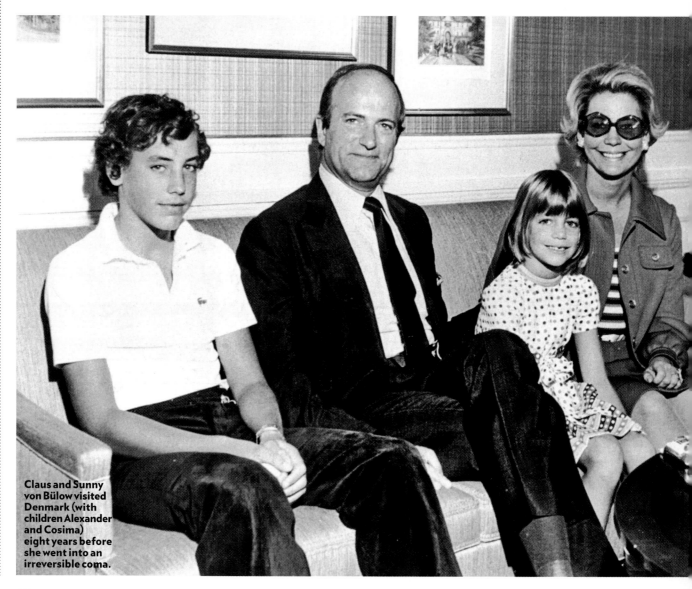

Claus and Sunny von Bülow visited Denmark (with children Alexander and Cosima) eight years before she went into an irreversible coma.

KEY BUSINESS CREW

GARY HART — 1987

Calamitous cruise: a Democratic star undone by Monkey Business

Politically, he defined "implosion." In May 1987, Colorado senator Gary Hart, front-runner for the Democratic presidential nomination, calmly told reporters that rumors of his womanizing were unfounded. "If anyone wants to put a tail on me, go ahead," he said. "They'd be very bored." Then the *Miami Herald* reported that Hart had spent most of a weekend alone in his Capitol Hill townhouse with Donna Rice, 29, a pharmaceutical rep and part-time actress. Days later, word of their overnight cruise aboard a yacht named *Monkey Business* sealed the senator's fate. Poll numbers plummeting, Hart withdrew from the race on May 8. Despite the scandal, Hart, now 72, has remained married to his wife, Lee, also 72, for 50 years and has stayed in the public arena as a teacher, author and consultant. Donna Rice Hughes, now 50, married a technology executive and became a born-again Christian.

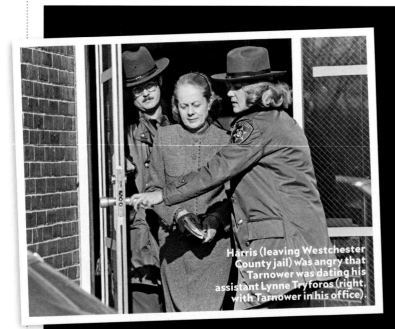

Harris (leaving Westchester County jail) was angry that Tarnower was dating his assistant Lynne Tryforos (right, with Tarnower in his office).

JEAN ▭ 1981 HARRIS

The prim headmistress knew how to use a finger bowl, the proper fork—and a .32

Students nicknamed her Integrity Jean, and no wonder: Headmistress of Virginia's exclusive Madeira School for girls, Jean Harris, 57, personified propriety. Right up until the day she put on a mink coat, drove to see her longtime lover—celebrity cardiologist and Scarsdale Diet doctor Herman Tarnower, 69—and shot him four times at close range. Harris, distraught that her beau of 15 years had begun seeing a younger woman, claimed during her 14-week trial that she had gone to his Westchester County, N.Y., estate on March 10, 1980, planning to kill herself, but that the gun went off accidentally when Tarnower tried to wrestle it away. The jury didn't buy it: Harris was convicted of second-degree murder and sentenced to 15 years to life. In prison she wrote three books and taught parenting classes to inmates before being granted clemency after nearly 12 years by New York governor Mario Cuomo. Harris, 85, now raises tuition money for the children of inmates and lives a quiet life in Hamden, Conn.

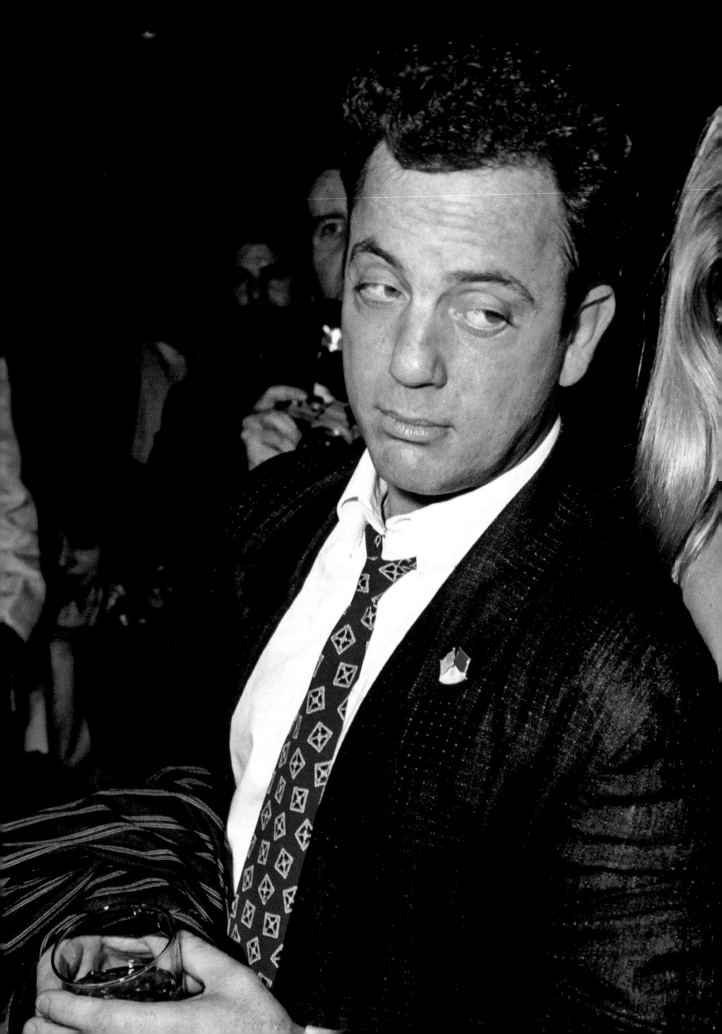

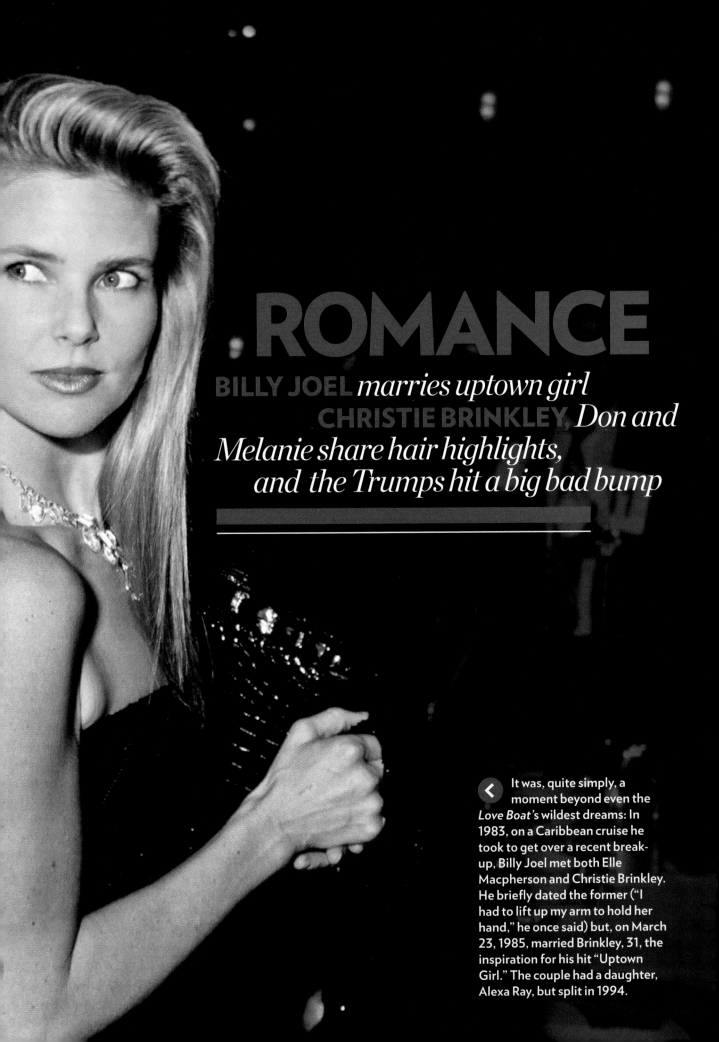

.ROMANCE

BILLY JOEL *marries uptown girl* **CHRISTIE BRINKLEY,** *Don and Melanie share hair highlights, and the Trumps hit a big bad bump*

It was, quite simply, a moment beyond even the *Love Boat's* wildest dreams: In 1983, on a Caribbean cruise he took to get over a recent break-up, Billy Joel met both Elle Macpherson and Christie Brinkley. He briefly dated the former ("I had to lift up my arm to hold her hand," he once said) but, on March 23, 1985, married Brinkley, 31, the inspiration for his hit "Uptown Girl." The couple had a daughter, Alexa Ray, but split in 1994.

GOOD SHOW!

She was a shy 19-year-old kindergarten teacher on the day Buckingham Palace announced the engagement. PEOPLE, in its first story about the upcoming marriage, didn't even mention the name of the little-known bride-to-be—one Lady Diana Spencer—until nearly line 20.

It would be—figuratively, if not literally—the last time she would receive second billing, in PEOPLE or anywhere else.

The wedding of Lady Diana and Great Britain's Prince Charles on July 29, 1981, drew 750 million television viewers and launched her into a world of unprecedented global celebrity in which nearly every aspect of her life—her clothes, her children, the state of her marriage—sparked breathless headlines.

No one, of course, knew then how it would end. "Here," said the Archbishop of Canterbury—echoing, no doubt, the thoughts of the cheering crowds—"is the stuff of which fairy tales are made."

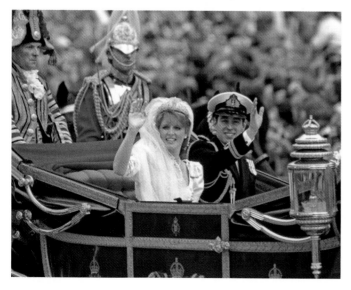

In London, 1 million people lined up to catch a glimpse of Charles and Diana. Five years later, his brother Prince Andrew borrowed the same family carriage for his wedding to Sarah Ferguson (left).

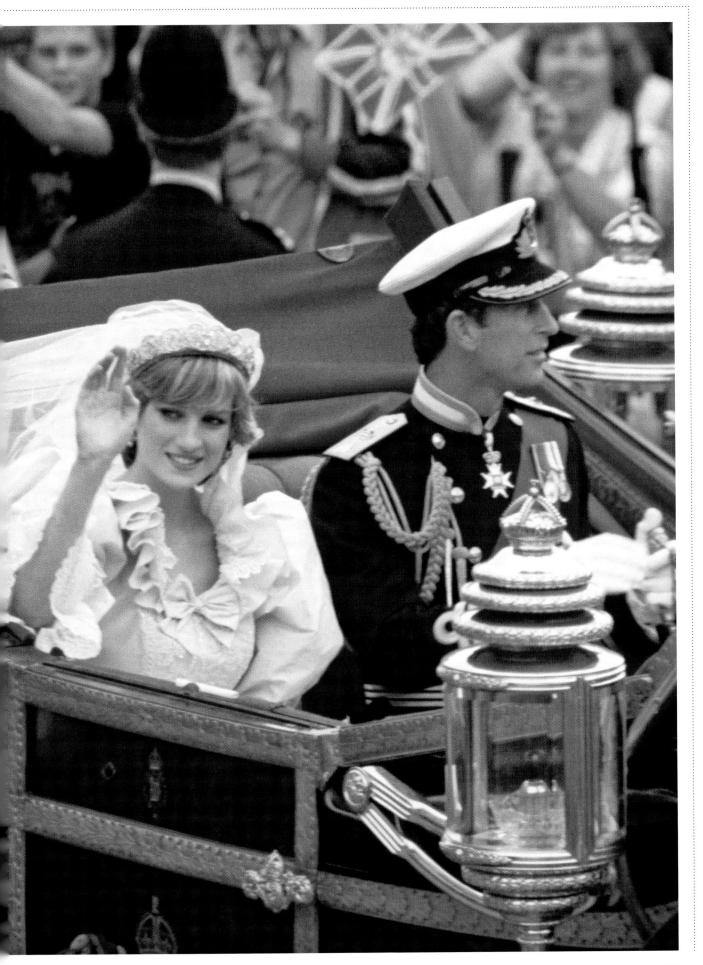

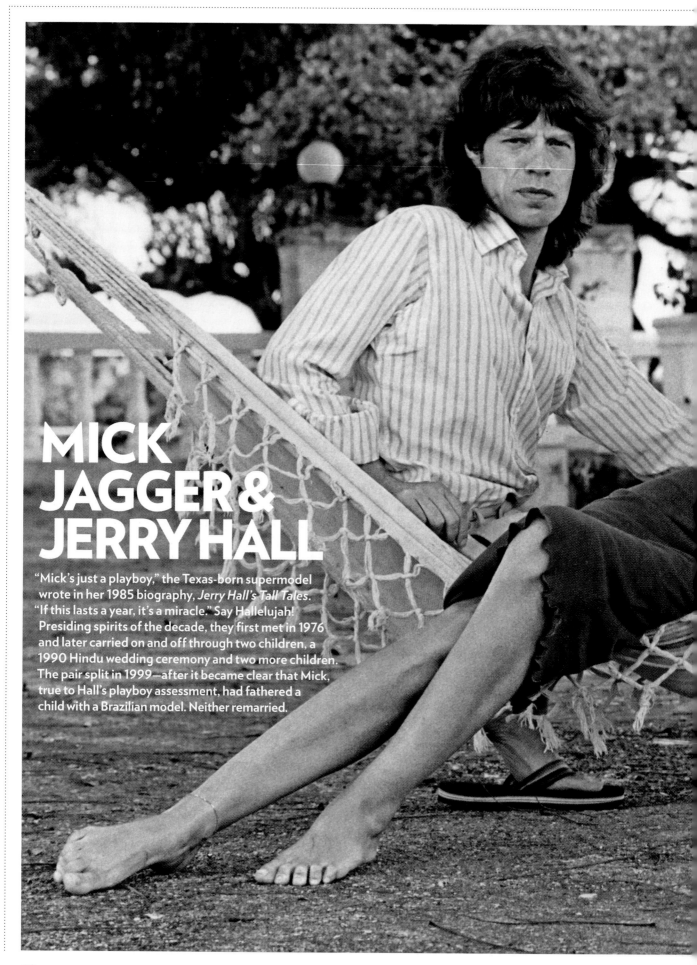

MICK JAGGER & JERRY HALL

"Mick's just a playboy," the Texas-born supermodel wrote in her 1985 biography, *Jerry Hall's Tall Tales*. "If this lasts a year, it's a miracle." Say Hallelujah! Presiding spirits of the decade, they first met in 1976 and later carried on and off through two children, a 1990 Hindu wedding ceremony and two more children. The pair split in 1999—after it became clear that Mick, true to Hall's playboy assessment, had fathered a child with a Brazilian model. Neither remarried.

BURT REYNOLDS & LONI ANDERSON

You know something is going terribly wrong with the marriage when the husband (in this case, macho actor Burt Reynolds) goes on national TV and challenges the wife (sultry Loni Anderson of *WKRP in Cincinnati* fame) to take a Sodium Pentothal test to determine who cheated first. (For the record, he'd already admitted to a two-year affair with a cocktail-lounge manager; she swore she never strayed.) The pair, who had married in 1988, adopted a son, Quinton, and divorced in 1994. Today Reynolds, 72, is single; Anderson, 63, wed folk singer Bob Flick of the '60s folk troubadours the Brothers Four on May 17, 2008.

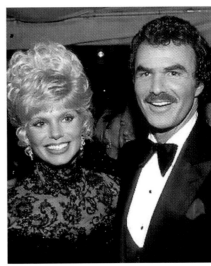

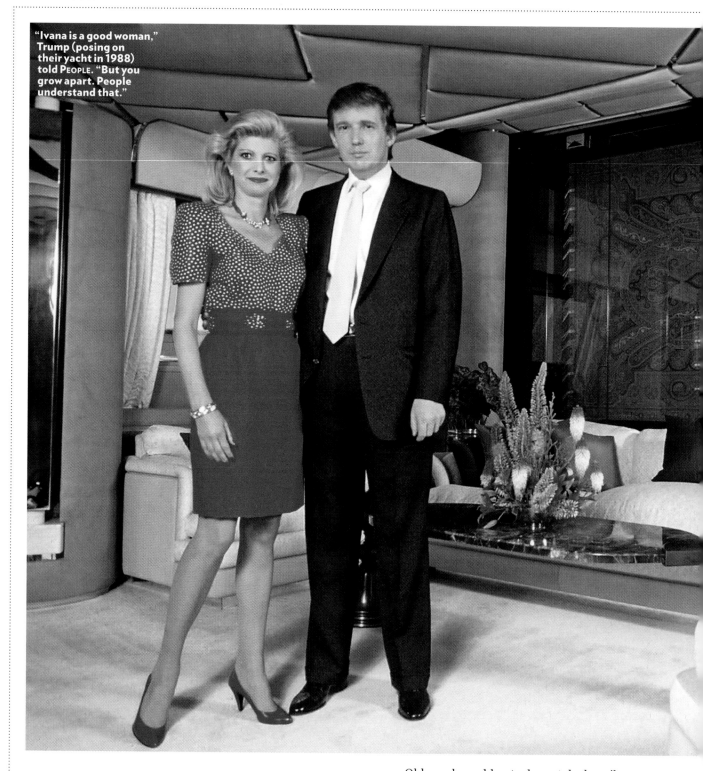

"Ivana is a good woman," Trump (posing on their yacht in 1988) told PEOPLE. "But you grow apart. People understand that."

DONALD TRUMP & IVANA TRUMP

Old words could not adequately describe Donald and Ivana in the '80s, so new ones had to be invented. Words like "Trumptastic!" "Trumplicious!" "Trumpcendent!"

He was the publicity-infatuated investor who made a fortune wheeling and dealing in real estate. She was a gregarious, Czech-born outsider who worked her way into New York's social circles. Following their 1977 marriage, they built an empire around tall buildings, regal hotels, fancy yachts and gem-encrusted casinos and made sure the Trump name was plastered on every one of

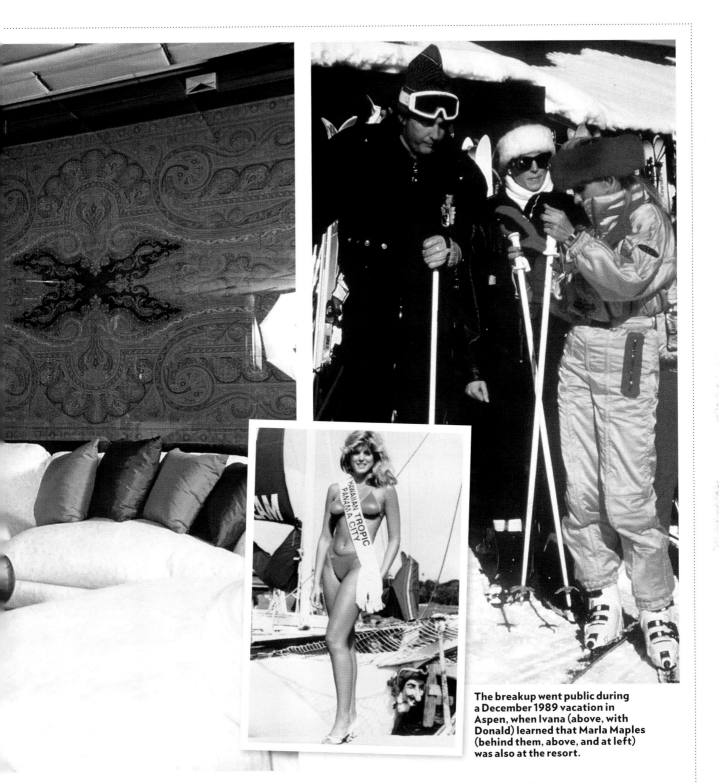

The breakup went public during a December 1989 vacation in Aspen, when Ivana (above, with Donald) learned that Marla Maples (behind them, above, and at left) was also at the resort.

them. They had three children—also branded Trump, of course—and seemed to enjoy having it all. Until "all," for "the Donald" (as Ivana dubbed him), included an alleged affair with a young actress named Marla Maples, which he denied, though they later wed. When a front-page headline in the New York *Daily News* declared Donald and Ivana's love "on the rocks," he issued a terse confirmation, and Ivana began looking at how to crack a prenup that would have given her custody of the kids, possession of the couple's 45-room, $3.7 million Greenwich, Conn., home and a

$25 million settlement. "Twenty-five million?" scoffed one insider. "She can't even do her nails with that." The Donald did not appear worried. "The prenuptial agreement is airtight," he told PEOPLE.

The divorce became final in 1992, the final settlement kept secret. Donald, now 62, married Maples in 1993; they divorced in 1999, and he married model Melania Knauss, 24 years his junior, in 2005. Ivana, now 59, married businessman Riccardo Mazzucchelli in 1993, divorced a year later, then married actor Rossano Rubicondi, 24 years her junior, in 2008.

DON JOHNSON & MELANIE GRIFFITH

They had almost the same hair—and a *lot* of history. Don Johnson and Melanie Griffith married young—he was 26, she 18—in 1976, but split within the year. He spent most of the '80s playing detective Sonny Crockett in the hit TV series *Miami Vice* and headed to Hollywood. While on the set of *Working Girl* in 1988, Griffith was reportedly fined for drunkenness and reached out to Johnson, an Alcoholics Anonymous alumnus, for help. At his insistence she entered the Hazelden clinic in Minnesota. They remarried the following year and had a daughter, Dakota. Drinking problems—this time, his—led to a second divorce in 1995.

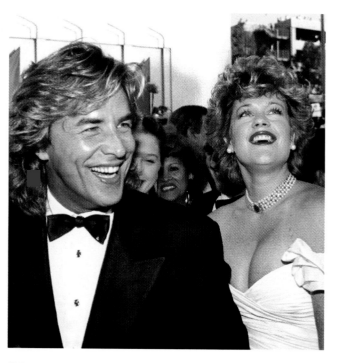

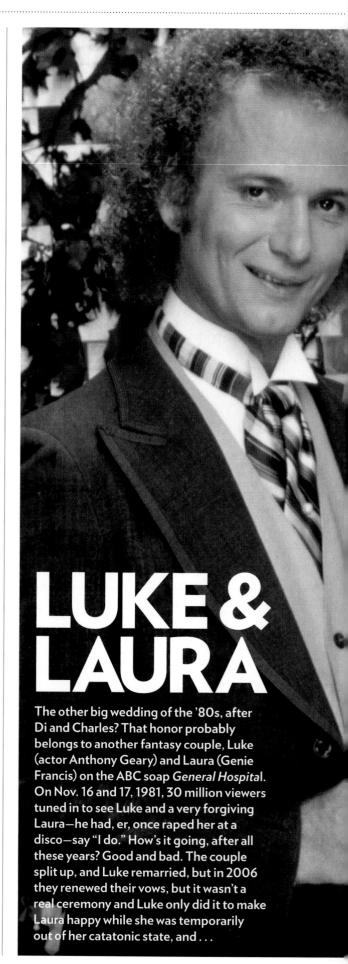

LUKE & LAURA

The other big wedding of the '80s, after Di and Charles? That honor probably belongs to another fantasy couple, Luke (actor Anthony Geary) and Laura (Genie Francis) on the ABC soap *General Hospital*. On Nov. 16 and 17, 1981, 30 million viewers tuned in to see Luke and a very forgiving Laura—he had, er, once raped her at a disco—say "I do." How's it going, after all these years? Good and bad. The couple split up, and Luke remarried, but in 2006 they renewed their vows, but it wasn't a real ceremony and Luke only did it to make Laura happy while she was temporarily out of her catatonic state, and . . .

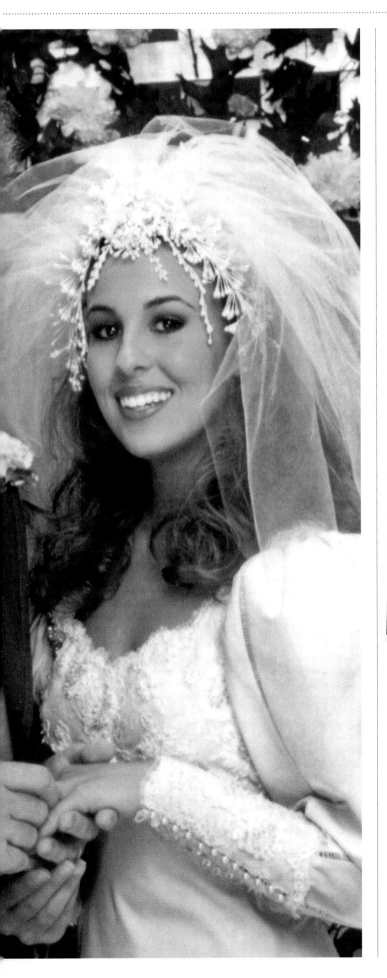

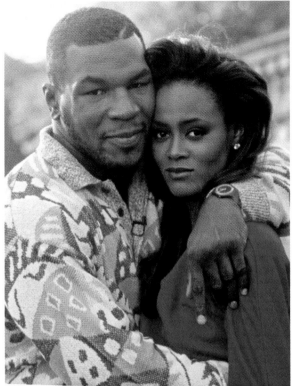

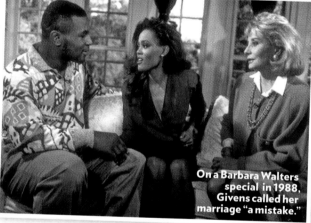

On a Barbara Walters special in 1988, Givens called her marriage "a mistake."

MIKE TYSON & ROBIN GIVENS

She played rich girl Darlene Merriman on the TV sitcom *Head of the Class*; he was the world heavyweight champ, one of boxing's more brutal competitors. An unlikely match indeed. Some whispered that Robin Givens married Mike Tyson, on Feb. 7, 1988, for money. Soon more whispered that she stayed married out of fear. "He can be very frightening," Givens once told PEOPLE, talking about a night when, she says, Tyson threw her up against a wall and began swinging and screaming at her. "It was there that I began to see that this thing was not going to work." Associates remembered Tyson calling his wife "whore" and shaking her. (Tyson denied ever abusing Givens.) They divorced on Feb. 14, 1989.

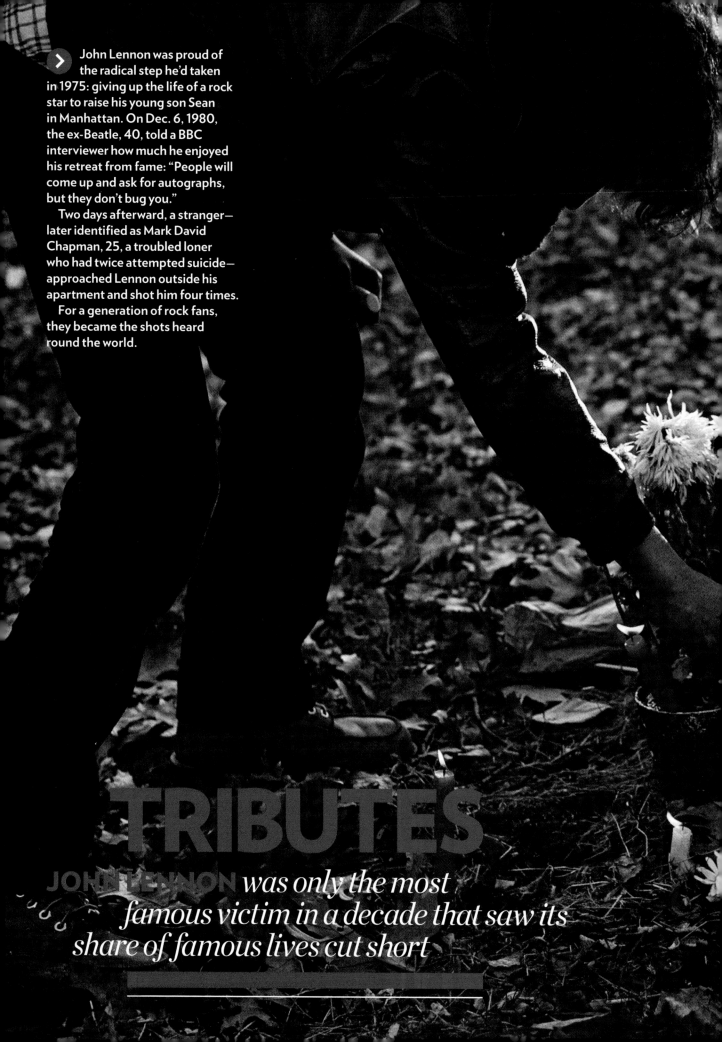

> John Lennon was proud of the radical step he'd taken in 1975: giving up the life of a rock star to raise his young son Sean in Manhattan. On Dec. 6, 1980, the ex-Beatle, 40, told a BBC interviewer how much he enjoyed his retreat from fame: "People will come up and ask for autographs, but they don't bug you."
>
> Two days afterward, a stranger—later identified as Mark David Chapman, 25, a troubled loner who had twice attempted suicide—approached Lennon outside his apartment and shot him four times.
>
> For a generation of rock fans, they became the shots heard round the world.

TRIBUTES

JOHN LENNON *was only the most famous victim in a decade that saw its share of famous lives cut short*

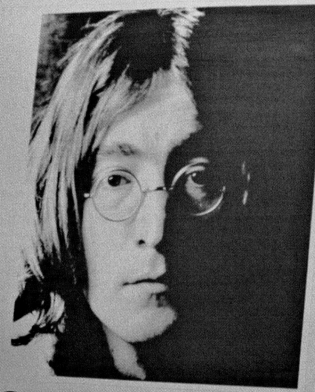

Hello

Goodbye

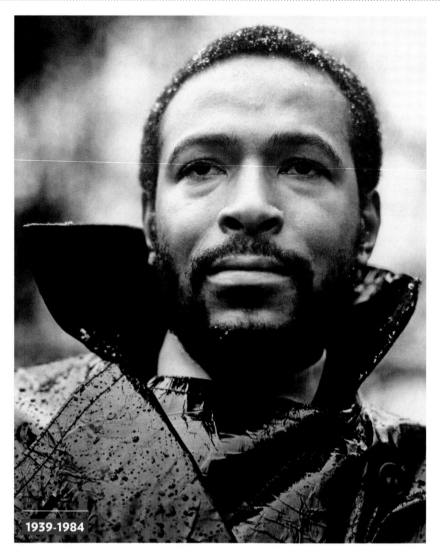

1939-1984

MARVIN GAYE

Beautiful voice, wild life, shocking end

"If my life story isn't as exciting as *Gone with the Wind*," soul superstar Marvin Gaye once told an interviewer, "I'll kiss your bottom in Macy's window." It was a safe bet: Gaye's journey was a nonstop drama of Motown success, drugs, tax woes, great loves and busted marriages, all punctuated by smooth, instant classics like "I Heard It Through the Grapevine" and "What's Going On" that belied the turmoil beneath. His death was in keeping with his tumultuous life: Gaye, reportedly back on drugs, was living with his parents in L.A. "Pushers, women, all kinds of people would come to the door all through the night," a friend recalled. On April 1, 1984, during an argument, Gaye's father, Marvin Sr., 69, shot him dead.

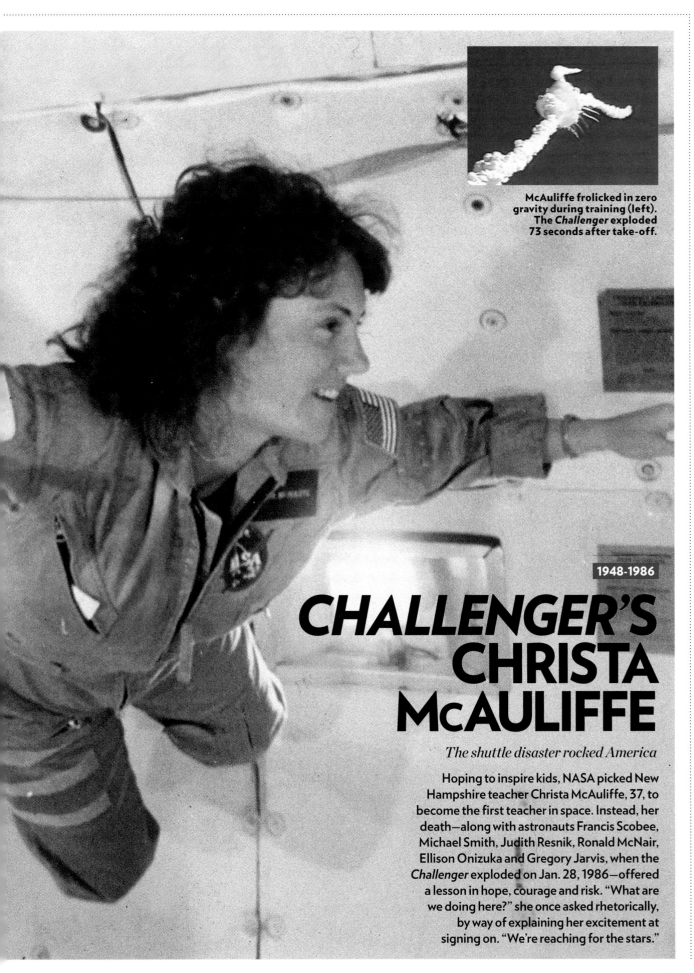

McAuliffe frolicked in zero gravity during training (left). The *Challenger* exploded 73 seconds after take-off.

CHALLENGER'S CHRISTA McAULIFFE

The shuttle disaster rocked America

Hoping to inspire kids, NASA picked New Hampshire teacher Christa McAuliffe, 37, to become the first teacher in space. Instead, her death—along with astronauts Francis Scobee, Michael Smith, Judith Resnik, Ronald McNair, Ellison Onizuka and Gregory Jarvis, when the *Challenger* exploded on Jan. 28, 1986—offered a lesson in hope, courage and risk. "What are we doing here?" she once asked rhetorically, by way of explaining her excitement at signing on. "We're reaching for the stars."

GILDA RADNER

The late-night funny girl who was stronger than anyone knew

"If *Saturday Night Live* was like Never-Never-Land, the Island of Lost Boys, she was Tinker Bell," *SNL* writer Anne Beatts said of Gilda Radner. "She just hadn't lost touch with the child in her." Indeed, a silly, kidlike askewness ran through all her most famous created characters, from Emily Litella to Roseanne Roseannadanna (below) and Lisa Loopner (bottom). When Radner was diagnosed with ovarian cancer in 1986, she found ways to be happy. And after her death, her husband cofounded a center in her name to help others as well. "My life had made me funny," she wrote in *It's Always Something,* her book about coping with her illness, "and cancer wasn't going to change that." She lost her battle, in 1989, at 42.

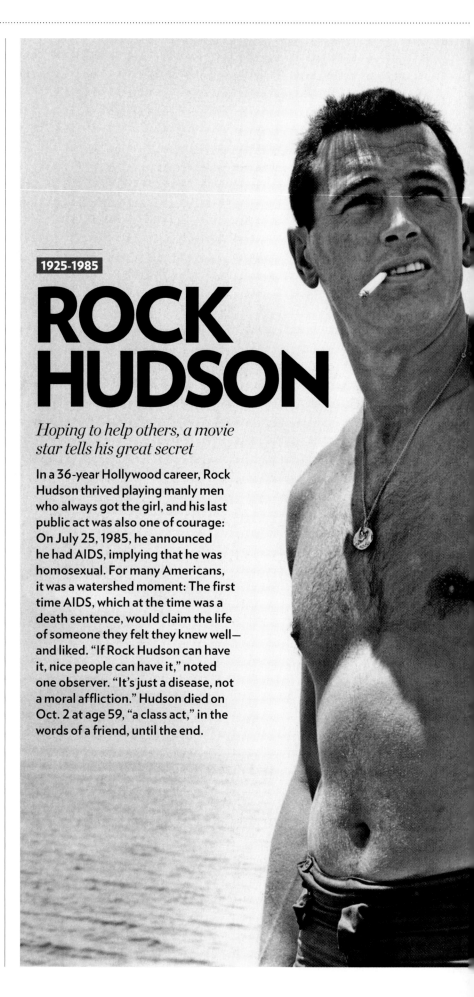

ROCK HUDSON

Hoping to help others, a movie star tells his great secret

In a 36-year Hollywood career, Rock Hudson thrived playing manly men who always got the girl, and his last public act was also one of courage: On July 25, 1985, he announced he had AIDS, implying that he was homosexual. For many Americans, it was a watershed moment: The first time AIDS, which at the time was a death sentence, would claim the life of someone they felt they knew well—and liked. "If Rock Hudson can have it, nice people can have it," noted one observer. "It's just a disease, not a moral affliction." Hudson died on Oct. 2 at age 59, "a class act," in the words of a friend, until the end.

1950-1983

KAREN CARPENTER

Her voice sang of all things light and beautiful—and hid her own struggle

The Carpenters—siblings Richard and Karen Carpenter—produced a sweet, upbeat sound as popular, then, as it is almost unimaginable, on the AM dial, today. But megahits like "Close to You" and "We've Only Just Begun," while capturing singer Karen Carpenter's gentle spirit, gave no hint she was fighting a desperate battle with a disease that, at the time, was barely on America's cultural radar: anorexia. In 1983, at 32, she died of heart failure. As an expert noted, "Many [anorexics] keep their emotions inside. They take care of other people, but they don't take care of themselves."

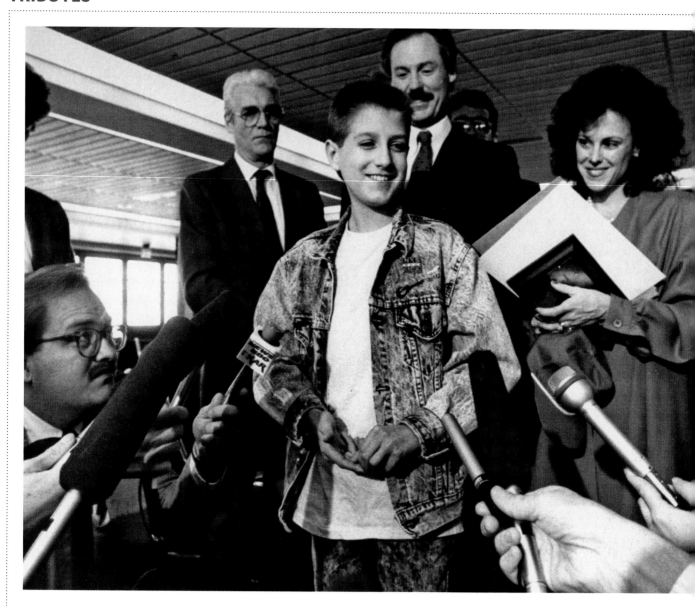

1971-1990

RYAN WHITE

An ordinary kid with extraordinary courage changed the way America thought about AIDS

A hemophiliac, Ryan White received an HIV-tainted blood transfusion at age 12 and in 1984 developed AIDS. Officials in his hometown of Kokomo, Ind., banned him from middle school; his parents' attempts to have him readmitted ignited an ugly backlash, with callers on radio shows labeling him a "faggot" and "homo." When someone fired a shot through the family's front window, they left town.

A charming kid who came across as everybody's younger brother, White became a face of AIDS and won America's heart. "You're gonna do good for everybody who is sick," his mother told him six years later as he lay dying. "It's a shame it has to be you." As the end grew nearer, she whispered to him, "Just let go, Ryan. It's time. Goodbye, buddy, goodbye, my pumpkin. I want to kiss you one more time." He passed away moments later—18 years old and, to many, a hero.

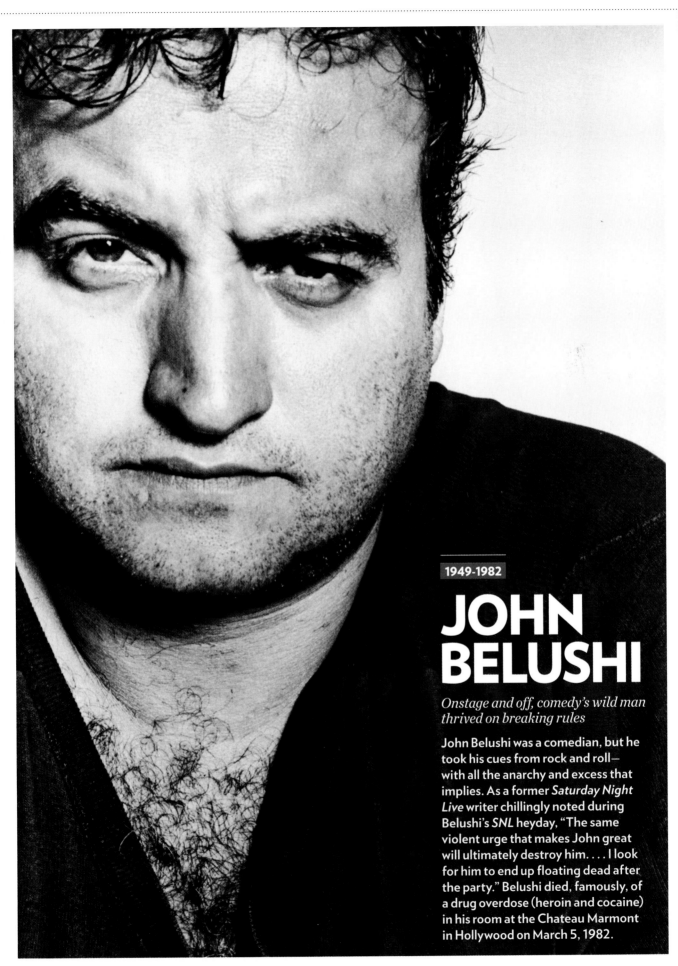

1949-1982

JOHN BELUSHI

Onstage and off, comedy's wild man thrived on breaking rules

John Belushi was a comedian, but he took his cues from rock and roll—with all the anarchy and excess that implies. As a former *Saturday Night Live* writer chillingly noted during Belushi's *SNL* heyday, "The same violent urge that makes John great will ultimately destroy him. . . . I look for him to end up floating dead after the party." Belushi died, famously, of a drug overdose (heroin and cocaine) in his room at the Chateau Marmont in Hollywood on March 5, 1982.

PUNKY BREWSTER

> **THEN** Perky, precocious, rainbow-clad star of the NBC sitcom *Punky Brewster*. **NOW** Married to producer Jason Goldberg, 38, partner in a baby shop, The Little Seed, and mom to daughters Poet, 3, and Jagger, 8 months. The motherhood effect? "When I had Poet," says Frye, 32, "it was like my eyes were opened for the first time."

KIDS THEN, PARENTS NOW

All grown up, **SOLEIL MOON FRYE** *and other child stars of the '80s explore the wonder years of parenthood*

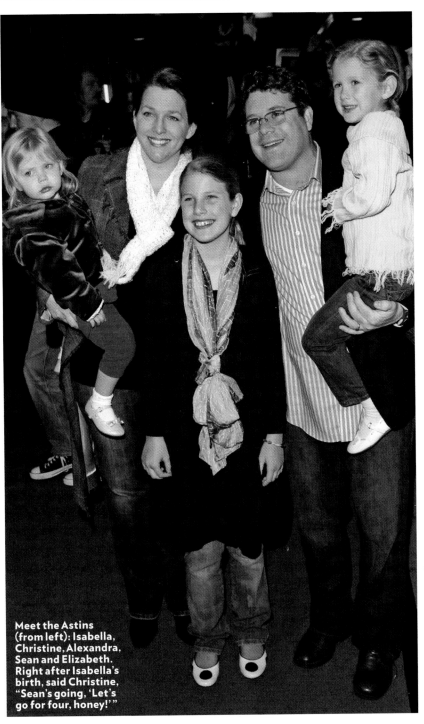

Meet the Astins (from left): Isabella, Christine, Alexandra, Sean and Elizabeth. Right after Isabella's birth, said Christine, "Sean's going, 'Let's go for four, honey!'"

SEAN ASTIN

THEN The unshakably optimistic Mikey Walsh ("Goonies never say die!") in the 1985 cult classic *The Goonies*.
NOW Star of the *Lord of the Rings* series, married to wife Christine for 16 years and the enthusiastic father of three girls: Alexandra, 12, Elizabeth, 6, and Isabella, 3.

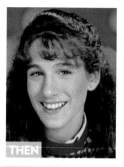

THEN

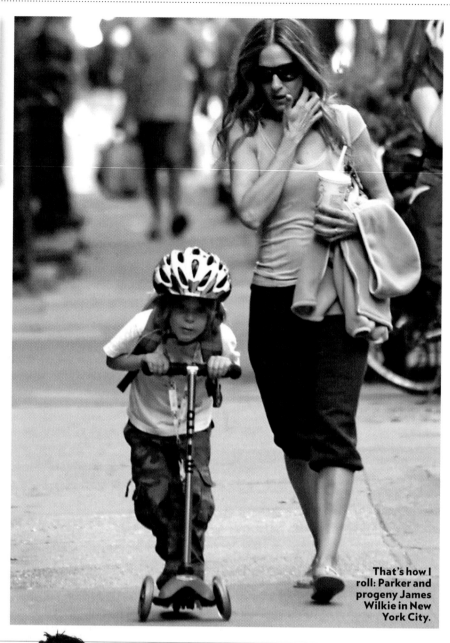

SARAH JESSICA PARKER

THEN Patty Greene, the geeky braniac on CBS' *Square Pegs* **NOW** *Sex and the City* sexpert, 43, married to Matthew Broderick, and mom to James Wilkie Broderick, 6. Momhood, she says, works for her: "Honestly, I love to do everything with him as long as he will have me around." Even "brushing his teeth with him is enjoyable right now."

That's how I roll: Parker and progeny James Wilkie in New York City.

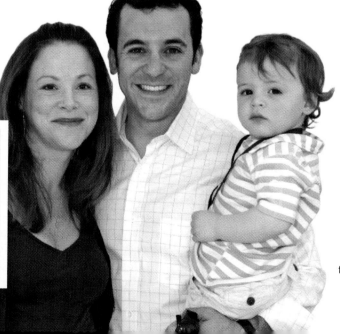

Happy Savages: Jennifer, Fred and Oliver in April 2008.

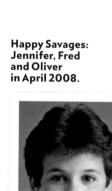

THEN

FRED SAVAGE

THEN Cute, confused Kevin Arnold on *The Wonder Years* **NOW** A director (*Daddy Day Camp*) and actor (the upcoming CBS pilot *Single White Millionaire*), married to his childhood sweetheart Jennifer (née Stone) and 32-year-old dad to two wonder-years-bound children: Oliver, 2 (left), and Lily, born May 3.

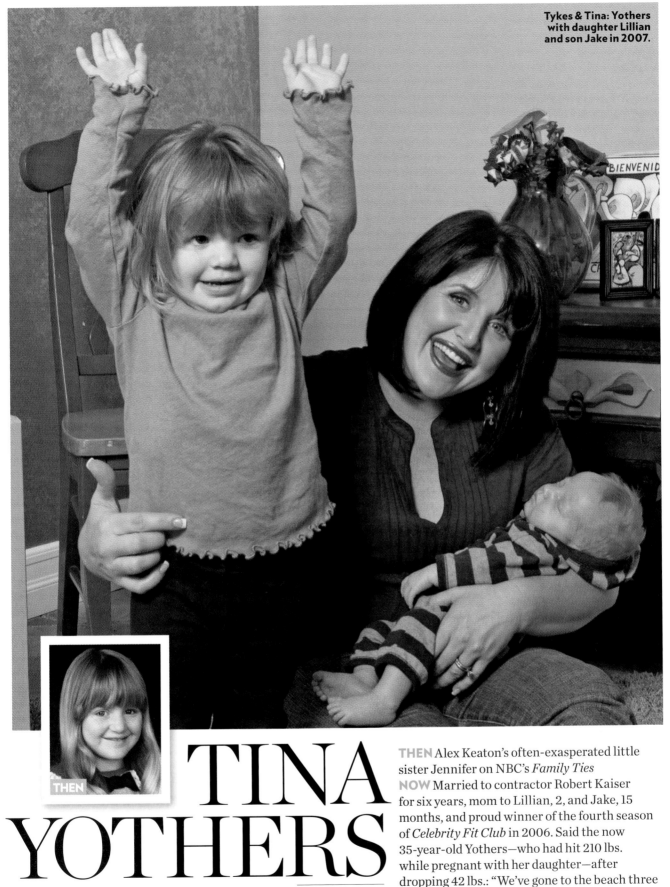

Tykes & Tina: Yothers with daughter Lillian and son Jake in 2007.

THEN

TINA YOTHERS

THEN Alex Keaton's often-exasperated little sister Jennifer on NBC's *Family Ties*
NOW Married to contractor Robert Kaiser for six years, mom to Lillian, 2, and Jake, 15 months, and proud winner of the fourth season of *Celebrity Fit Club* in 2006. Said the now 35-year-old Yothers—who had hit 210 lbs. while pregnant with her daughter—after dropping 42 lbs.: "We've gone to the beach three times this year. And I've worn a bikini every time! I feel great. I'm healthy, I'm athletic. I feel really confident."

THEN

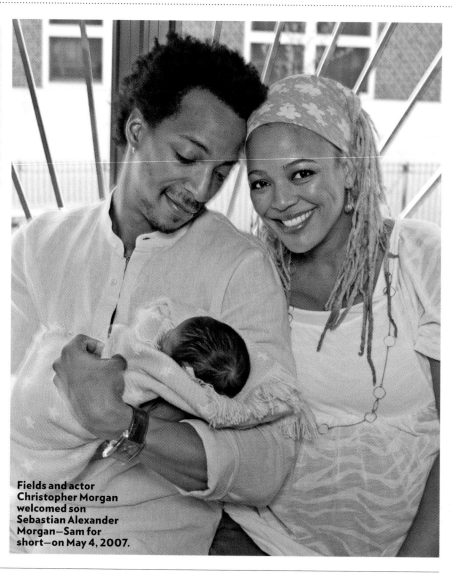

THE FACTS OF LIFE

KIM FIELDS

THEN She was the perky gossip Tootie, one of the sassy schoolgirls on the NBC sitcom *The Facts of Life,* which ran from 1979 to 1988. **NOW** Fields, 39, costarred with Queen Latifah on FOX's *Living Single* in the '90s. She produced and directed a 2006 documentary about jazz saxophonist Najee called *Najee: Sax in South Africa.*

Fields and actor Christopher Morgan welcomed son Sebastian Alexander Morgan—Sam for short—on May 4, 2007.

Money, moppets and modern mores: Pigeon (left) played Schroder's geeky pal Freddy.

THEN

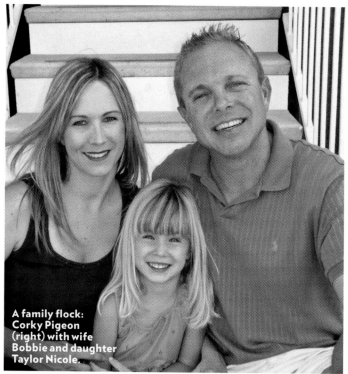

A family flock: Corky Pigeon (right) with wife Bobbie and daughter Taylor Nicole.

SILVER SPOONS

CORKY PIGEON

THEN On the sitcom *Silver Spoons,* Pigeon portrayed a most uncool kid, Freddy Lippincottleman, but rich, decent Ricky Stratton (Rick Schroder) liked him anyway. **NOW** Pigeon, 38, enjoyed being a punk rock drummer with his band The Gain and now focuses on acting.

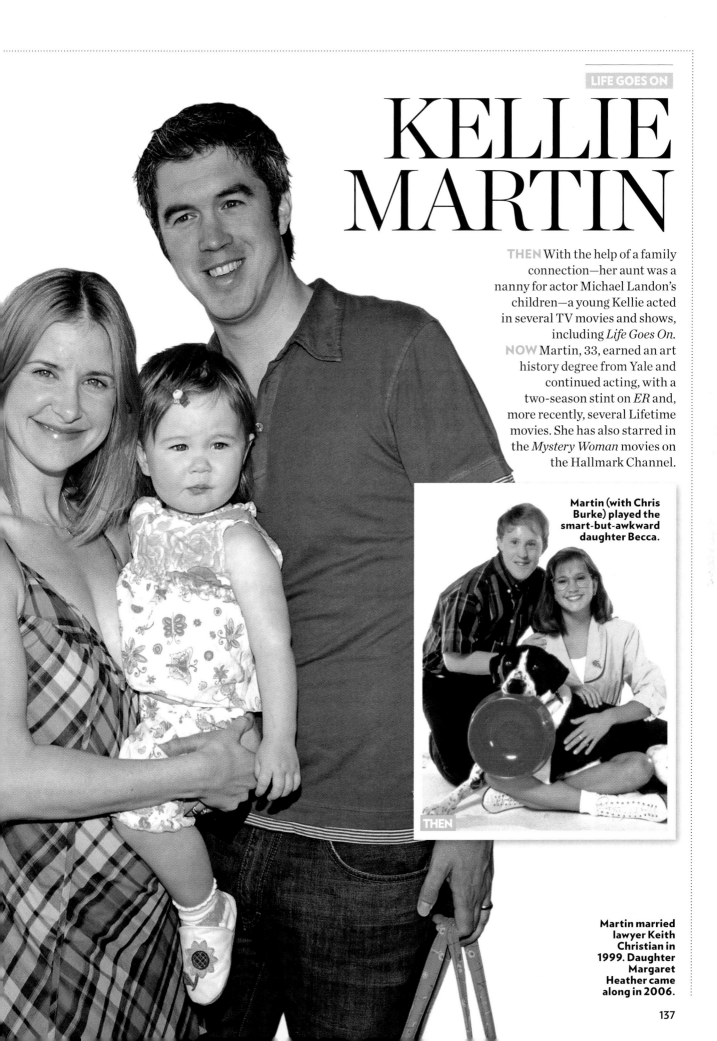

KELLIE MARTIN

THEN With the help of a family connection—her aunt was a nanny for actor Michael Landon's children—a young Kellie acted in several TV movies and shows, including *Life Goes On.* **NOW** Martin, 33, earned an art history degree from Yale and continued acting, with a two-season stint on *ER* and, more recently, several Lifetime movies. She has also starred in the *Mystery Woman* movies on the Hallmark Channel.

Martin (with Chris Burke) played the smart-but-awkward daughter Becca.

THEN

Martin married lawyer Keith Christian in 1999. Daughter Margaret Heather came along in 2006.

WHAT WERE YOU DOING IN THE '80s...?

They weren't always big stars

. . . BRAD PITT?
New to Hollywood
and working the
teen-dream cheese

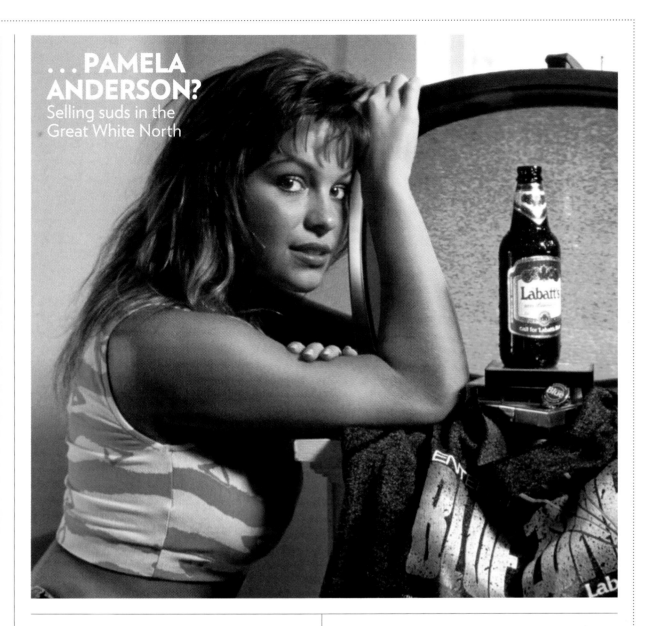

...PAMELA ANDERSON?
Selling suds in the Great White North

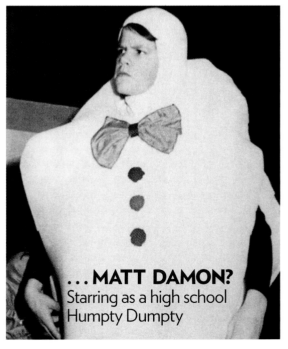

...MATT DAMON?
Starring as a high school Humpty Dumpty

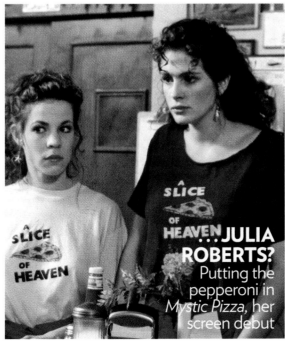

...JULIA ROBERTS?
Putting the pepperoni in *Mystic Pizza*, her screen debut

…KIRSTEN DUNST?

A curly-haired moppet (right), modeling for Sears

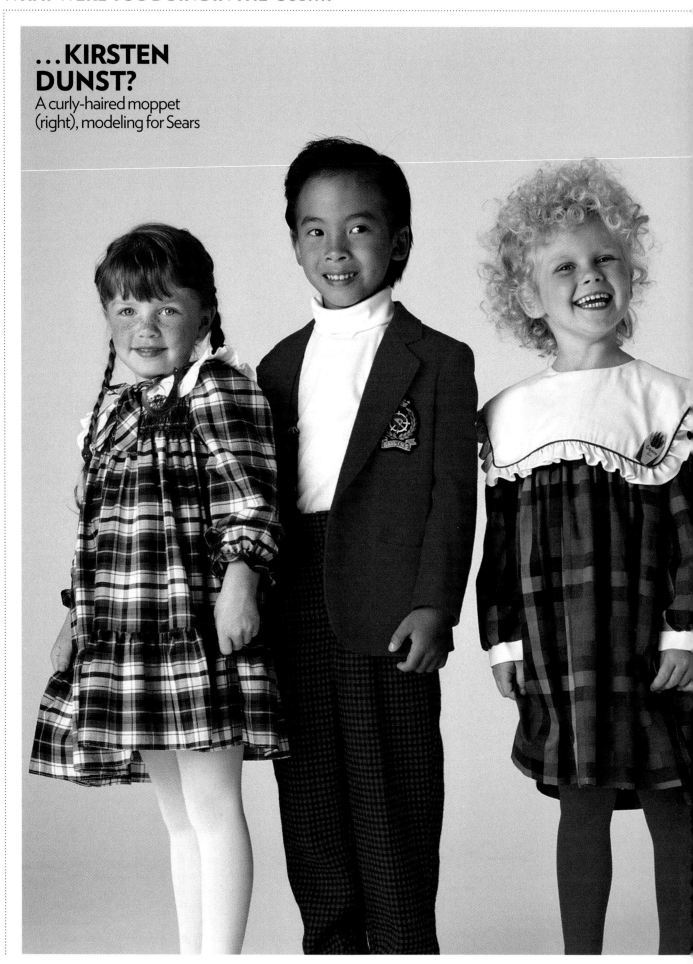

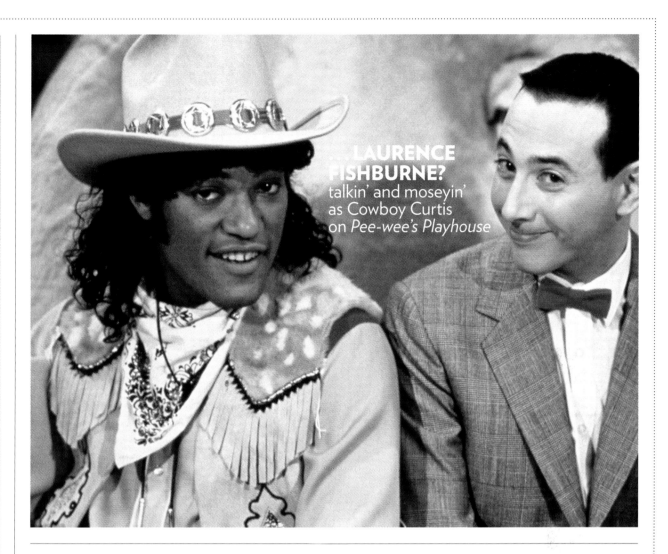

...LAURENCE FISHBURNE?
talkin' and moseyin' as Cowboy Curtis on *Pee-wee's Playhouse*

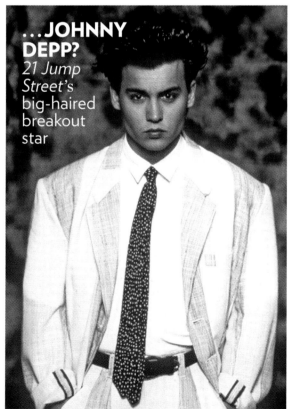

...JOHNNY DEPP?
21 Jump Street's big-haired breakout star

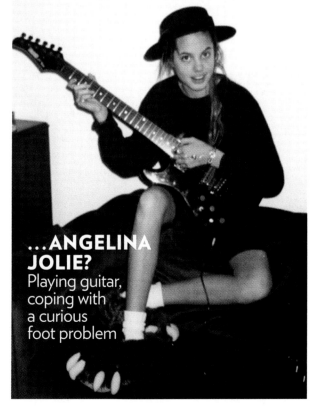

...ANGELINA JOLIE?
Playing guitar, coping with a curious foot problem

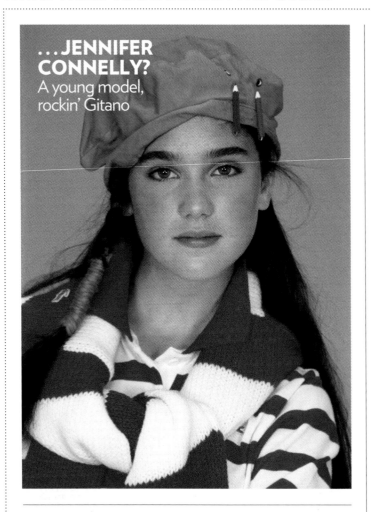

...JENNIFER CONNELLY?
A young model, rockin' Gitano

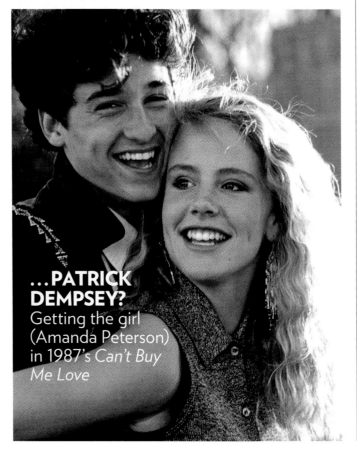

...PATRICK DEMPSEY?
Getting the girl (Amanda Peterson) in 1987's *Can't Buy Me Love*

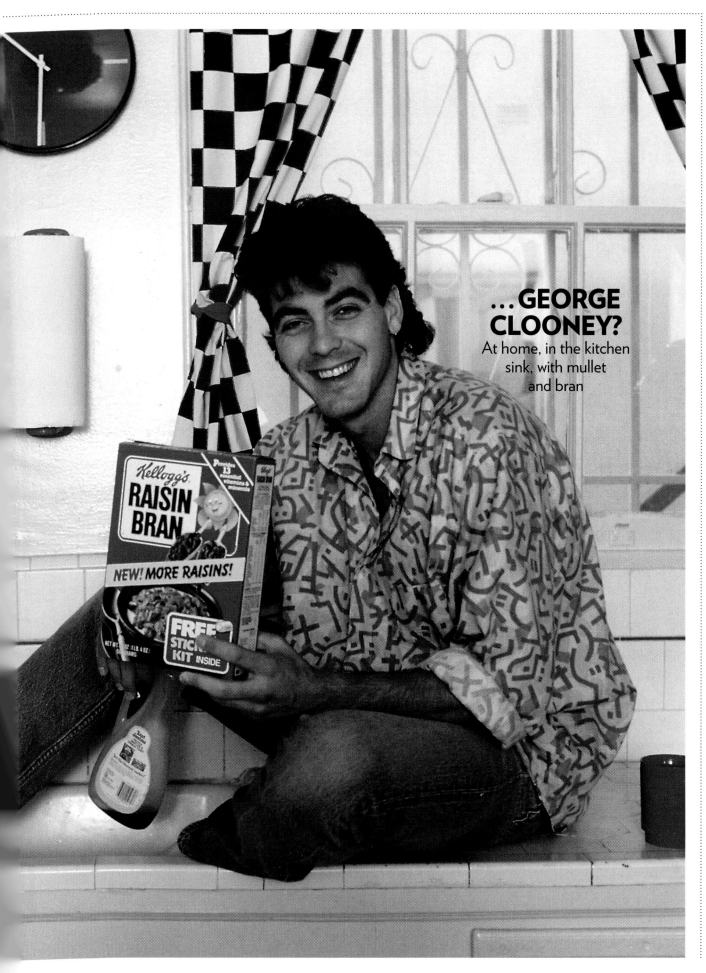

…**GEORGE CLOONEY?**
At home, in the kitchen
sink, with mullet
and bran

CREDITS

Editor Cutler Durkee **Creative Director** Sara Williams **Director of Photography** Chris Dougherty **Art Director** Heather Haggerty **Photography Editor** C. Tiffany Lee Ramos **Editorial Manager** Andrew Abrahams **Writers** Kara Warner, Steve Dougherty, Larry Sutton, Ellen Shapiro, Jessica Haralson **Reporters** Shayla Byrd, Madeline Desmond, Deirdre Gallagher, Debra Lewis-Boothman, Kristen Mascia, Lesley Messer, Hugh McCarten, Gail Nussbaum, Vincent R. Peterson, Thailan Pham, Callie Schweitzer, Brooke Bizzell Stachyra, Emmet Sullivan, Jane Sugden, Christina Tapper, Melody Wells, Chris Willard, Jennifer Wren **Copy Editors** Ben Harte (Chief), James Bradley, Jennifer Broughel, Aura Davies, Alan Levine, Ed Rooney, Jennifer Shotz **Production Editors** Denise M. Doran, Ilsa Enomoto, Cynthia Miele, Daniel J. Neuburger **Scanners** Brien Foy, Stephen Pabarue **Imaging** Romeo Cifelli, Charles Guardino, Jeff Ingledue. Robert Roszkowski **Special thanks to** Robert Britton, David Barbee, Jane Bealer, Sal Covarrúbias, Margery Frohlinger, Suzy Im, Ean Sheehy, Céline Wojtala, Patrick Yang

TIME INC. HOME ENTERTAINMENT Publisher Richard Fraiman, **General Manager** Steven Sandonato, **Executive Director Marketing Services** Carol Pittard, **Director Retail & Special Sales** Tom Mifsud, **Director New Product Development** Peter Harper, **Assistant Director Newsstand Marketing** Laura Adam, **Assistant Director Brand Marketing** Joy Butts, **Associate Counsel** Helen Wan, **Book Production Manager** Suzanne Janso, **Design & Prepress Manager** Anne-Michelle Gallero, **Senior Brand Manager TWRS/M** Holly Oakes, SPECIAL THANKS to Glenn Buonocore, Tymothy Byers, Susan Chodakiewicz, Margaret Hess, Brynn Joyce, Robert Marasco, Brooke Reger, Mary Sarro-Waite, Ilene Schreider, Adriana Tierno, Alex Voznesenskiy
ISBN 10: 1-60320-026-6; ISBN 13: 978-1-60320-026-4; Library of Congress Number: 2008904769

If you would like to order any of our hardcover Collector's Edition books, please call us at 1-800-327-6388 (Monday through Friday, 7a.m.–8 p.m., or Saturday, 7 a.m.–6 p.m. Central Time).

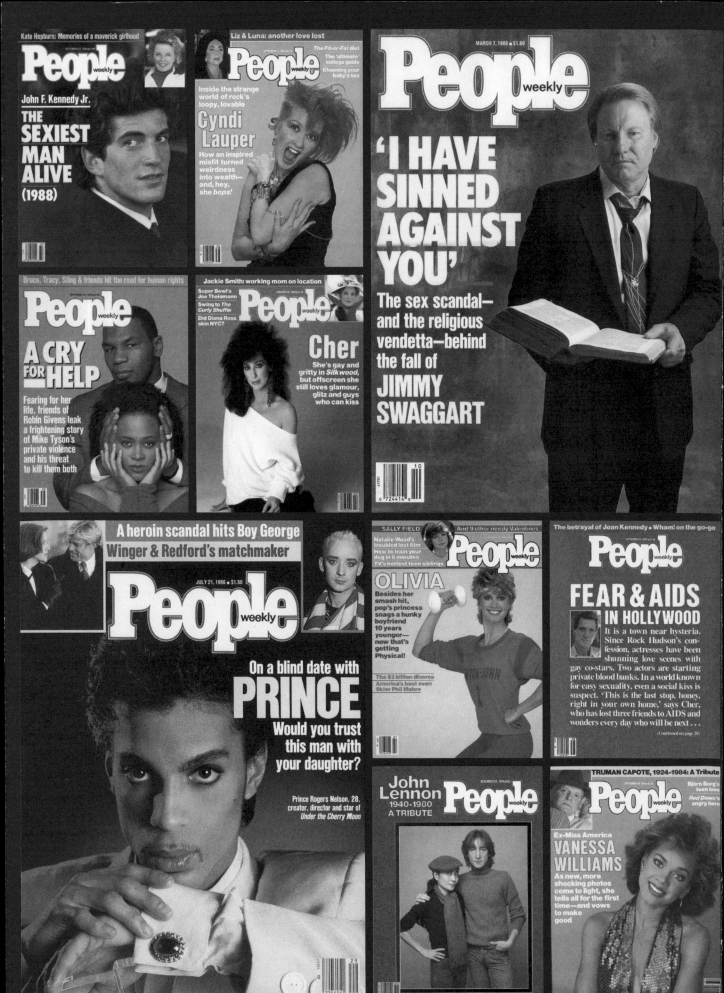

Kate Hepburn: Memories of a maverick girlhood

People weekly

John F. Kennedy Jr.

THE SEXIEST MAN ALIVE
(1988)

Liz & Luna: another love lost

People weekly

The *Fit-or-Fat* diet
The 'ultimate' college guide
Choosing your baby's sex

Inside the strange world of rock's loopy, lovable

Cyndi Lauper

How an inspired misfit turned weirdness into wealth—and, hey, she *bops!*

MARCH 7, 1988 ■ $1.69

People weekly

'I HAVE SINNED AGAINST YOU'

The sex scandal—and the religious vendetta—behind the fall of **JIMMY SWAGGART**

Bruce, Tracy, Sting & friends hit the road for human rights

People weekly

A CRY FOR HELP

Fearing for her life, friends of Robin Givens leak a frightening story of Mike Tyson's private violence and his threat to kill them both

Jackie Smith: working mom on location

Super Bowl's Joe Theismann
Swing to *The Curly Shuffle*
Did Diana Ross skin NYC?

People weekly

Cher

She's gay and gritty in *Silkwood*, but offscreen she still loves glamour, glitz and guys who can kiss

A heroin scandal hits Boy George
Winger & Redford's matchmaker

People weekly

JULY 21, 1986 ■ $1.50

On a blind date with
PRINCE
Would you trust this man with your daughter?

Prince Rogers Nelson, 28, creator, director and star of *Under the Cherry Moon*

SALLY FIELD And 9 other needy Valentines

Natalie Wood's troubled last film
How to train your dog in 6 minutes
TV's hottest teen siblings

People weekly

OLIVIA

Besides her smash hit, pop's princess snags a hunky boyfriend 10 years younger—now that's getting Physical!

The $3 billion divorce
America's best ever Skier Phil Mahre

The betrayal of Joan Kennedy ● Wham! on the go-go

People weekly

FEAR & AIDS IN HOLLYWOOD

It is a town near hysteria. Since Rock Hudson's confession, actresses have been shunning love scenes with gay co-stars. Two actors are starting private blood banks. In a world known for easy sexuality, even a social kiss is suspect. 'This is the last stop, honey, right in your own home,' says Cher, who has lost three friends to AIDS and wonders every day who will be next . . .

(Continued on page 28)

John Lennon
1940-1980
A TRIBUTE

People weekly

TRUMAN CAPOTE, 1924-1984: A Tribute

Björn Borg's teen love
Red Dawn's angry hero

People weekly

Ex-Miss America
VANESSA WILLIAMS

As new, more shocking photos come to light, she tells all for the first time—and vows to make good